Canaletto

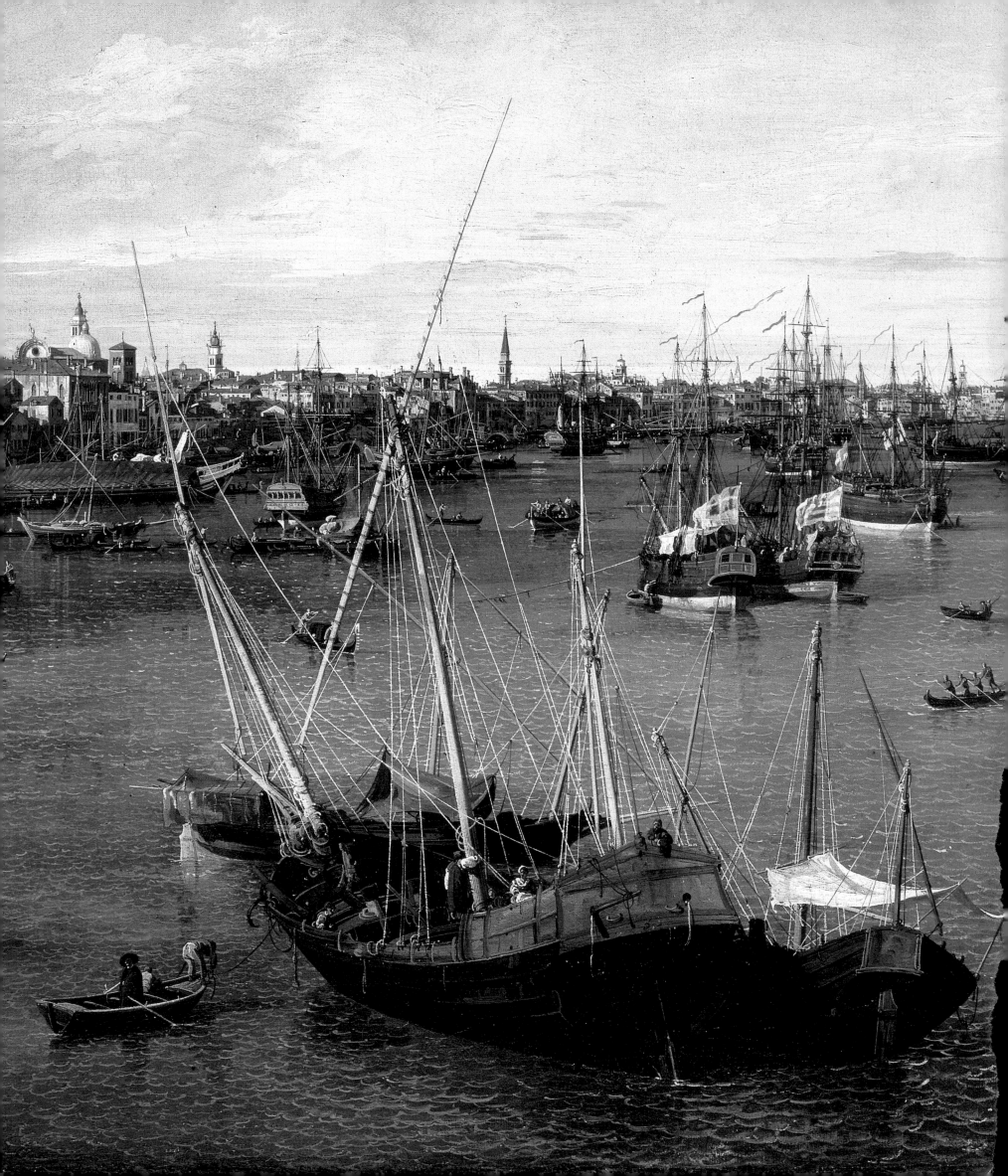

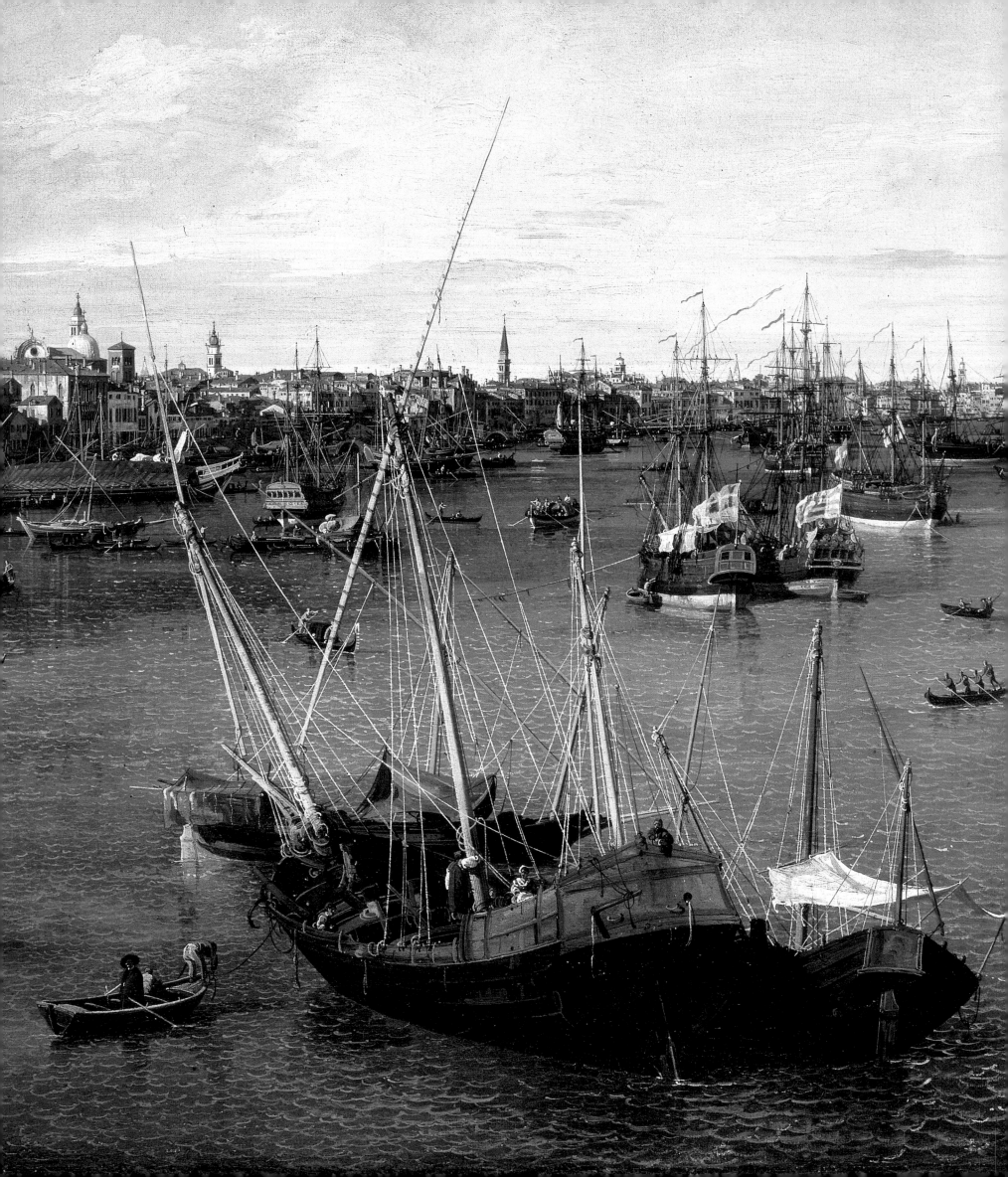

Dorothea Terpitz

Giovanni Antonio Canal, known as
Canaletto

1697–1768

KÖNEMANN

1 (frontispiece)
Riva degli Schiavoni (detail ill. 53), ca. 1740
Oil on canvas, 46.5 x 63 cm
The Toledo Museum of Art, Toledo, Ohio

© 1998 Könemann Verlagsgesellschaft mbH
Bonner Str. 126, D-50968 Köln

Art Director: Peter Feierabend
Project Manager and Editor: Sally Bald
Assistant: Susanne Hergarden
German Editor: Ute E. Hammer
Assistant: Jeannette Fentroß
Translation from the German: Anthony Vivis
Contributing Editor: Chris Murray
Production Director: Detlev Schaper
Assistant: Nicola Leurs
Layout: Claudia Faber
Typesetting: Greiner & Reichel, Cologne
Reproductions: Omniascanners, Milan
Printing and Binding: Neue Stalling, Oldenburg
Printed in Germany

ISBN 3-8290-0242-4
10 9 8 7 6 5 4 3 2 1

Contents

FROM SCENE PAINTER TO VEDUTÀ ARTIST

2 Entrance to the Canal Grande, ca 1726–1728
Oil on canvas, 191 x 203 cm
Musée de Grenoble, Grenoble

From the Molo, we can see the church of Santa Maria della Salute with its enormous dome. The Dogana da Mar, the Customs House for goods travelling by sea, is situated on the headland. Between the island of Giudecca, which is visible in the left-hand section of the picture, and the Dogana da Mar, the harbor of maritime republic used to lie. At the height of Venice's fame as *La Serenissima*, this was one of the most important harbors in the Mediterranean. On the tower of the Customs House, which was renovated in the 17th century, two Atlantes used to support the globe, crowned by Fortuna, the capricious goddess of good fortune, who was holding a fluttering sail in the wind.

Over the centuries, the city of Venice, uniquely situated on a lagoon between the mainland and the sea, has been admired by writers and artists, by scholars, and by those travelling to broaden their education. Politicians, diplomats, and statesmen have praised the political skill the Venetian Republic demonstrated in becoming a strong and wealthy maritime trading power. In the 18th century, the city's splendor and its citizens' lifestyle continued to attract many visitors from abroad. For those making the Grand Tour in the 18th century, the classical sites of Rome were the traditional goals: yet the metropolis of Venice was still regarded as a center of entertainment and lasciviousness well worth a detour.

The Carnival, which went on for some six months, and the arrival of ambassadors and other important guests, offered welcome opportunities for the extended celebrations that characterized the city. The faded magnificence of Venice, the beauty of *La Serenissima* – "the Most Serene", as the Venetians themselves called their city – are reflected in the city's art. In the 18th century Venice produced art works of exceptional quality that were highly prized by contemporaries abroad. This happened despite the fact that by the 18th century Venice was no longer central to East-West trade. The Venetian Republic enjoyed its heyday in the 15th and 16th centuries, when it had achieved immeasurable wealth through its wide-ranging foreign trade. In the 18th century, however, it saw a period of steady decline. Because both its political and economic life deteriorated, Venice increasingly took second place to other European great powers, notably Britain and the Netherlands. In the 16th century the city's political leader, the Doge, had concluded treaties with neighboring states in order – successfully – to avert threats from the Ottoman Turks. In the 18th century, however, the policies of the Doges were characterized by an inflexible neutrality that amounted to a withdrawal from international politics. This cautious jockeying for position in foreign relations, as well as an inability to guarantee merchant vessels safe passage through the Mediterranean, caused the political life of Venice to be increasingly concentrated on the city's internal affairs.

In the arts, however, there was a final, incomparable flowering in the 18th century. At the same time, Venice became a place catering for many pleasures. In 1683, the first coffee house opened in the Procuratie district, and casinos swiftly increased in number. Aristocrats and wealthy citizens purchased country estates on the Terraferma (the neighboring mainland), where they indulged their private pleasures. Within the city, there lived a great many musicians, showpeople and clowns, among whom mingled members of the Venetian demimonde – small-time card-sharpers and crooks. Both theater and opera flourished, and, although Naples had gradually developed into the main center of Italian opera, many foreign musicians and artists gave guest performances in Venice. Handel, Gluck and Mozart all visited the city on the lagoon, letting it inspire their music. The Venetian ballet was also very famous: foreign royalty made strenuous efforts to engage well-known Venetian dancers – male and female – at their courts.

It was in this Rococo world – at the end of the Baroque – that Canaletto grew up and became one of the leading artists of the day. His paintings present not only enchanting views of his native city spread out between canals and lagoon, but also a closely observed portraits of the social life of his contemporaries. He left vivid images of the city's many festivals and ceremonies, customs and traditions, and shared with us his intimate knowledge of 18th-century modes of dress.

Canaletto, whose real name was Giovanni Antonio Canal, was born in Venice on 28 October 1697, the son of the scene painter, Bernardo Canal (1674–1744), near the Campo San Lio – in the heart of Venice, not far from the Rialto Bridge. It is very likely that later in life Canaletto lived in the family house on the Corte del Perini where he was born. The Canal family's social origins are not clear. A signed drawing in the Collection of Copperplate Engravings (in the Staatliche Museen Preußischer Kulturbesitz) in Berlin suggests that Canaletto was descended from a Venetian aristocrat family. This is not certain, however. Canaletto's father, Bernardo Canal, earned his living mainly by creating set designs for Venetian theaters and opera houses, and by designing the décor for state receptions, weddings, and funerals. The main task of these commissions was to create impressive, illusionistic scenery; he had to use his

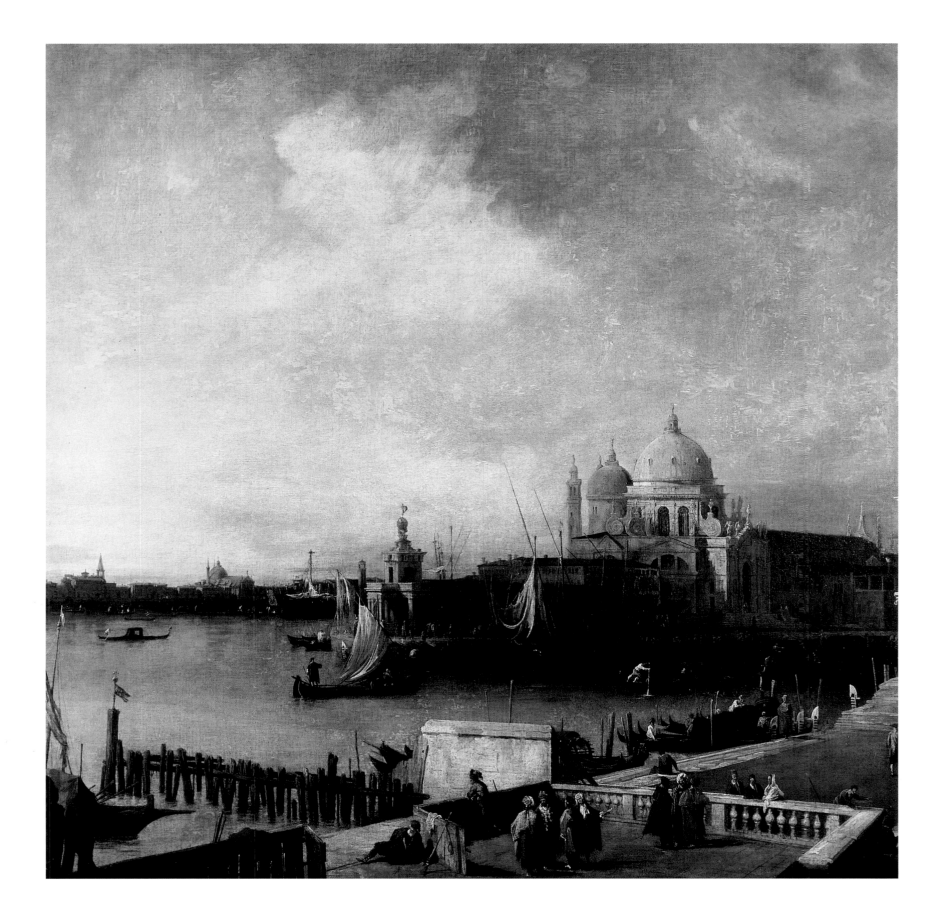

skills to create an architecture that would draw the spectators irresistibly into the scene. From the early Renaissance onwards, such architectural constructions, faithfully depicted according to the laws of linear perspective, were well known and had become a familiar part of painting's repertoire. The knowledge of perspective developed by the architect Filippo Brunelleschi (1377–1446), as well as the discoveries and insights of Leonardo da Vinci (1452–1519), set the standard for the way space was to be depicted. In stage design, the *scena dell'angolo* ("angled scene") had been developed. Here, lines were no longer symmetrically arranged around a central axis, as in traditional perspective. Centrality was abandoned in favor of angular perspective, in which diagonal and crosswise viewpoints opened up new spatial insights. Moreover, a complex system of foreshortening and intersecting was developed to intensify the effect of depth.

Canaletto had the opportunity to assimilate all this knowledge in his early years, for he helped his father create set designs. He completed his first independent set designs, for the Venetian theaters, San Angelo and San Cassiano, about 1716. Here Canaletto developed a new type of stage design. Instead of following the usual pattern of treating space in an architectural manner, he incorporated ideas developed by the Galli-Bibiena family of theater architects and stage designers. By applying the *scena dell'angolo* already mentioned, these

designers managed to achieve effects similar to *trompe l'œil*, creating set designs and décor that are now regarded as the high points of Baroque stage construction. One of the designers who followed this new direction was Marco Ricci (1676–1729), who came from Belluno, and, like Canaletto, worked for the Theatro San Angelo. He was the nephew of the well-known painter, Sebastiano Ricci (1659–1734), one of the leading artists of the late Baroque in Venice, and may well have influenced Canaletto strongly in his choice of subjects.

For the Carnival in Rome in 1720, two operas by Alessandro Scarlatti (1660–1725) were performed, "Titus Sempronius Graccus" and "Turno Aricino". Commissioned to design the sets, Bernardo and Antonio Canal both travelled to Rome in 1719. As yet, unfortunately, no details of these sets have come to light. Nor do we know much about other works that Canaletto may have created before 1720. Thereafter, Canaletto seems to have turned his back on stage design, and began instead to paint *vedute*, a genre that had grown in importance in the late 17th century.

Although an aspect of landscape painting, the *vedutà* is a genre in its own right. *Vedute* are topographically accurate views of urban architecture, individual streetscapes, squares, or rows of houses. They usually feature staffage figures, which help to create an impression of everyday life. The first cityscapes date

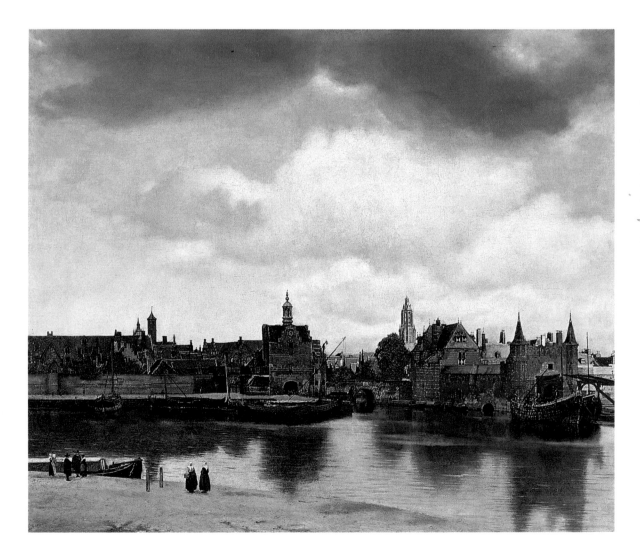

3 Jan Vermeer
View of Delft, ca. 1660/61
Oil on canvas, 96.5 x 115.7 cm
Koninklijk Kabinet van Schilderijen Mauritshuis, The Hague

This view of Delft goes back to the tradition of topographical painting, in which large Dutch maps were framed by views of cities. In this painting, however, Vermeer goes far beyond mere topographical depiction, and presents an atmospheric portrait of the city of Delft. Striking features include the impasto brushwork and the varied colors in which the details of the buildings are depicted. Along with his *Street in Delft*, this is the only landscape Vermeer painted. The two paintings are regarded as the first Dutch landscape to be painted directly from nature.

4 (left) Gaspar van Wittel
The Molo and the Piazzetta, ca. 1697
Oil on canvas, 98 x 174 cm
Museo Nacional del Prado, Madrid

This picture is signed "Gas. V. W. 1697", and so dates
from the year in which Canaletto was born. From a
slightly raised viewpoint in the Bacino di San Marco, we
can see the Molo as well the Doge's Palace and the
Piazzetta, with the cathedral San Marco and the Torre
dell'Orologio in the background. Canaletto chose this or
similar viewpoints primarily in his *vedute* of the
celebrations for Ascension Day.

from as early as the Middle Ages, though in medieval art
city views served to embellish religious events: they
generally form the background to paintings, and often
depict the city of Jerusalem. In 14th-century Italian
paintings, however, we begin to find more and more
views of real, European cities. The purpose of these
views was to document the power and influence of
Italian city states or to illustrate important events
connected with a city. Such city views had a political
purpose, though they were never the main subject of a
picture. In the art of the Netherlands, city views became
a familiar feature of art from the mid-16th century
onwards. The product of a middle-class culture, they
confirm how far the artist – as well as the patron or
purchaser – identified with familiar surroundings. We
know of numerous landscapes by Netherlandish artists
such as Rubens (1577–1640), Rembrandt (1606–
1669), Jacob Ruisdael (1628/29–1682), and Vermeer
(1632–1675).

Among these landscapes were depictions of the artists'
native towns: views that come under the heading of
traditional topographical paintings. In Jan Vermeer's
View of Delft (ill. 3), however, which dates from about
1660/61, we have a unique example of how a city view
could become a pictorial subject in its own right: it
demonstrates the genre's emancipation from the
traditional, purely topographical city view. Vermeer
depicts Delft from the opposite bank of the river, in
other words from the south. Dark clouds create deep
shadows in the foreground, stretching as far as the city
wall and the large city gate. By contrast, the city in the
background, with the high tower of the Nieuwe Kerk
(New Church) clearly visible, is bathed in bright
sunlight. Vermeer's subtle color scheme emphasizes the
materiality of the scene – especially the structural
characteristics of buildings, with their red tiled roofs
and stuccoed walls. The way in which Vermeer has

approached the picture, painting in white outlines and
adding points of light to the houses and the boat in the
right-hand part of the picture, helps him to create a
highly individual, highly atmospheric depiction of
Delft. The city seems at one and the same time curiously
close to – and yet remote from – the viewer.

One of the favorite subjects for 17th- and 18th-
century cityscape painters, apart from their native cities,
was Rome. Gaspar van Wittel (1653–1736), whom the
Italians called Vanvitelli, was a key figure among the
Dutch artists who had settled in Rome, and who were
known collectively as the *bamboccianti*. In 1694 Van
Wittel visited Venice and opened a new chapter in
topographical painting for the city on the lagoon. In his
earlier drawings and paintings of Rome and its environs,
van Wittel had already demonstrated the precision of his
powers of observation. In Venice he discovered the
atmosphere and light that gave his pictures their
distinctive character and vitality. On his return to Rome,
he created a series of large-scale paintings from the
motifs he had sketched in Venice; one of these pictures
was *The Molo and the Piazzetta* (ill. 4). The atmosphere
is warm and flooded with light, and the topography
more or less exactly reproduced. The figures help to
bring the picture to life and to sustain its impression of
realism. Van Wittel's later paintings of Rome and Naples
failed to achieve the same high quality. Canaletto had
still not been born when van Wittel painted his Venetian
pictures. They may, nevertheless have been an early
inspiration, for Canaletto could have seen them during
his visit to Rome in 1720. We know of no personal
contact between Canaletto and van Wittel. Yet, thanks
to his cityscapes, the Dutch artist is regarded as a pioneer
of *vedutà* painting, and as such, directly or indirectly,
was an important influence on Canaletto.

Canaletto may also have been inspired by the
paintings of Giovanni Paolo Pannini (1691–1765). He

5 (following double page) Gentile Bellini
The Procession of the Holy Cross on the Piazza San Marco,
1496
Oil on canvas, 365 x 389 cm
Gallerie dell'Accademia, Venice

This large-scale painting, now in the Academy of Fine
Arts in Venice, is considered a masterpiece of the late 16th
century. Bellini painted the procession bearing a relic of
the Holy Cross for the Sala della Croce in the Scuola di
San Giovanni Evangelista, which owned some of these
relics. Bellini combined different viewpoints in order to
extend the field of vision. The procession and the old
Procuratie are viewed from the center, whilst the rest is
seen from the side of the square. Bellini has, however,
made the perspective clear and harmonious.

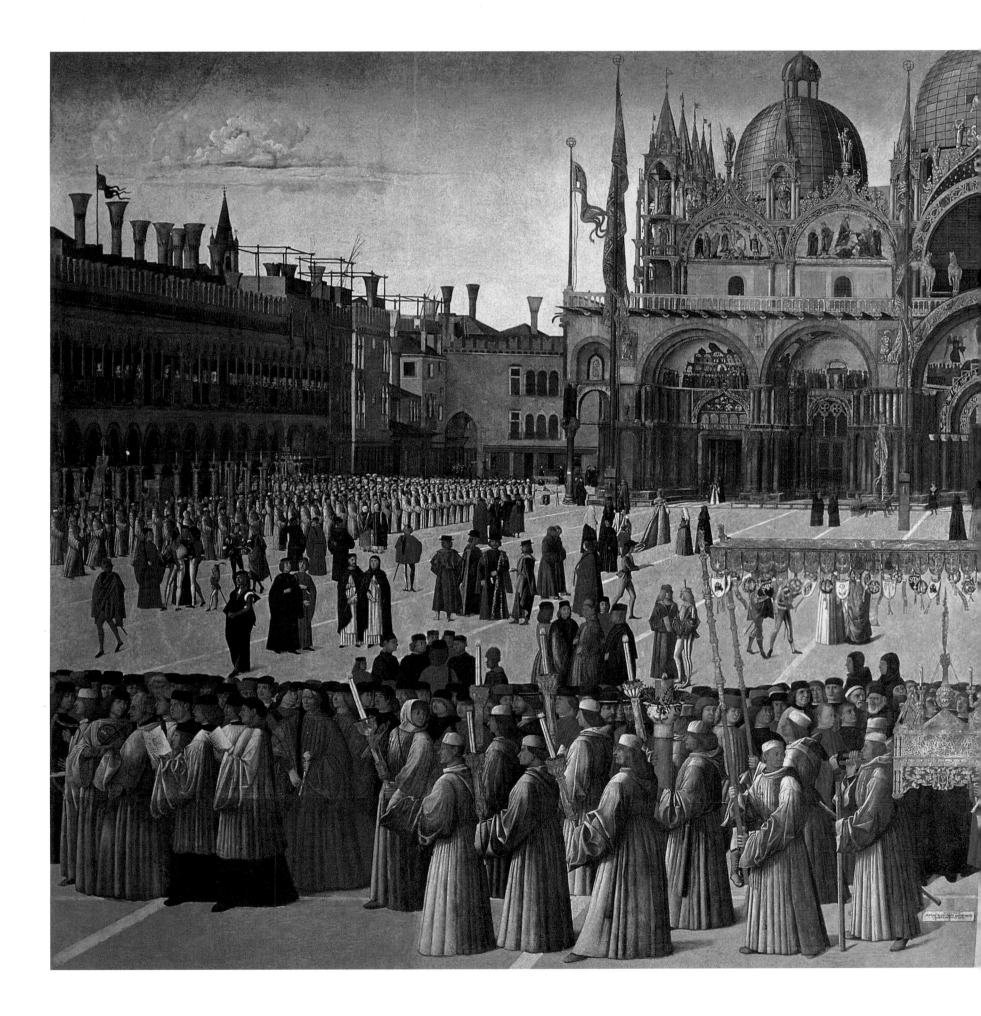

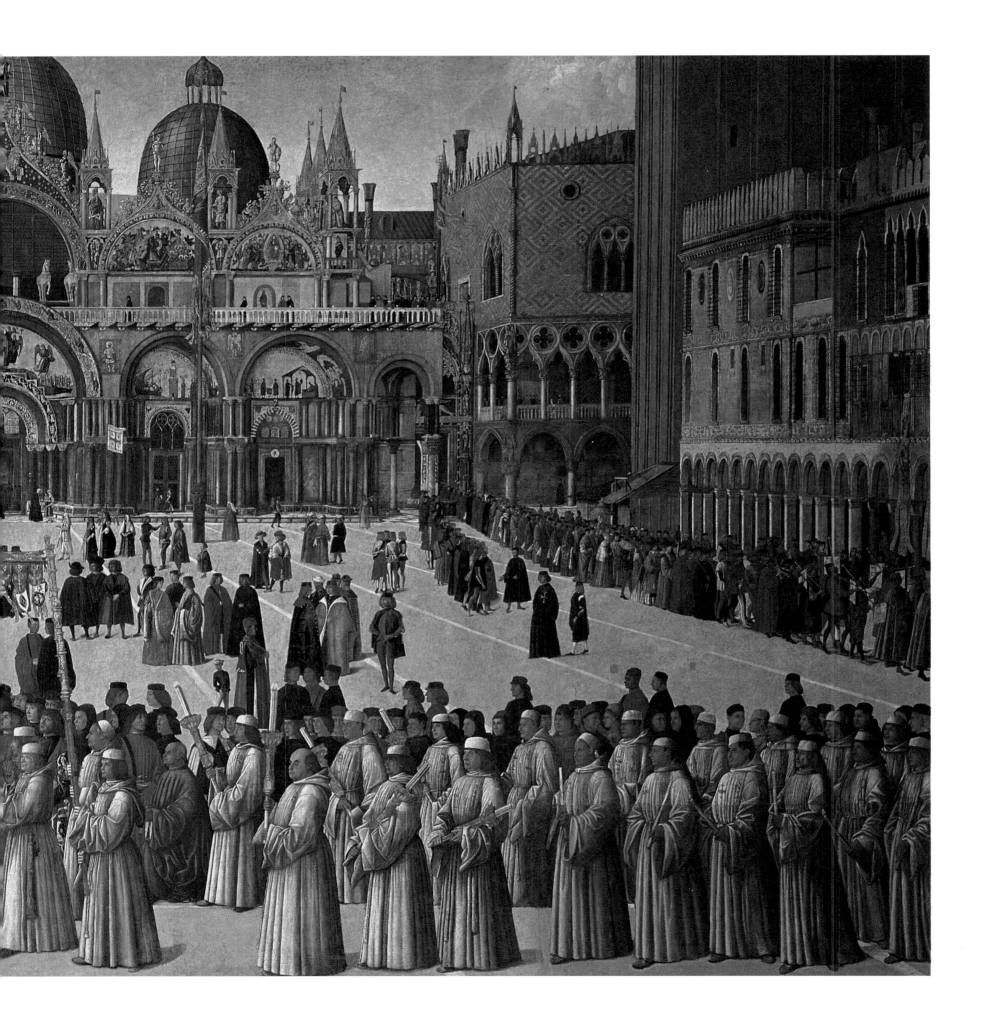

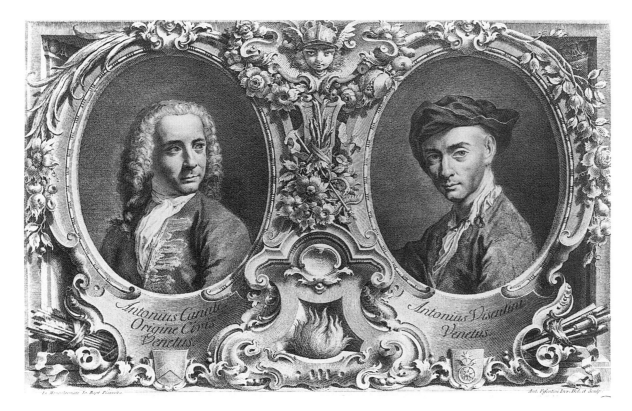

6 Antonio Visentini
Portrait of Canaletto, 1735
Engraving after Giovanni Battista Piazzetta for the title page of the "Prospectus Magni Canalis Venetiarum" Biblioteca Nazionale Marciana, Venice

This portrait of Canaletto is to be found on the left-hand side of the title page of the "Prospectus Magni Canalis Venetiarum", an album of copperplate engravings by Visentini after originals by Canaletto. On the right-hand side, we can see a portrait of Visentini himself. Giovanni Battista Piazzetta created both portraits. Joseph Smith, Canaletto's art dealer, utilized the "Prospectus" for advertising purposes – in other words, to make his protégé's *vedute* known to a wider public and, as a result, find clients.

was born in Piacenza, and it was there that he trained as a set designer and landscape painter in the circle around the Galli-Bibienas. In 1711 he went to Rome, where he completed several fresco-decorations for villas, and designed elaborate festive décor for special occasions. It was in Rome that Canaletto may have seen Pannini's cityscapes, as well as his pictures of festive occasions and state visits; he may also have seen Pannini's pictures of ruins, know as *vedute ideate*, or fantasy *vedute*.

When considering the origins of the *vedutà*, we should remember not merely the influence of landscape painting in the Netherlands. In Italy also there was a long-established tradition of depicting cityscapes that stretched far back into the Middle Ages. The buildings and architectural details we can see in the backgrounds of late medieval altarpieces were part of the pictures' religious subject matter. From the early Renaissance onwards, however, the buildings and churches depicted became more and more important as background scenery, and at the same time they also became increasingly realistic. The Venetian artist, Gentile Bellini (ca. 1429–1507), for instance, exactly depicted the Piazza San Marco in two large-scale paintings, completed between 1496 and 1500, and now in the Gallerie dell'Accademia, Venice. These are *The Procession of the Holy Cross on the Piazza San Marco* (ill. 5), and *The Miracle of the Relic of the Holy Cross*. Bellini was commissioned to paint these pictures by the Scuola di San Giovanni Evangelista, which owned a valuable relic of the Cross. The pictures primarily satisfy the needs of those who venerate the relic; but an accurate depiction of the Piazza San Marco was inextricably bound up with this function. In both pictures, the religious content is paramount; yet the depiction of

the city in the background has already taken on a new significance. This painting clearly shows how the depictions of the city evolved into the fully fledged *vedutà*.

Luca Carlevaris (1663–1730), who was born in Udine and moved to Venice while still young, was another important representative of early Venetian *vedutà* painting around 1700. He saw himself more as a mathematician and scientist than as an artist; nevertheless he left several fantasy landscapes and those depicting ruins, as well as maritime and battle pictures and biblical scenes. After initially concentrating on these subjects, he extended his repertoire by making topographic studies of the city of Venice (ill. 7). He also presented the main sights of the city in an edition of 140 copperplate engravings. He did not draw the scenes down to the last detail; they are often merely sketches. Nor did he possess van Wittel's ability to convey the luminous atmosphere of the city by the sea. His real strength lay in the lively way he depicted the figures in his pictures – his many sketches prove how fascinated he was by figures as pictorial motifs. One of the ground-breaking artists in the early development of the *vedutà* in Venice, Luca Carlevaris created works that contributed decisively to an accurate depiction of the city. Canaletto thought highly of his fellow artist, who was his senior by over 30 years, and was also greatly influenced by him, especially in terms of composition. It therefore comes as no surprise to learn that Canaletto was often regarded as a pupil of Carlevaris – something that has yet to be proved.

Finally, Canaletto's early work as a scene painter and the apprentice years in his father's set-design studio had a great influence on his later *vedutà* painting (ill. 8). For Canaletto, the influence of stage design always remained

crucial, especially in pictorial perspective. This was particularly true from the 1730s onwards, when an ever-widening angle of vision helped transform his cityscapes into panoramic landscapes.

One of Canaletto's first paintings is of the *Grand Canal from the Campo San Vio* (ill. 8), of which he was to paint four variations (cf. ills. 43, 44). Starting from a slightly raised viewpoint to the side of the Campo San Vio, and above the canal, Canaletto lets the viewer's gaze wander over the Grand Canal towards the Bacino di San Marco. The large palace on the left-hand side of the canal is the Palazzo Corner, whose marble façade Canaletto conveys in great detail. It was not only the palace façade that engaged Canaletto's interest, for he also concentrated on the side facing the viewer. Here he shows us the irregular plaster surface of the walls, as well as the rows of slightly rickety windows. The Campo San Vio, of which a small section protrudes into the foreground bottom right-hand edge of the picture, is full of life. Four poorly clad men are resting in the square, enjoying the sun. Two other men, chatting to each other, are standing in front of them. On the wall of the house that rises up steeply behind the figures, we can see a detailed drawing of a boat, complete with flags. On a small balcony at the top of the building there is a

woman; with a broom in her hand, and her duster spread out over the balustrade, she is watching what is going on in the square. The chimney sweep on the roof completes an everyday scene, which gives this section of the picture the feel of a genre painting. There is scaffolding against the lantern crowning the dome of Santa Maria della Salute, which rises up further back in the picture behind the houses on the right. Documentary sources confirm that restoration work was indeed carried out on the church, which Canaletto depicts in faithful detail here, in 1719. It is possible that the artist had begun the picture as early as 1719; he presumably completed it early in 1720, after his return from Rome. That this is one of Canaletto's very first views is supported by the testimony of Anton Maria Zanetti (1680–1757), a contemporary painter and art collector, who states that Canaletto did not turn his attention to *vedutà* painting until he had come back from Rome. At all events, no other authenticated cityscapes painted before 1720 – either of Rome or Venice – have come down to us.

In his views of the Campo San Vio, light and shadow are clearly differentiated, indeed strongly contrasted. The Campo itself is bathed in bright sunlight, although the adjoining façade is darkened by the shadow of

7 Luca Carlevaris
Piazza San Marco, Looking East, ca. 1722
Oil on canvas, 135.9 x 252 cm
Private Collection, Venice

From a slightly raised viewpoint to one side, the viewer is looking at the façade of the cathedral of San Marco. This viewpoint is unreal – it is higher than the square so that both wings of the Procuratie can be shown. The square itself seems confined by the buildings that surround it, and is dominated by the massive Campanile. Numerous groups of figures, deep in conversation, make the picture come alive. A stage has been erected in front of the Campanile, and this attracts several more inquisitive onlookers. The painting is one of the earliest examples we have of a *scena dell'angolo* form of perspective.

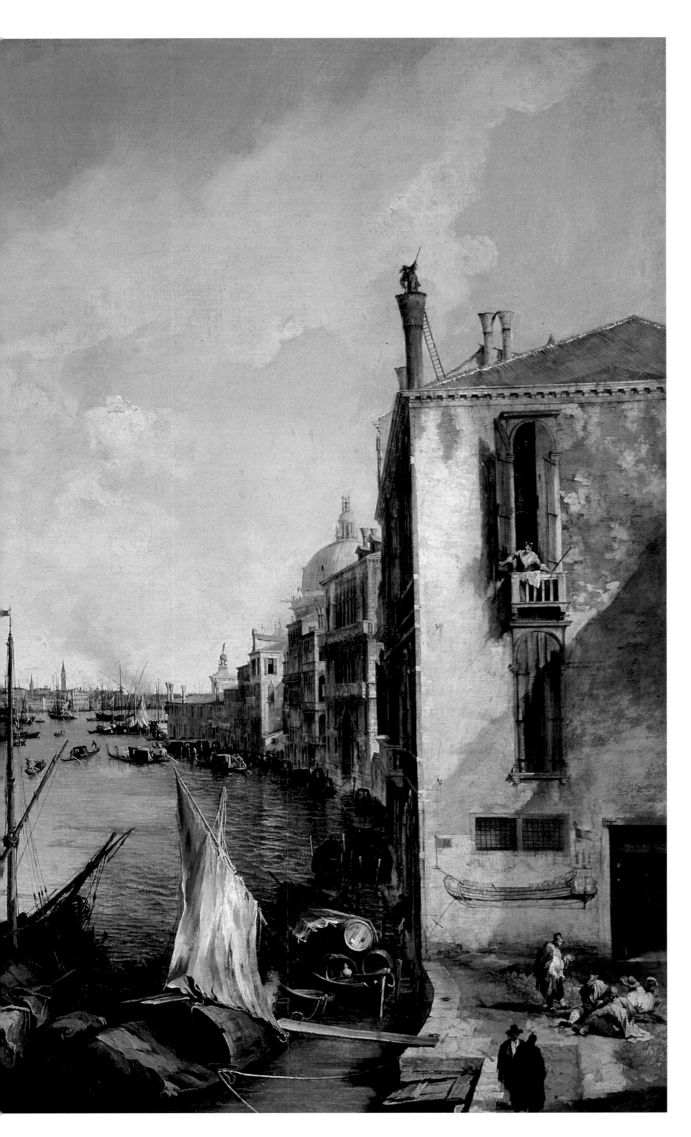

8 *Grand Canal From the Campo San Vio*, before 1723
Oil on canvas, 140.5 x 204.5 cm
Museo Thyssen-Bornemisza, Madrid

If we compare this very early painting with the variant on
the same subject Canaletto completed later (ills. 43, 44),
we will be struck by how deeply Canaletto was initially
attached to painting stage sets, with their "dramatic"
coloration.

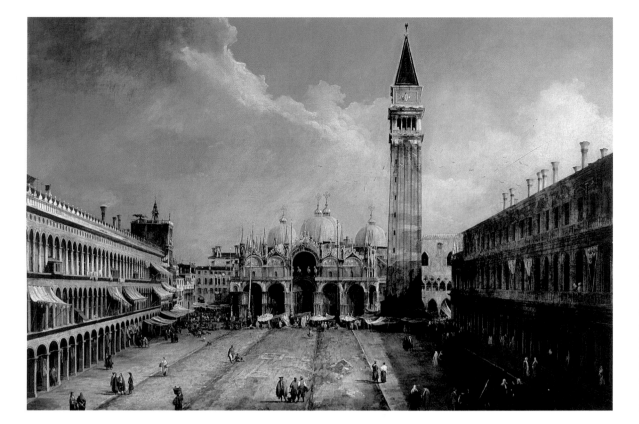

9 (left) *Piazza San Marco, Looking East*, 1723
Oil on canvas, 140.5 x 204.5 cm
Museo Thyssen-Bornemisza, Madrid

The Piazza San Marco and the Grand Canal were among
the most popular subjects for 18th-century Venetian
vedutà painters. This view is one of the earliest of
Canaletto's works. It depicts the Piazza San Marco when
it was being repaved about 1723/24, and so it can
therefore be assigned this date. The buildings on the side
clearly close off and frame the square. This shows us how
strongly Canaletto's *vedute* of the early 1720s still reflect
the influence of stage design.

houses not visible in the picture. The façades of the
palaces on the left bank of the Grand Canal also cast
deep, dark shadows on the water, shadows Canaletto has
strongly accentuated. These do not merge with the
lighter areas, and this gives the canal water a quality of
restless vitality. Here, Canaletto employed chiaroscuro,
the technique of vividly contrasting light and dark, a
technique characteristic of Caravaggio (1571–1610)
and his successors. Like the followers of Caravaggio,
Canaletto used this technique to emphasize fine details
of perspective.

In 1720, after his return from Rome, Canaletto was
accepted as a member of the Venetian painters' guild,
and from that moment on his name was to appear in the
guild's register. Even so, his father was still not a member
of the guild by this stage – he did not join until 1737.
Canaletto, who seems to have planned his career
very carefully, now started painting a series of *vedute*
depicting the most important squares and sights in
Venice. Luca Carlevaris, who was now approaching 60,
had created a market for *vedute* in the course of his
long career. There was a considerable demand for them
among tourists – especially among the English, who
purchased views of the city as mementoes of their visit.
Although he was only 23 years old, Canaletto had not
only a highly developed talent for observation but also
exceptional technical skill. Together, these abilities
clearly promised a successful career.

One of the first pictures we can date reliably is his
Piazza San Marco, Looking East (ills. 9, 10). The church
of San Marco and the Campanile both tower up from
the center of the picture, and the buildings of the
Procuratie close off the square at the sides. The figures
in the square are arranged in pairs or small groups; along

with the market stalls in the background, they fill the
square with bustling vitality. The Piazza itself has still
not been fully paved: in its center we can see waste pipes
still exposed. About a third of the square has already
been paved, but the strong shadow, which more or less
coincides with the edge of the paved area, keeps this in
the background. The paving, with its distinctive
geometric pattern, was completed by Andrea Tirali
between 1723 and 1724. This indicates that the picture,
too, was probably painted about 1723, which makes it
one of his four early views of Venice. These are: the
Grand Canal From the Campo San Vio (ill. 8); the *Piazza
San Marco, Looking East* (ill. 9); the *Grand Canal From
the Palazzo Balbi Towards the Rialto Bridge* (ill. 11); and
the *Rio dei Mendicanti* (ill. 13). Their size (they are all
approximately 140 x 200 cm) and their elaborate
execution suggest that they were all commissioned by
the same patron, though we do not know for sure who
it was. All four pictures, however, were once part of
the collection owned by the Prince of Liechtenstein.
This allows us to suppose that his ancestor, Prince
Joseph Wenzel von Liechtenstein, commissioned them.
Although he did not begin his reign until 1748, this
soldier and diplomat was well known as an art lover well
before that date. Anton Maria Zanelli, who was a long-
standing friend of his, may have helped to arrange the
commission.

Canaletto's view of the Piazza San Marco, the second
picture in this group of four, shows the piazza tapering
like a trapezium. The Procuratie, which enclose the
square from the sides, transform architecture into stage
scenery. Both the regular repetition of the façade
ornamentation and the strongly foreshortened lines of
perspective unmistakably suggest theater sets. However,

10 (opposite) *Piazza San Marco, Looking East*
(detail ill. 9), 1723

Whilst the front section of the square almost looks like an
empty stage, the façade of San Marco in the background
brings the picture to life. This impression is reinforced by
the profusion of small market stalls in front of the
cathedral, and by the alleyway to the side of the cathedral.
In the foreground, exposed waste pipes lead the eye across
the square, which is yet to be paved.

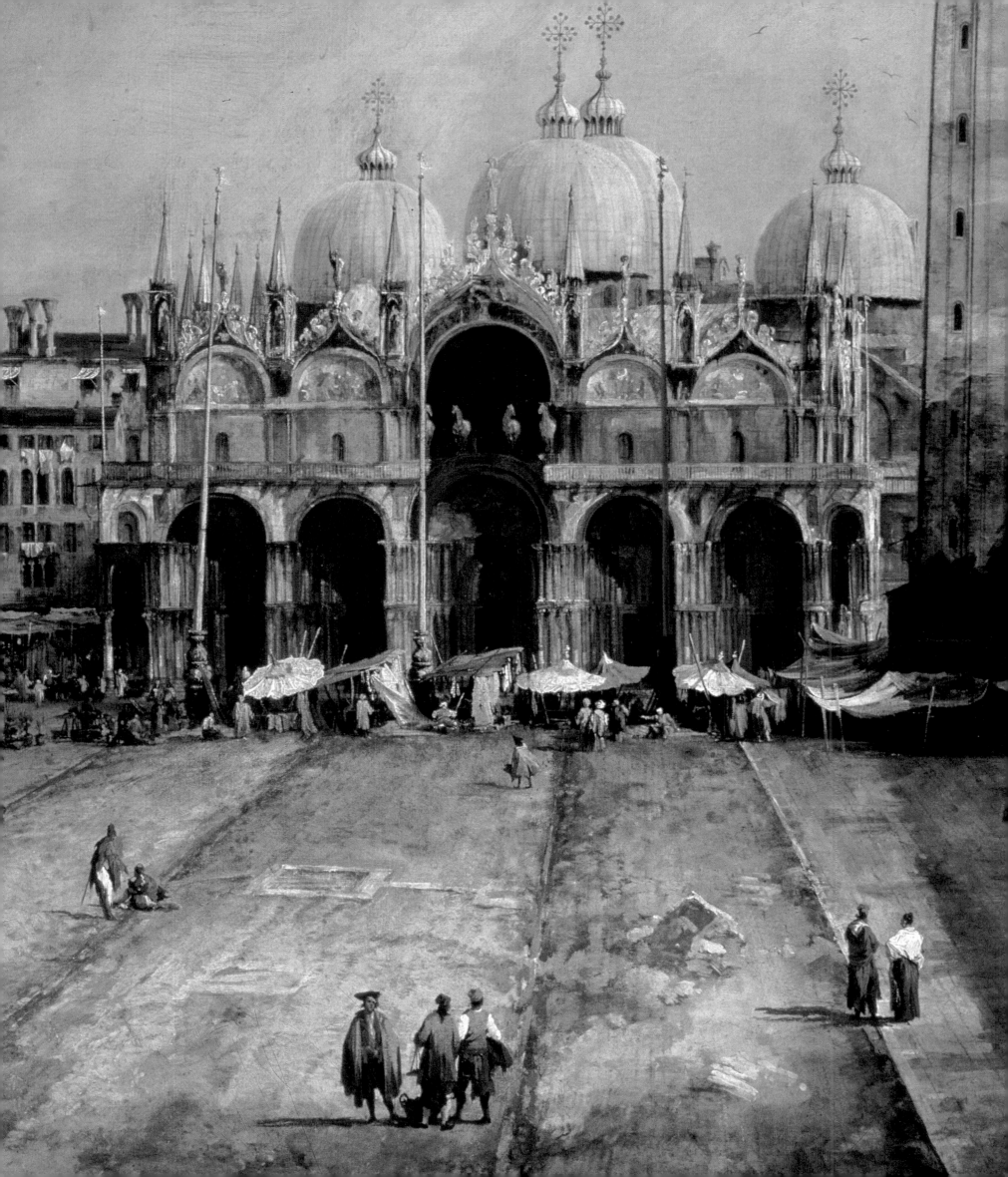

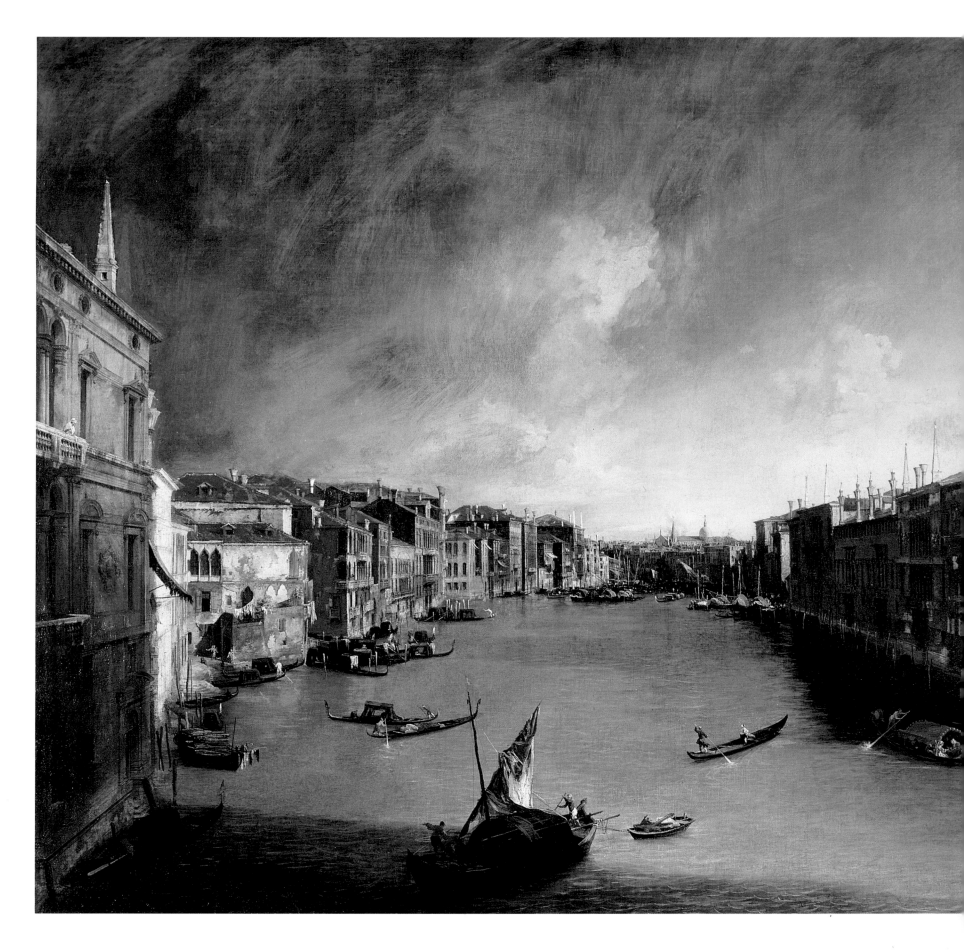

11 *Grand Canal From the Palazzo Balbi Towards the
Rialto Bridge*, 1723–1725
Oil on canvas, 144 x 207 cm
Museo del Settecento Veneziano di Ca' Rezzonico, Venice

Although we cannot reliably date this picture, stylistically
it belongs with Canaletto's early work. As in the first view
he painted of the Piazza San Marco, the artist has
primarily used brown tones. His staffage figures lose
themselves in the architectural framework, which evokes a
stage set. The theater is also suggested by the way
Canaletto directs two different sources of light on the
foreground and background. This helps him to achieve a
greater sense of depth.

Canaletto clearly preferred to create a ordered, neatly patterned depiction of the square's architecture than to give a faithful depiction of its every detail. Even as a young artist, Canaletto paid more attention to creating an integrated pictorial whole than to capturing topographical details accurately. Even so, taken as a whole, the painting still seems rather lifeless. Despite the sunblinds that are pulled out here and there, the façades project a certain monotony. Real life is taking place in the shadowy colonnades beneath the Procuratie, and we can only dimly make out the activities of various tradespeople. In this picture light and shade are again shown in contrasting opposition; even the sky is divided into areas of cloud and clear blue.

The third painting in the group is another view of the Grand Canal seen this time from the Palazzo Balbi towards the Rialto Bridge (ill. 11). Viewers again find themselves looking from a slightly raised standpoint above the center of the canal. In terms both of his angle of vision and pictorial structure, Canaletto is once more basing his picture on Luca Carlevaris's depiction of the regatta on the Grand Canal. On both sides the canal is edged with rows of palace façades. In the background we can make out a section of the Rialto Bridge, and above the houses on the horizon we can just make out the dome of the church of Santa Maria della Salute. In this painting Canaletto depicts the canal at its widest possible point, which allows him to include a distant view as far as the Rialto Bridge. In the foreground, beams of sunlight fall on the façades of houses, and mysteriously illuminate the obelisks on the roof of the second palace. Only a few gondolas disturb the tranquillity of the water. The sky, however, with its almost black clouds in the foreground and a much clearer patch in the distance, looks a great deal more lively. Overall, brown tones predominate. By comparison with the first two views, this picture seems to have less severe contrasts, though even here areas of shadow collide. As regards his depiction of light, Canaletto took advantage of various painterly devices familiar to him from the theater; the shadow cast on the canal by the palace in the foreground comes from a light-source directly opposite the palace. In the architecture along the canal there are no clues as to when the picture was painted. Stylistically, however, it clearly belongs with the artist's early works. In terms of composition all these early works are still heavily influenced by Canaletto's knowledge of stage design, and in their use of highly contrasting colors they evoke the work of Marco Ricci.

Contrasting chiaroscuro, as well as the use of brown tones, also characteristic of Canaletto's early work, predominate in the fourth work of the group, the *Rio dei Mendicanti* (ills. 12, 13). It is at first surprising that Canaletto, who was generally not very strict about topography, here depicts the poor district of Venice in such detail. This kind of depiction was unusual in the late Baroque, which on the whole was dedicated to the ideal beauty. The picture radiates a certain intimacy and mystery. Canaletto's approach to lighting is particularly striking. By using lighter colors, he shows the river bathed in warm, rich light; against these colors, light and shade do not contrast as harshly as in the three other pictures in this group. This shows us that Canaletto was already turning his back on the followers of Caravaggio and the Baroque tradition of chiaroscuro. Interestingly, it was about this time that Venice's second great artist, Giambattista Tiepolo (1696–1770), gradually changed his style, notably in the way he painted the fresco decorations in the Palazzo Sandi, in 1725. In their attempts to depict the qualities of air and light accurately, 18th-century Venetian artists explored new territory in coloration and style. At this point, Canaletto was still on the threshold of his artistic development. Even so, his works were already highly regarded. The Veronese artist, Alessandro Marchesini (1664–1738), wrote to Stefano Conti, a merchant and art lover who lived in Lucca, that Antonio Canal was gradually taking the place of Luca Carlevaris, in whose style he painted. In contrast to the paintings by Carlevaris, Marchesini continued, Canaletto's picture gave one the impression that they really were bathed in sunlight.

The *Piazza San Marco With the Cathedral* (ills. 14, 15), the second version of a view he first painted in 1723, is similar to the earlier version in both subject and composition. In this picture, again, the artist was not primarily concerned with exact topographical reproduction of architectural details. He depicts the square in wide and deep perspective, so that the cathedral of San Marco recedes into the background. He also depicts the whole height of the Campanile. Here again Canaletto has based the composition on techniques of stage design, even though the square now looks larger and broader than it did in the first picture. By now it is also completely paved over. We can clearly see Andrea Tirali's geometric pattern – similar to a Greek key design – on the paving stones. This dates the picture to late 1724 at the earliest, with most scholars settling on 1725. For this second picture Canaletto chose colors that tend more towards blue. In fact his palette gradually veered from brown to blue tones, a change that greatly helped to create atmosphere. This view of the Piazza San Marco is one of those paintings that Canaletto completed at the start of his attempts to depict lighting effects accurately. Areas of chiaroscuro are still set against one another, but they do not contrast as strongly as in earlier works.

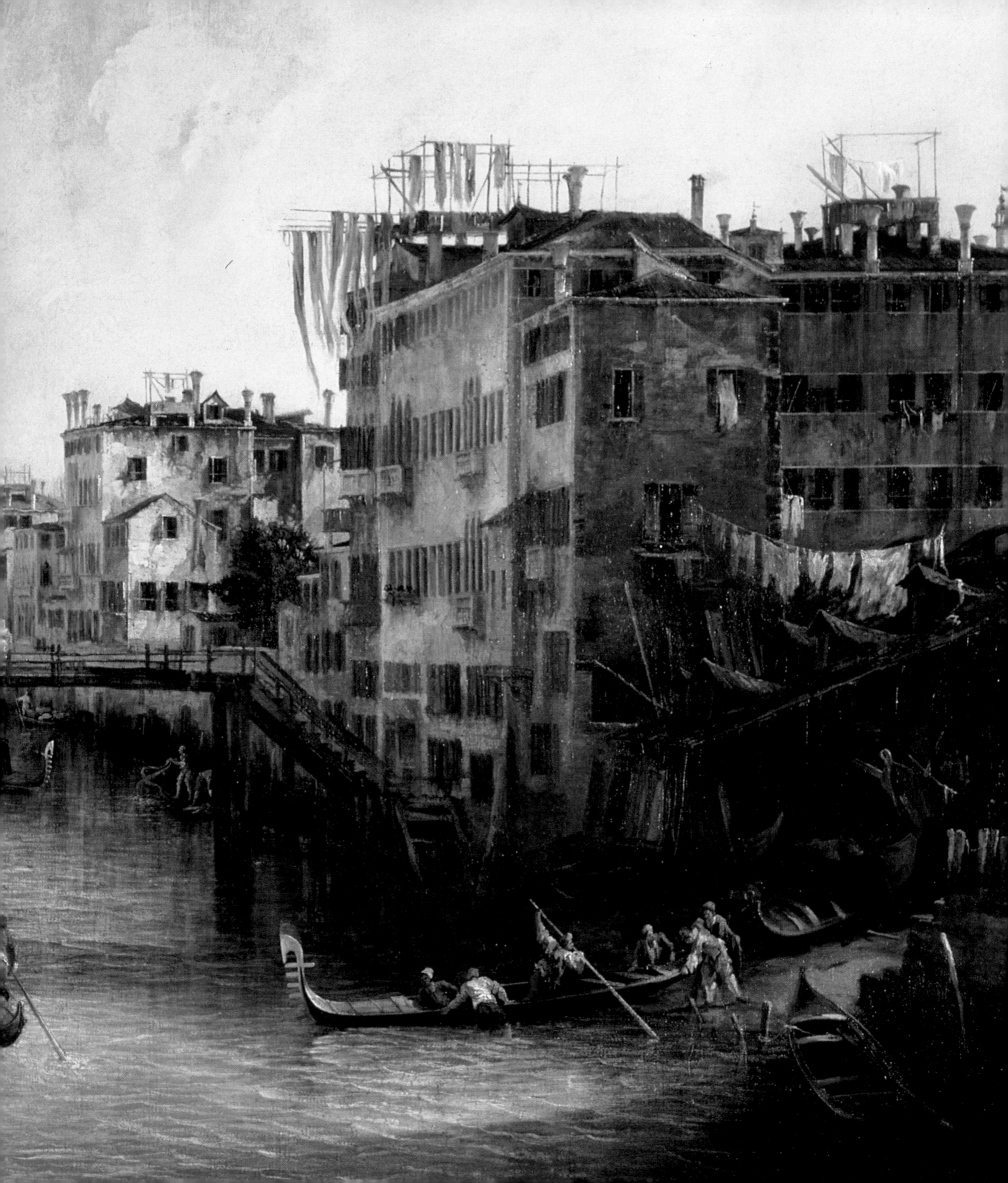

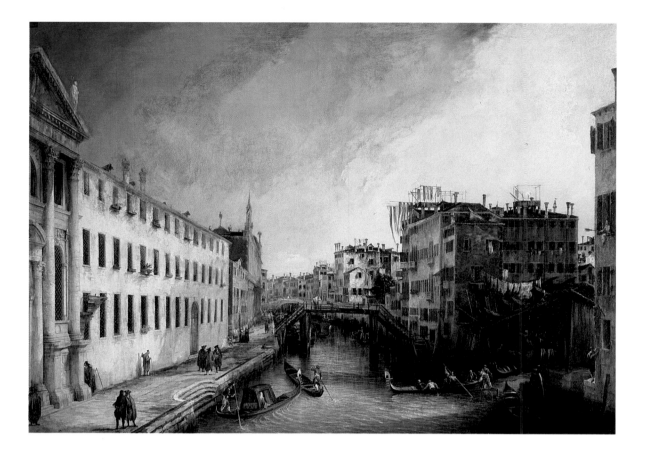

13 (right) *Rio dei Mendicanti*, 1720–1725
Oil on canvas, 143 x 200 cm
Museo del Settecento Veneziano di Ca' Rezzonico, Venice

It was unusual for Venetian *vedutà* artists to depict a view of the Rio dei Mendicanti, the city's poor district. In the background, we can make out a simple wooden bridge, which was typical of the less wealthy areas of Venice.

12 (opposite) *Rio dei Mendicanti* (detail ill. 13), 1720–1725

The façade of the houses on the right – part of which we can see here – is a particularly good example of an area in Venice which most pleasure-seeking holiday makers would avoid. Clothes have been hung up to dry; Canaletto sketches them roughly, so that they look like tattered sheets. A small boat-shed, with a long slanting roof and gabled skylights, is wedged in between the houses. A small sailing boat is just tying up at the narrow, rickety landing stage. The chiaroscuro effectively accentuates the realism with which the milieu is depicted.

One of the high points in Canaletto's early work is *The Stonemasons' Yard* (ills. 16, 18), in the background of which there is a view of the Church of Santa Maria della Carità and its small square. From about 1726, Canaletto became more and more successful at capturing Venice's light and special atmosphere. His pictures grew brighter and more flooded with light, literally glittering with the sunshine that was reflected in the canal and that gave the city its characteristic luminosity. Apparently Canaletto was now suddenly able to apply delicate, well judged brush strokes to transmute forms and colors on the canvas into seemingly real houses, palaces, canals, and small squares, his images wholly convincing and almost photographic. Everywhere we see crooked roofs and chimneys; in between, church spires and domes tower up into the sky. In *The Stonemasons' Yard*, the wooden shed in the foreground, the stonemason's workshop, seems really to protrude into the yard.

In this picture the arrangement of buildings and the transition from foreground to background are handled informally. Here Canaletto gave his composition the perspective normal in the theater, without depriving the picture of any of its spatial depth. The figures in the picture, caught spontaneously in the middle of a particular activity or gesture, create an aura of intimacy. Such genre scenes allow us to glimpse inside the city's day-to-day life, and we can certainly see *The Stonemasons' Yard* in this light. Standing at a slightly raised vantage point, we are looking down on the stonemason as he works. In a small foreground scene, a child has fallen over; the mother rushes over to offer comfort and put the child back on its feet. All over the small square people are at work; in the yard and in the

nearby houses women are busily cleaning. This painting, with the workshop caught in bright sunlight, is not simply a depiction of a remote corner of Venice; it is also the study of a milieu that has captured the everyday activity of the ordinary working population. Through this minor everyday scene in the foreground, Canaletto has subtly achieved that high degree of realism that his contemporaries so admired in his work. We do not know if this extraordinary work was the subject of a commission. As with many other small-scale *vedute*, Canaletto completed it primarily in order to satisfy the demands of a constantly developing art market.

According to contemporary accounts, Canaletto achieved success relatively early, and his first major commissions swiftly followed. In July 1725, Stefano Conti, the merchant we have already mentioned, asked the Veronese painter, Alessandro Marchesini, who lived in Venice, to commission several pictures from Canaletto. Stefano Conti was so impressed by Canaletto that he preferred his work to that of Luca Carlevaris – three of whose paintings he owned and who at this time was more famous in Venice that Canaletto. In accordance with the contract of August 1725, Canaletto delivered the first two *vedute* to the merchant in November of that year. Meanwhile, Conti instructed his agent, Marchesini, to commission two further pictures. After completing all the paintings the following June, Canaletto was paid the sum of 90 zecchini. For the first two paintings the artist had asked 30 zecchini each. Then, however, he agreed to a payment of between 20 and 25 zecchini for each picture, leaving the exact amount to Conti. Apparently Canaletto was paid well for his works, even though he rarely received the price

14 (left) *Piazza San Marco With the Cathedral*, ca. 1725
Oil on canvas, 76 x 114.5 cm
Harvard University Art Museums, Fogg Art Museum,
Cambridge, Massachusetts

This view of the Piazza San Marco demonstrates the great
strides Canaletto's style made in the 1720s. In this
picture, painted only two years after his first view of this
scene – the Piazza had meanwhile been paved – the
square looks broader and more generous in its
proportions. Canaletto's palette has noticeably lightened.
By now he was regarding the effect of light as highly
important. He has carefully worked out the angle at
which the light falls, and separated areas of light and
shadow.

he asked for his paintings. We know from other sources
that many customers complained about the high prices
the artist charged; yet, in the early stages of his career
Canaletto was obviously willing to compromise.

In the correspondence between Conti and
Marchesini, the latter remarks that Canaletto created all
his paintings outside the studio directly from the subject
in question. It is not at all clear, however, that Canaletto
really did work *sopra il loco*. Many of his sketches and
drawings have survived – these helped him prepare his
paintings. There is no doubt that he completed these
preparatory drawings direct from nature. To do so, he
used the *camera obscura*, a common practice the time.
Presumably he then painted the final pictures in his
studio. Marchesini gave Conti the above information to
excuse the artist from failing to meet his deadline for
completing the commissioned paintings. Canaletto was
also having problems locating the blue pigment that was
so important to him. Research has established that he
must have used so-called Prussian blue, a synthetic
pigment that had been developed in Berlin in 1704, and
that was notable for the strength of its tonal value and
its permanence.

Canaletto's pictures up to 1726 have much in
common. They are almost twice as big as his later works.
Dark grounds, which have been revealed by X-ray
examination, are also typical of Canaletto's early works;
later he opted for lighter colors. Unlike his fellow artists,
he always applied several coats of ground in order to
cover the surface of the canvas completely. The figures
populating his paintings are small and slender; fre-
quently they appear only in sketchy form – yet they
always create a sense of exceptional vitality. Even though
Canaletto gradually moved away from pure theater
perspective, he continued to abide by the principles of

scene painting. He moved the viewer's standpoint
closer to the given subject, thereby achieving specific
perspective effects. His use of extreme foreshortening
and pictorial depth helped him to emphasize how like
stage sets the architecture really was. As already stressed,
creativity and overall artistic impression mattered more
to Canaletto than exact topographical reproduction.

The first of Conti's four commissions was for a picture
showing the view over the Grand Canal from the Rialto
Bridge. Even though Canaletto depicted the scene natu-
ralistically, we cannot be sure of the viewer's standpoint.
As a companion piece to this painting, Canaletto
painted a view of the Rialto Bridge from the Grand
Canal. When we consider that the merchant lived
outside Venice, it may seem astonishing that Canaletto
did not – at least once – paint for him the best known
sight in the city, the Piazza San Marco. However, Conti
already owned pictures of the square painted by
Carlevaris, for whom it was a favorite subject. Even at
that time, Canaletto avoided showing views which
already existed in several paintings by Carlevaris: for
Canaletto this was clearly the best way to establish
himself as a *vedutà* artist alongside his better-known
colleague. The third painting is another depiction of the
Rialto Bridge, this time viewed from the Vegetable
Market. The last of the four pictures was another view
of the Grand Canal, now viewed from the church of
Santa Maria della Carità. In all four works, the brush-
strokes are broad and relaxed, which helps make the
palaces and houses look realistic. In his depiction of the
effects of light and air, however, Canaletto had not yet
reached his artistic peak, and his use of chiaroscuro is
reminiscent of the work by the scene painter Marco
Ricci.

This series of *vedute* was followed by a commission for

15 (opposite) *Piazza San Marco With the Cathedral*
(detail ill. 14), ca. 1725

The square is bathed in full sunlight, and the limpid air
reflects the warmth of the sun. Looking at the scene in the
background, we notice that the disorder of market stalls
and traders in the picture painted two years previously
(ills. 9, 10) has now given way to ordered clarity. The
whole impression is of light and friendliness. The staffage
figures populating the square are combined into pairs or
groups.

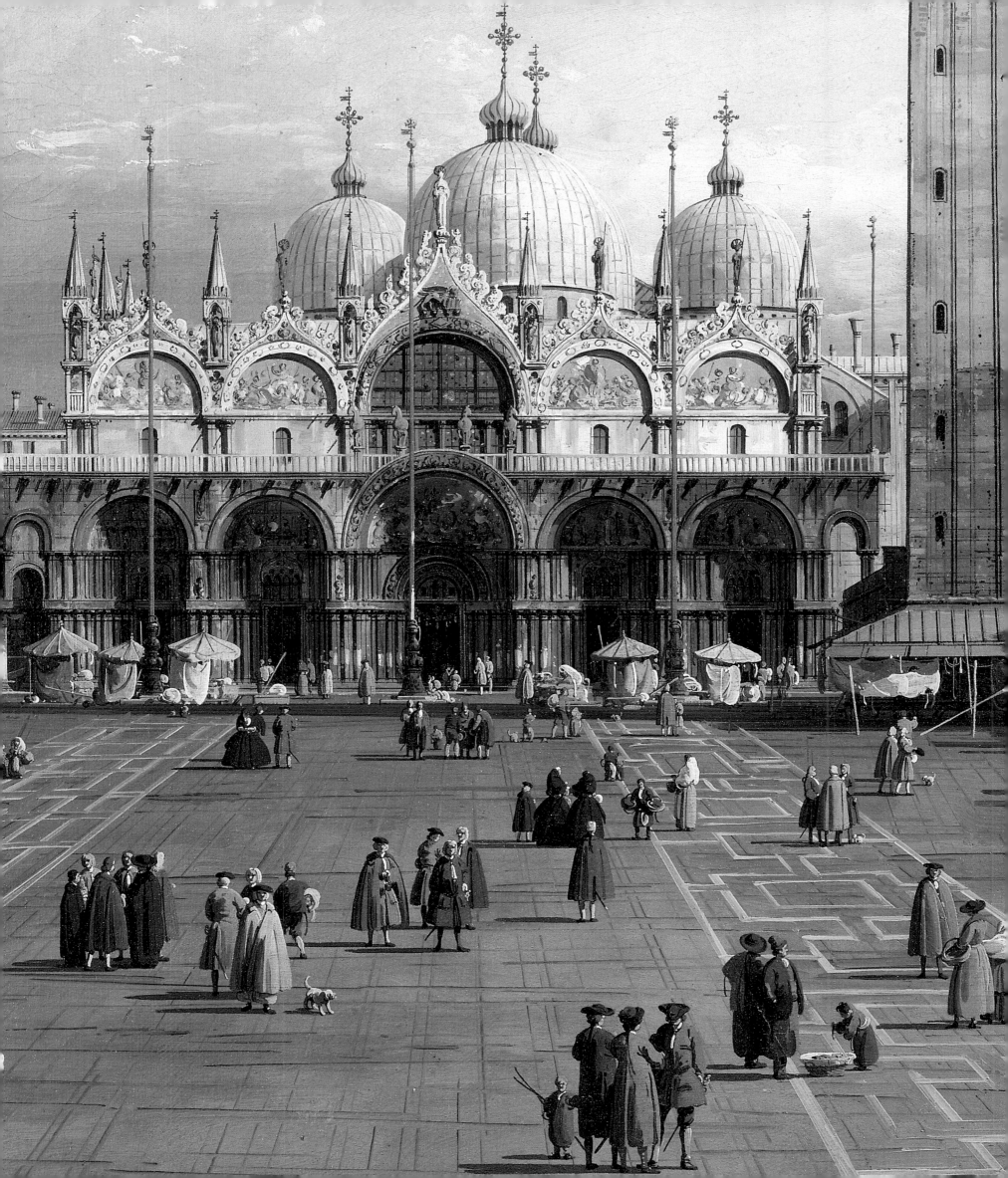

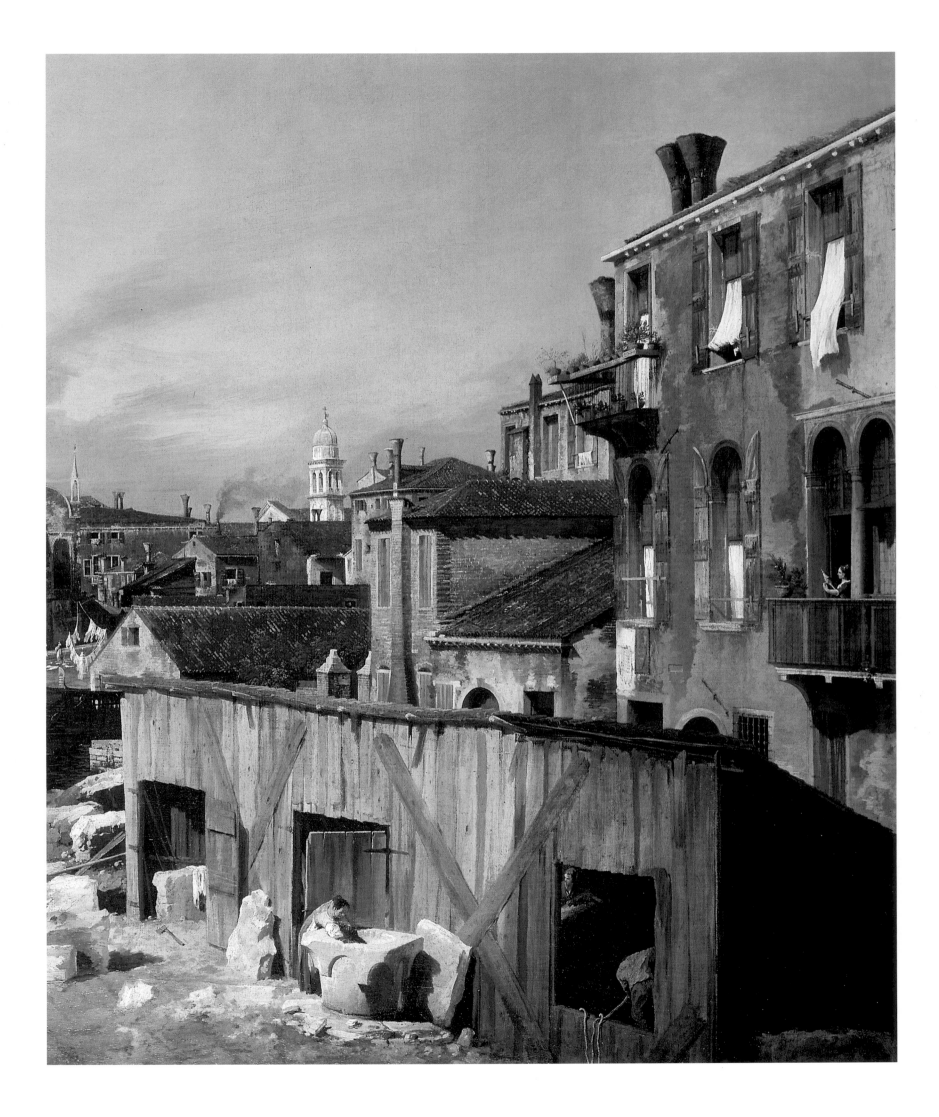

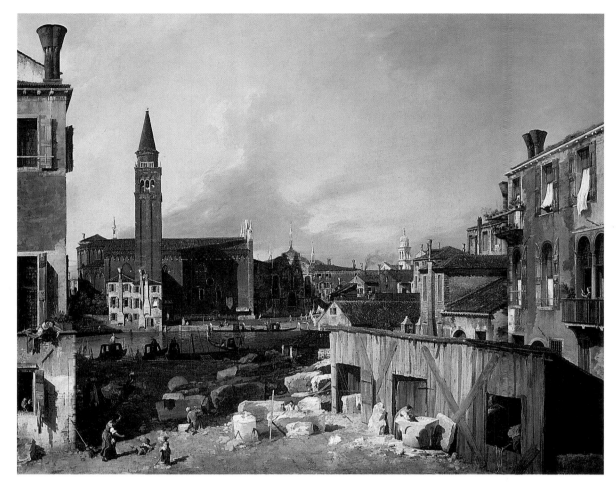

17 (above left) Giambattista Piazzetta and Giovanni Battista Cimaroli
Allegorical Tomb for Lord Somers, ca. 1726/27
Oil on canvas, 279.4 x 142.2 cm
Birmingham Museum and Art Gallery, Private Loan, Birmingham

This allegorical tomb is one of a group of pictures that Owen McSwiney, an Irishman living in Italy, initiated. In Italy, he commissioned the best Italian artists to paint tombs in memory of famous English personalities. Canaletto collaborated on this project.

18 (above right) *Chiesa della Carità* or *The Stonemasons' Yard*, 1725/26
Oil on canvas, 124 x 163 cm
The National Gallery, London

From a slightly raised standpoint, the viewer looks across towards the Chiesa della Carità on the far side of the canal. But it is the small square between two terraces of houses, not the church, which occupies the pictorial center. Here, waiting blocks of stone are bright with sunlight. The contrast between the sun-drenched foreground and the shadowy background conveys an impression of the heat in which the stonemasons are working. This picture, with its subtly painted coloration and composition, marks a high-point in Canaletto's early work.

16 (opposite) *Chiesa della Carità* or *The Stonemasons' Yard* (detail ill. 18), 1725/26

The midday sun is reflected on the wooden shed that houses the workshop. Through a window in the foreground we can make out two stonemasons. On the right, we see a woman holding a bobbin. Canaletto often introduced women as staffage figures. He liked to depict them engaged in everyday activities, since this added a subtle impression of ordinary life taking place.

a completely new subject – an unusual one to modern eyes. An Irishman, Owen McSwiney, who had gone bankrupt in London as an impresario and had lived in Venice since 1711, acted as an agent for London impresarios and various art collectors. He came up with the idea of commissioning a series of "allegorical paintings of tombs" (ill. 17) for illustrious English personalities. The intention was for three artists to work in collaboration. By March 1726, McSwiney was able to inform one of his clients, the Duke of Richmond, that he had commissioned 15 paintings, of which six were already completed. Among these were the paintings of the tombs of Lord Somers, Lord Chancellor of England, and John Tillotson, Archbishop of Canterbury. The artists responsible for the "perspective and architecture" were Canaletto and Giambattista Cimaroli (1700–1753); Giovanni Piazzetta (1682–1754) and Giovanni Pittoni (1687–1767) were to paint the figures. Of the two paintings Canaletto contributed both owe a great deal to theater design and standard stage techniques. This appealed to McSwiney who, like Canaletto, had a theatrical background. This ambitious project was not completed. Nevertheless, McSwiney, seeking to find buyers for this ambitious and costly project, commissioned engravings of the tomb paintings and planned to have some grisailles produced.

More than this, McSwiney became an important and successful intermediary for Canaletto. He encouraged the artist to complete two small *vedute* painted on sheets of copper for the Duke of Richmond – which

means that Canaletto accepted commissions from McSwiney even while working for Stefano Conti. The correspondence between McSwiney and the Duke of Richmond dating from late 1727 expresses the patron's annoyance over the artist's delay in completing the four paintings he had already paid for. McSwiney obviously knew that at this point Canaletto had more work than he could complete single-handed. He wrote to the Duke telling him that Canaletto was causing problems over the negotiations and that his prices kept changing from day to day. But McSwiney did not call into question the quality of the paintings themselves, stressing that Canaletto was better able than any other artist to paint things exactly as he saw them. Here, McSwiney was speaking not simply of topographical accuracy but also of the bright and luminous atmosphere present in all Canaletto's works from 1727 onwards – Canaletto had by now made a decisive break with the chiaroscuro painting of his early years. The English aristocrats who visited Venice or had heard of the spell cast by the city on the lagoon would value these pictures highly.

19 Luca Carlevaris
Piazza San Marco, Looking East (detail ill. 7), ca. 1722

This detail shows a typical scene from the *commedia dell'arte*. On the left, we can clearly see the figure of Arlecchino, who traditionally used to wear a costume covered with red patches, which, in time, became stylized into diamonds. The figure on the right is presumably Dottore, who is dressed stylishly in black, with a white ruff-collar. In the *commedia dell'arte*, the figure of Dottore represents the know-all, who knows so much about the world that he cannot understand it.

During the Baroque – the age that saw the invention of theater props such as movable flats and painted backdrops, festive illumination and fireworks, machinery to change sets, equipment to lower the stage and fly people or objects in from the wings – it became possible to create scenery of eye-deceiving realism. In Baroque theater the merging of appearance with reality was intended to enchant the soul and senses of the court audience. In order to create the effects that would beguile the senses, this theater needed an enclosed space, a deep stage and a building that separated spectators from performers.

The *commedia dell'arte*, on the other hand, was the exact opposite. It was a popular form of extemporaneous performance, using neither script nor stage set – a theater for all social strata, it was presented on wooden scaffolding in market squares. The dramatic performances of the *commedia dell'arte* (ill. 19) were entirely animated by the art of improvisation, by body-language, and by the actors' dramatic talents. Their main characters were the two lazy and slow-witted servants, Arlecchino and Brighella, as well as the two rich but stingy old men, Pantalone and Dottore. The stereotypical appearance of the stock figures was

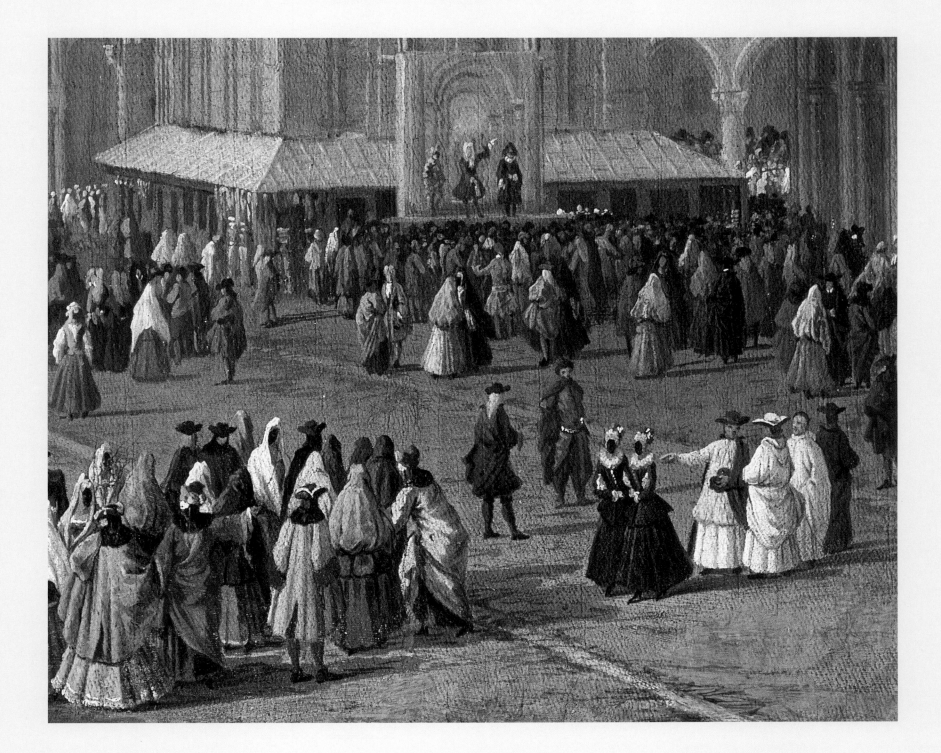

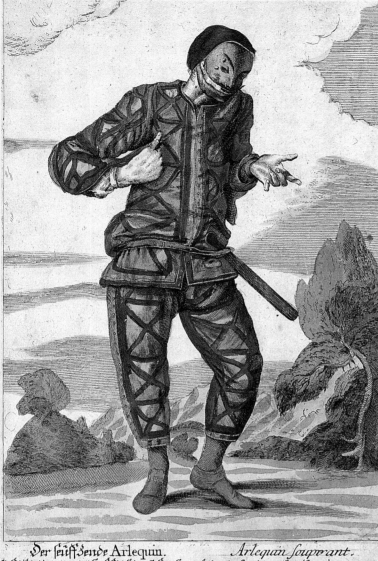

accentuated by leather masks that covered the top half of the face, and also by a dialect specific to each character. Thus Arlecchino, for example, spoke the dialect of Bergamo. In Venice – Bergamo was part of the region – everyone could easily identify the city's porters by this dialect. Pantalone, the quintessence of the miserly merchant, spoke in Venetian dialect (ills. 20, 21).

By Canaletto's day however – the age of the late Baroque – the formal canon of the *commedia dell'arte* was largely defunct and this virtually 200 year-old dramatic art had gone out of fashion. Nor did the class-conscious mercantile burghers of Venice, who oriented themselves on aristocratic taste, like this "immoral" form of popular entertainment – enjoying neither the coarse humor nor the obscene jokes. Moreover, there were many public and private theaters – the very first opera house in history, the Teatro di San Cassiano, was built in Venice in 1637 – in which plays and operas were produced (ill. 22). This was the situation when the two leading reformers of the "commedia dell'arte" made their appearance in Venice. They were Carlo Goldoni (1707–1793), who had been trained as a lawyer, and Count Carlo Gozzi (1720–1806), who had a Venetian aristocratic

background. Their social origins were as different as their attempts to revitalize the *commedia dell'arte*. Goldoni created a form of popular drama by abolishing the stereotypical masks, transforming the stock characters into more lifelike figures. To achieve this – keeping a sharp eye on contemporary taste – he looked closely not only at ordinary working folk but also at the middle classes. Gozzi, on the other hand, accentuated artifice, and wrote plays full of miraculous apparitions, with a fairy tale quality and elaborate décor-elements he took from popular stories and legends. He is famous for "Turandot", his fairy tale about a Chinese princess; "Il re cervo" (King Stag); and "L'Amore delle tre me arance" (The Love for Three Oranges). Gozzi's anti-realism, his worlds of magic and fairies, re-activated all the Baroque paraphernalia of magic, now dressed up by a new spirit – ornate Rococo. In the long-term, however, Goldoni's greater realism was to have a more enduring influence on developments in Italian theater. At all events, both dramatists were able to transform the *commedia dell'arte* into a literary form. They brought it from the market place into the auditorium and made the city of Venice – which was already a theater city *par excellence* – into its unrivalled center. In

20 (above left) Artist Unknown (Claude Gillot?)
Arlecchino Scratching Himself
Engraving with added watercolor
Raccolta Teatrale del Burcado, Rome

This image depicts the figure of Arlecchino in traditional costume, including a leather half-mask. A wooden sword, with which he belabors his enemies, hangs down from his belt.

21 (above right) Artist Unknown (Claude Gillot?)
Pantalone
Engraving with added watercolor
Raccolta Teatrale del Burcado, Rome

The name, Pantalone, is supposed to be a distortion of *pianta leone*, literally: "someone who plants the lion, that is, the flag of Venice". This refers to the sea-faring Venetian merchants who had to contend with numerous adventures on their voyages. In the *commedia dell'arte* the figure of Pantalone is not only old but also miserly, a fact to which his very full money bag alludes.

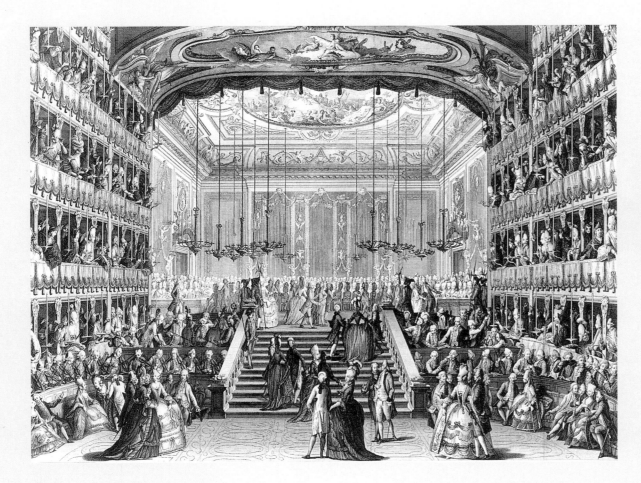

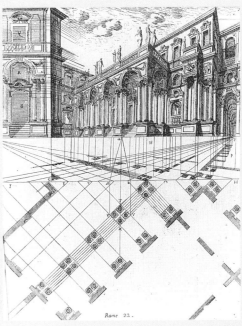

1762, Goldoni became director of the Comédie Italienne in Paris. Before this, however, he had written his best-known plays, such as "Il servitore di due padroni" (The Servant of Two Masters), performed by Antonio Sacchi, the best Arlecchino-actor of his day, as well as "La bottega del caffe" (The Coffee-house), and the "Trilogia della villeggiatura" (The Trilogy of Country Holidays).

In the 18th century the dramatic theater faced competition from opera, which now began its triumphant progress throughout Europe. Venice, which had been the leading opera city in the 17th century, was now outshone by Naples. Even so, Venetian musicians were much sought after all over Europe, for the City Republic maintained conservatories where tuition was excellent and where virtuoso musicianship was fostered. Even Antonio Vivaldi (1678–1741), who had been "maestro di violino" of San Marco since 1714, was director of one such educational establishment, the Ospedale della Pietà, an activity he continued – with interruptions – until 1739. This was the golden age of *prima donne* and – since women singers were not allowed to enter churches – also that of *castrati*, among whom Carlo Broschi, who was known as Farinelli (1705–1782), was, it is widely believed, the most famous of his day.

Throughout Europe, Italian artists were active as celebration organisers, theater architects, or set designers. The Galli-Bibiena family from Bologna, who have already been mentioned, and who worked at the courts of Vienna, Dresden, Bayreuth, and Prague – though less often in Venice – set the standard. Ferdinando Galli-Bibiena (1657–1743) abandoned the conventional arrangement of a stage set with a central perspective. By applying rules of symmetry and placing flats at an angle he was able to create new

views of theater space. He considered himself the inventor of this form of construction, called angular perspective. He outlined his method "Per disegnare un'altra scena d'una sale, o'stanza veduta per angolo" in his instruction manual published in 1711, "L'Architettura civile" (ill. 23). Giuseppe Galli-Bibiena (1696–1757), probably working in collaboration with other members of his family, compiled a practical sketchbook that has been preserved in Vienna. This consists of 162 pages containing 450 different sketches with precise particulars about color for the scene-painters. The range of these sketches is impressive. They include views of prisons and castle courtyards, as well as whole harbor installations, gardens, cemeteries, and cities. Here, we once again come across the *capricci*, in other words, the *ideal vedute*, now placed in a spatial context.

The Galli-Bibienas encountered no competition until the arrival of the theater architect Filippo Juvarra (1678–1736), and his "Il pittoricismo" (Inclination to Painterly Effects), whose virtuoso illusionism points far beyond the Galli-Bibienas' Baroque treatment of space. Juvarra, who specialized in a kind of asymmetrical architecture of curves, often also used colored lengths of material, in order to accentuate the fluent, painterly and poetic qualities of his work. In this, Juvarra struck a chord with contemporary Rococo taste for elaborately ornate effects, displacing the Galli-Bibiena family as the leading stage designers – not least stylistically (ill. 24). At absolutist courts throughout Europe, the late Baroque style of Italian theater architecture and the opera set the standard. On the eve of the Enlightenment, the arts of an aristocratically imposing society combined for the last time into one magnificent "Gesamtkunstwerk".

Eva J. Heldrich

22 (above left) Antonio Baratti
Gala Evening in the Teatro San Benedetto, 1782
Engraving
Venice

The Teatro San Benedetto was the forerunner of La Fenice, the famous opera house, which did not open until after Canaletto's death. By about 1700, there were some 15 theaters in Venice. Most of them belonged to wealthy Venetian families. They were run by impresarios, who put a company together for one season – the *stagione* – at a time. As was usual at that time, the Teatro San Benedetto had boxes. The tiers were relatively shallow and reached almost as far as the ceiling. The boxes were rented on a subscription basis, whereas admission was charged for the stalls.

23 (above right) Ferdinando Galli-Bibiena
Cortile per angolo (illustrato, plate 22 of the book "L'Architettura civile"), ca. 1711
Engraving, 35.5 x 27.1 mm
Biblioteca Nacionale Marciana, Venice

This stage set construction is probably based on the mathematically exact technique of Brunelleschi (1377–1446), which utilized both the ground plan and the elevation to create a picture with full perspective. The artist has been able to depict the courtyard in angular perspective by reflecting and twisting the ground-plan (Lower Section) into the frontal plane (Upper Section), and by inserting a horizontal line (H), which lies parallel to the Reflection Line (R). In contrast to a simple form of central perspective, this picture requires two vanishing points, both of which lie on the horizontal line.

24 Filippo Juvarra
Portico With the Temple of Jupiter (Scene 16 of "Giunio
Bruto"), 1711
Colored pen and ink drawing
Österreichische Nationalbibliothek, Vienna

This is an illustration of a scene from the heroic opera,
"Giunio Bruto" by Alessandro Scarlatti and others, the
subject taken from Roman history. From 1708–1714,
Juvarra, who trained for the priesthood, worked as a stage
designer for the theater run by Cardinal Pietro Ottobani,
which was based in rooms in the Palazzo della Cancelleria in
Rome. Although the set design still shows the influence of the
Baroque, we can clearly see Juvarra's taste for curving spaces.

THE CONQUEST OF LIGHT

The collaboration between Canaletto and McSwiney ended in 1730: the impresario was annoyed about the delays in delivery of the pictures he had commissioned. Both artistically and financially Canaletto was now at the zenith of his career. He was highly regarded as a painter of *vedute,* and he had numerous patrons. Moreover, Carlevaris, the second most important *vedutà* artist in Venice, against whom Canaletto was initially in competition, had just died. It was now that Canaletto got to know the English merchant banker and consul, Joseph Smith, who became the single most important agent and patron of Canaletto's paintings. Joseph Smith, who lived to be nearly a hundred, spent his whole life in Venice. His collection of manuscripts and works of Venetian art – especially 17th-century works – was widely known. Those visiting Venice to broaden their education, as well as those Venetians who were interested in art, respected him as the last word in matters of taste. That said, he was not particularly well liked: he was considered ostentatious, arrogant and high-handed. He cherished a special passion for the opera, through which he may have met Canaletto. Smith immediately recognized the artist's importance, and for the rest of his life Canaletto enjoyed Smith's support. After the conflicts with McSwiney, Smith took over all Canaletto's business arrangements. Before very long, everyone who wanted a picture from Canaletto had first to get past Smith. Yet Smith does not seem to have exploited his monopolistic position. Regarded a reliable and honest business partner, he helped the artist to obtain many good commissions, and kept on good terms with him on a personal level – despite Canaletto's reputation for being very difficult at times – for the rest of their lives. Moreover, he was obviously able to persuade the artist to complete his commissions on time. The collaboration between the two men was in every respect a very productive one.

For each of his paintings, Canaletto initially prepared several sketches and preliminary drawings. He would then show them to Smith, explaining in advance what a picture's composition and concept would be. Smith carefully stored all these drawings and sketches, and his collection of works by Canaletto, kept in his palace on the Grand Canal, could be seen at any time. The first six paintings Smith commissioned were to depict the Piazza San Marco from various viewpoints. The view towards the church of San Geminiano is dominated by the lower section of the Campanile. Nearby, the three large flagpoles give the square a rhythmic identity. These so-called *pili*, in their bronze stands, commemorate the territories formerly conquered by Venice, and symbolize Crete, Cyprus and the Peloponnese. The figures in the foreground are relatively large. Examination of the picture has revealed that, in accordance with the preparatory drawing, they were originally meant to be smaller. Also missing from the drawing are the Campanile and the Loggetta: Canaletto integrated both into the painting in order to create a more harmonious overall composition. He enlarged the figures, however, only after completing the picture.

Back in 1723, for a commission from the Prince of Liechtenstein, Canaletto had painted a view of San Marco from the opposite side. Now he varied his viewpoint. In this painting the Campanile appears narrower and lower, so that it fits better into the overall composition. Every one of Canaletto's pictures of the Piazza San Marco reveals architectural changes. In his view of the Piazzetta, for example, the flagpoles are standing in quite a different way to how they stand in reality. Canaletto used to approach topographical details with relative nonchalance, his concern being a painting's overall effect. The English art collector Horace Walpole was astonished by these paintings when he saw them in the collection of King George III, to whom Smith sold much of his collection in 1762. Walpole noticed that these paintings were broader, more impressive, and more austere than Canaletto's earlier works. Surprisingly, the artist's subtle manipulation of architecture gave rise to an overall impression of greater realism.

In 1730, Smith described his collaboration with Canaletto in a letter to Samuel Hill. He emphasized the fact that he had persuaded the artist to complete two more paintings for him within the year, even though Canaletto had a great many commissions and had been promised the fees he had requested. In 1735, Smith published, through the Venetian publisher Giambattista Pasquali, his "Prospectus Magni Canalis Venetiarum",

which contained 14 engravings by Antonio Visentini of paintings by Canaletto. The "Prospectus" sold so well over the next few years that Smith had commissioned a new edition by as early as 1742. This new edition was expanded by a few new pictures, so that the collection would not appear out-of-date. Apart from depictions of festive occasions in Venice, these were once again views of the Grand Canal and of various small squares with their churches and *scuole*, the guilds' social and charitable institutions. Representatives of English aristocrats in particular regarded the "Prospectus" highly, and, as a result, also commissioned paintings – Smith's intended object.

The second and highly productive phase of Canaletto's creative work fell between 1726 and 1730. An early artistic high point is *The Stonemasons' Yard* (ill. 18). In this painting, we can already see the depiction of light and the luminous atmosphere that were to become so characteristic of Canaletto's mature works. Nevertheless, *The Stonemasons' Yard* is still painted in the brown tones of his early work. From 1727 onwards, Canaletto began much more to use blue and green tones, mixing the latter out of blue. His paintings

became increasingly light and luminous. Henceforth, he succeeded in expressing his own vision of his native city in his pictures – and more convincingly and realistically than any of his contemporaries did. The transparent, watery blue atmosphere of Venice is characteristic of his works of this period. The difference in his treatment of light is obvious if we look at the paintings he completed in 1727 after an excursion along the Brenta Canal. In these pictures, Canaletto first turned his attention away from Venice in order to take a look at the provinces.

The view of the *Sluice Gates at Dolo* (ill. 25) was one result of this journey. The canal runs calmly and coolly in the center of the picture. Its banks are edged with terraces of two-storey houses, which border the painting on the left. To break the composition up a little, the campanile of the village church towers up in the background. Canaletto indicates the other side of the built-up area only by a wall. The structures of the sluice gates, which he moves a little towards the edge of the picture, are much more important to him. The oblique viewpoint onto the sluices gives the structure a provisional, almost accidental quality. The parapet near the sluice gates, the square in front of them, and the path

26 (above) *Fonteghetto della Farina*, 1727–1729
Oil on canvas, 66 x 112 cm
Giustiniani Recanati Collection, Venice

The afternoon sun is shining on this building opposite the Doge's Palace. It was once used as a warehouse, and later as the headquarters of the artists' guild. From 1750 onwards, it became the headquarters of the Accademia di Pittura e Scultura. It was demolished in the 19th century. This picture is therefore a valuable document in terms of architectural history and topography, since it captures a view of the city now lost.

27 (opposite) *Fonteghetto della Farina* (detail ill. 26), 1727–1729

Canaletto was supremely successful in depicting the sandy color of the path and the plaster on the house walls. The whole picture is bathed in a bright, luminous atmosphere. The figures, which Canaletto created in a few brushstrokes as if by magic, help make the picture come to life. They are like the gondoliers who are deep in conversation – simple people. Two of them are offering passers-by their services. The woman on the bridge directs our gaze towards the entrance to the Fonteghetto, where a notice board on the wall refers to the headquarters of the Collegio dei Pittori (the artists' guild).

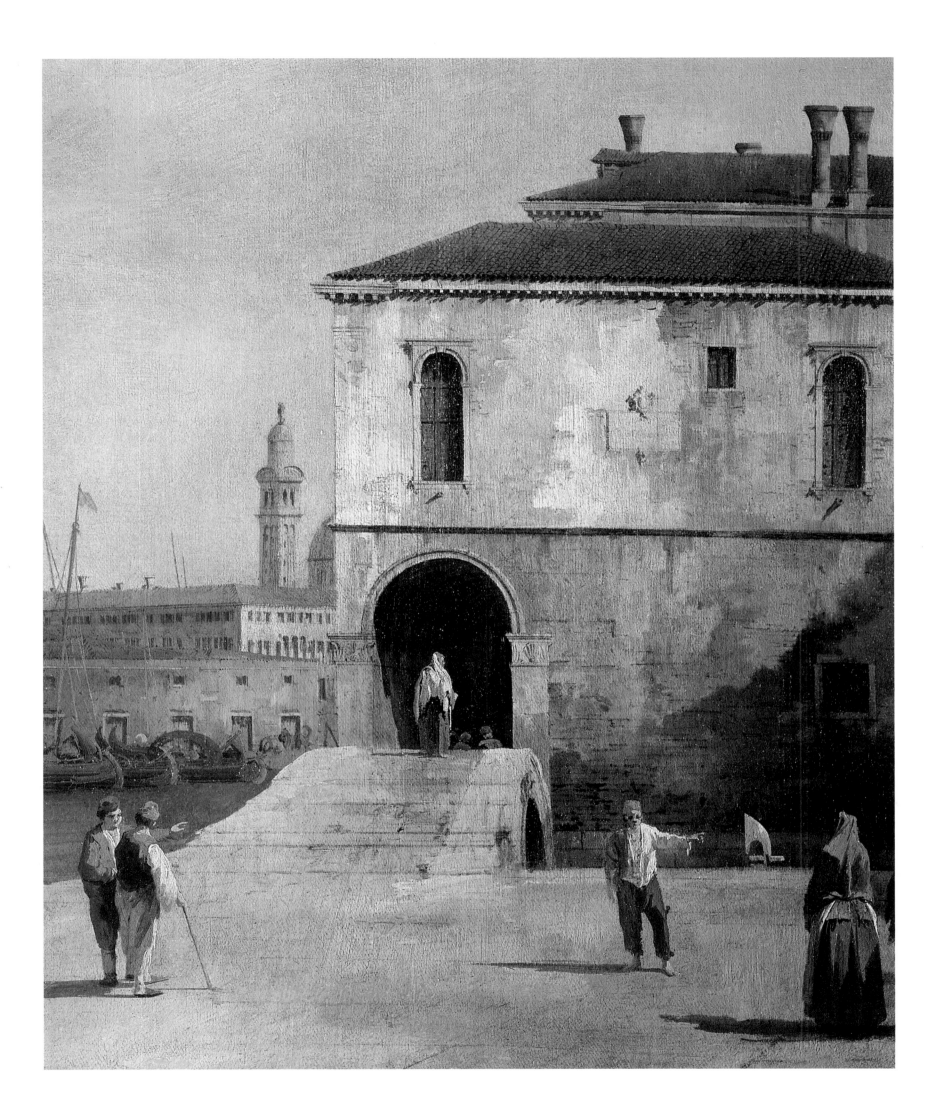

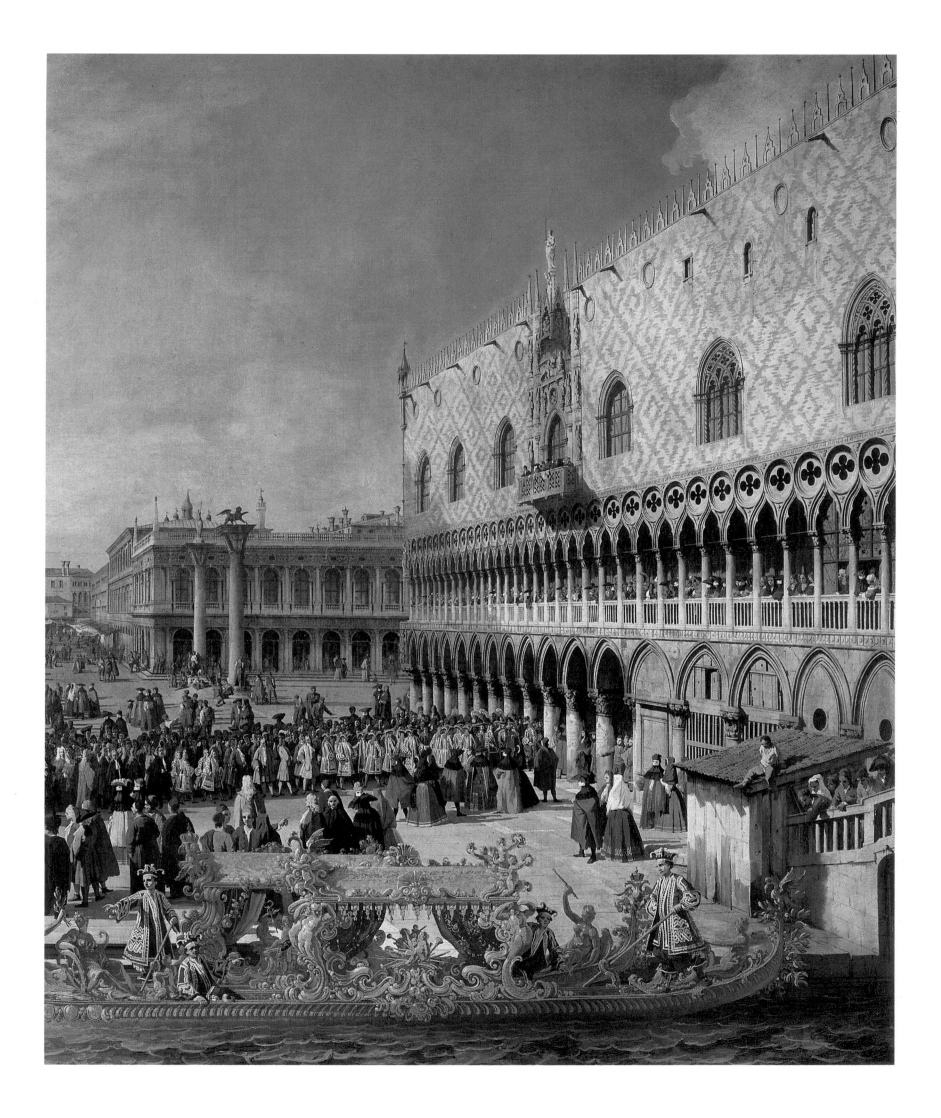

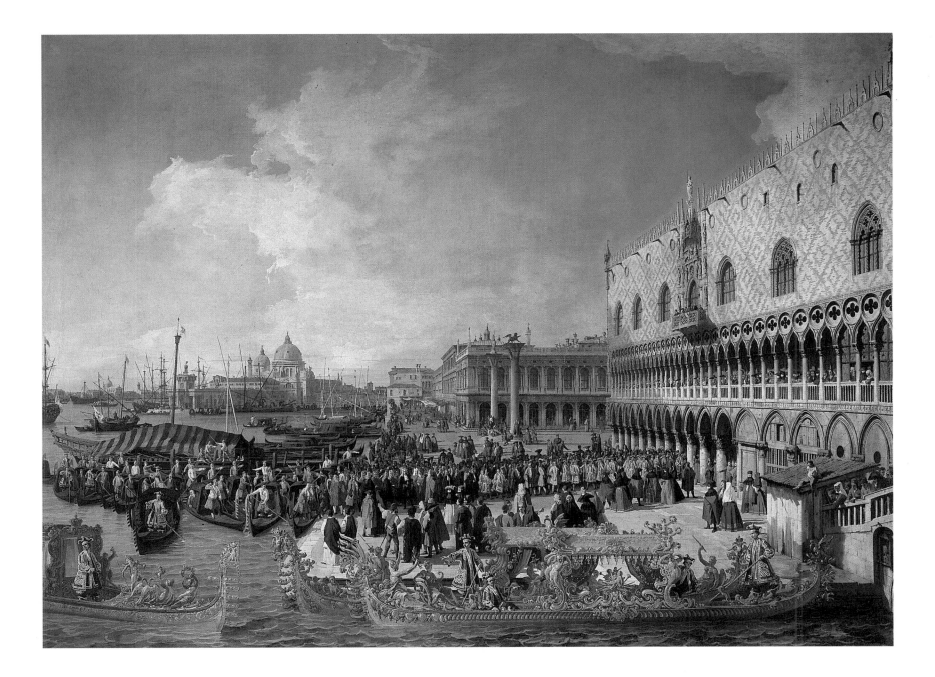

29 (above) *Reception of the Imperial Ambassador at the Doge's Palace*, 1729
Oil on canvas, 184 x 265 cm
Aldo Crespi Collection, Milan

In a riot of color and exuberant detail, Canaletto is here depicting one of the major events that Venice regularly celebrated. The painting is not a *vedutà* in the strict sense. The ceremonial reception of an Ambassador is the focus of attention here.

28 (opposite) *Reception of the Imperial Ambassador at the Doge's Palace* (detail ill. 29), 1729

The right-hand corner of the painting that depicts the reception of the Imperial Ambassador also conveys an impression of how class-conscious Venetian society was. A wooden shack stands between the aristocrats and the ordinary folk, blocking their access to the Molo. The differences in clothing are striking. The aristocratic state-employees are wearing their official uniform, cloaks of red, violet, or black. Others have masks on. The wooden shack, with a boy on its roof, does not reappear in other views of the Molo.

from the terraces of houses, are all populated by groups of people and inquisitive onlookers, who are either talking or just calmly walking by. Canaletto presents the scene in broad daylight. Life along the Brenta Canal seems happy and relaxed. In warm, soft tones of brown and yellow, the artist depicts the atmospheric mood of the provinces. The air is bright and dry. The women's pink and light blue clothes blend in well with this scenery, and bring the picture to life.

Canaletto's search for variation in the way he painted light was not confined to this pictorial detail of the Venetian hinterland. The light in the *Fonteghetto della Farina* (ills 26, 27) is depicted in a similar way. This picture falls roughly into the period between 1727 and 1729, when Canaletto was concentrating intensely on trying to capture the various ways in which sunlight changed the appearance of the city. Many of Canaletto's pictures from about 1730 onwards are animated by a diffuse light that accurately depicted the climatic conditions of the often misty city on the lagoon in summer heat. In the *vedutà* of the Grand Canal near the

church of Santa Chiara, which is one of the works from about 1730, the contrasting coloration and emotive brushwork of the preceding period have disappeared. The terrace of houses extends along the bank of the Grand Canal in a relaxed, serene manner. The light unites the people on the Molo, the boats on the canal, and the architectural details of the houses into one pictorial entity.

Canaletto was interested in more than the city's everyday scenes. Between 1730 and 1740, as well as the city views of tomb monuments, churches and palaces, of squares and canals, Canaletto completed a series of formal scenes that document the city's cultural life. The arrival of ambassadors and guests of the state were special reasons for celebration in Venice. Presumably on commission from the ambassador, Count Giuseppe de Bolagno, who wanted to have a picture commemorating the act of state whereby his credentials were handed over, in May 1729, Canaletto created the large painting the *Reception of the Imperial Ambassador at the Doge's Palace* (ills. 28, 29). In structuring this composition, Canaletto

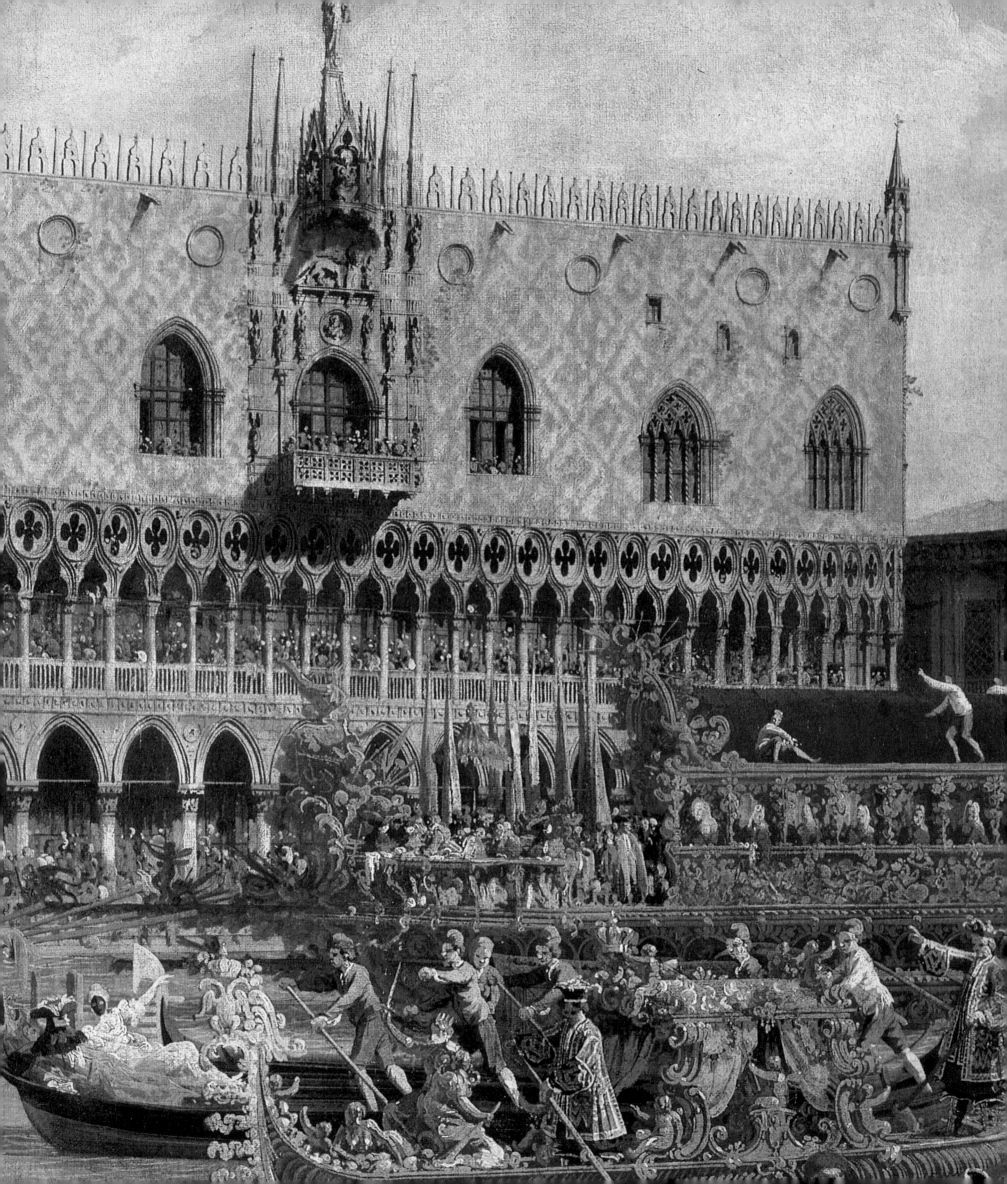

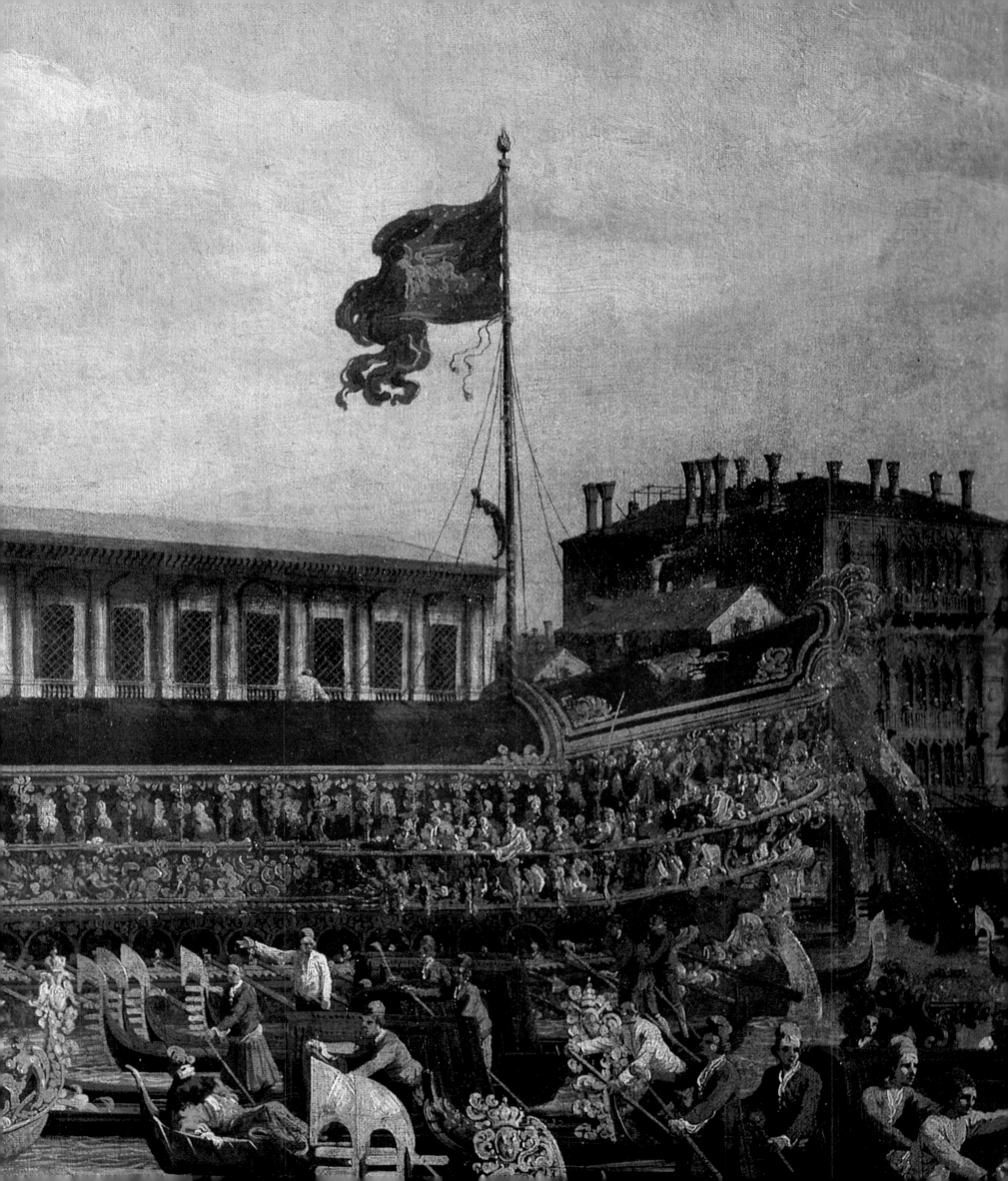

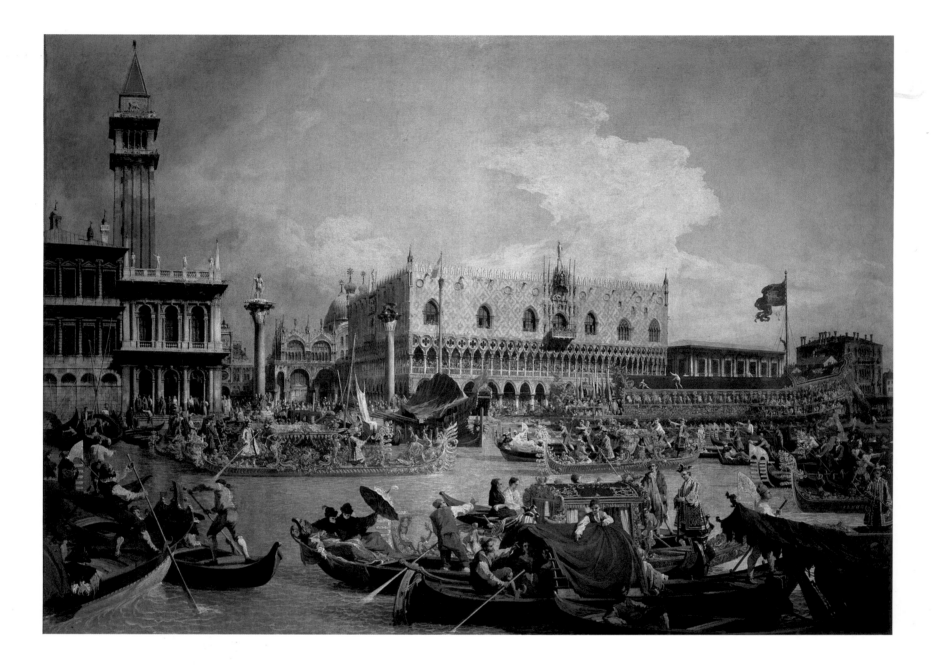

30 (previous double page) *The "Bucintoro" by the Molo on Ascension Day* (detail ill. 31), 1729

With its red awning and opulent gold ornaments, the *Bucintoro* is a splendid sight as it lies immediately in front of the Doge's Palace in the Bacino di San Marco. This was the Doge's state galley, which took its name from the 200 people who were needed to row it, and which made its appearance at official receptions, especially Ascension Day festivities.

31 (above) *The "Bucintoro" by the Molo on Ascension Day,* 1729
Oil on canvas, 182 x 259 cm
Aldo Crespi Collection, Milan

In this picture Canaletto is immortalizing one of the city's most important festivities. Every year, on Ascension Day, the Doge would sail out into the open sea in his ceremonial galley, the *Bucintoro*. Once there, he used to throw a ring consecrated by Venice's patriarch into the waters to symbolize the union *of La Serenissima* with the sea. In the background on the right, we can recognize the magnificently adorned *Bucintoro*. The aristocrats are assembled on the Molo in front of the Doge's Palace, whilst ordinary people watch the spectacle from the approach to the Molo.

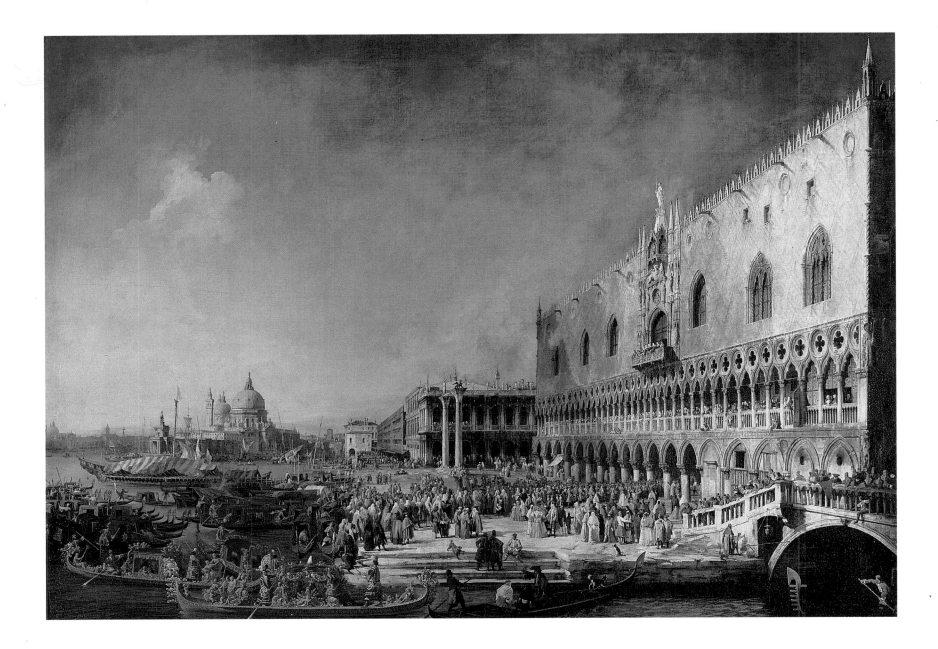

followed examples of work by Carlevaris, who had painted similar subjects. Canaletto's view along the Doge's Palace across the Piazzetta as far as the church of Santa Maria della Salute, with the Molo and the lagoon in the foreground, is not vastly different from Carlevaris' views of the Doge's Palace or the Molo. That said, the foreground of Canaletto's picture is populated by numerous figures. Noble onlookers are crowding the Palace's arcades. On the square in front, the Venetian aristocracy and other dignitaries are awaiting the arrival of the ambassador, whose ceremonial galley is just landing at the Molo. To the right, on the bridge cut off by the edge of the picture, stands a crowd of ordinary people, shut off from the ceremony by a barrier. Since many of the noble spectators are masked, the painting had been interpreted as a Carnival scene. Carnival, however, went on for six months – from the first Sunday

in October to Christmas, and from Epiphany on 6 January to Easter – and is therefore well over by this time. On the other hand, masks and disguises were so much the fashion in Venice that they were also worn outside Carnival time. The viewer is looking from a slightly raised standpoint. The picture is bordered on the right by the Doge's Palace and the Library, but is open on the other side. Only part of the lagoon is depicted, leaving the viewer with the impression that there is more of it beyond the picture's edge. In terms of perspective, Canaletto has achieved an effect of great breadth, which he had been striving for in preceding paintings, and which is produced here naturally by the water of the lagoon.

The picture the *Arrival of the French Ambassador at the Doge's Palace* (ill. 32), which is now in the Hermitage, St Petersburg, is laid out in a very similar way. The compositional differences, however, are very interesting.

32 *Arrival of the French Ambassador at the Doge's Palace,* 1727–1729
Oil on canvas, 181 x 259 cm
Hermitage, St. Petersburg

The arrival of the French Ambassador is one of a series of paintings depicting public ceremonies in Venice. Another picture on this subject is now in the Pushkin Museum, Moscow. Both pictures are replicas of an original painted for the French ambassador, Jacques-Vincent Lanquet, Count of Gergy. Unfortunately the original has been lost.

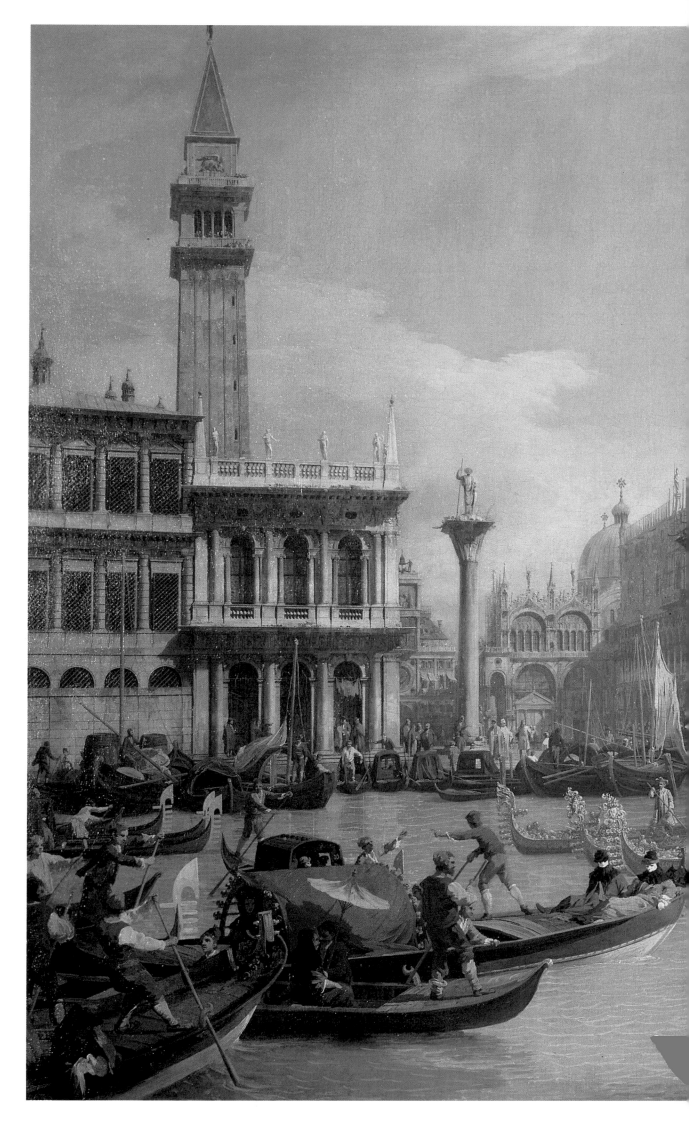

33 Bacino di San Marco with the "Bucintoro" on Ascension Day, after 1729
Oil on canvas, 187 x 259 cm
Pushkin Museum, Moscow

This depiction of the Ascension Day festivities is rightly regarded as one of Canaletto's major works. We can clearly see the boats as well as a mass of individual figures, who are attending the festivities and who bring the picture to life. The atmosphere seems full of light. Shadows and outlines flow softly into one another, though without merging.

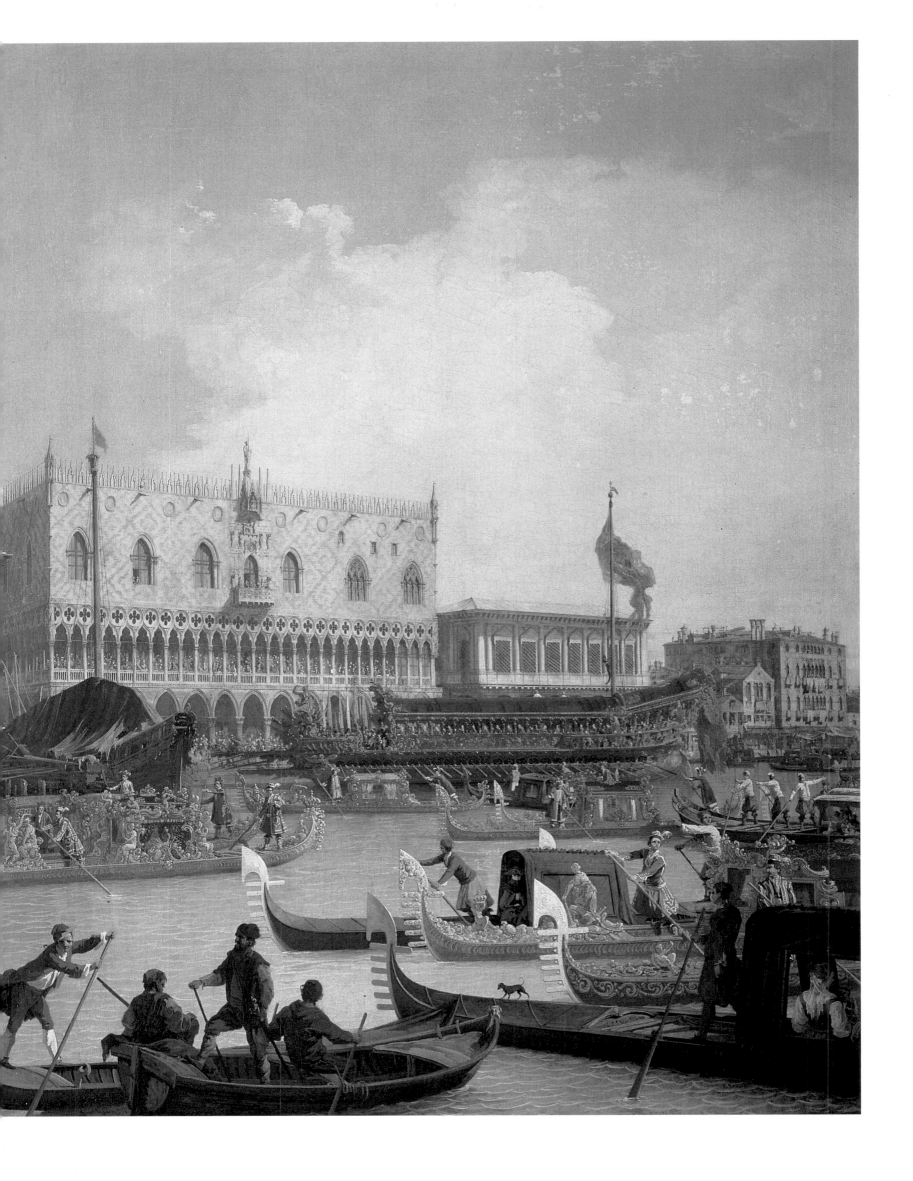

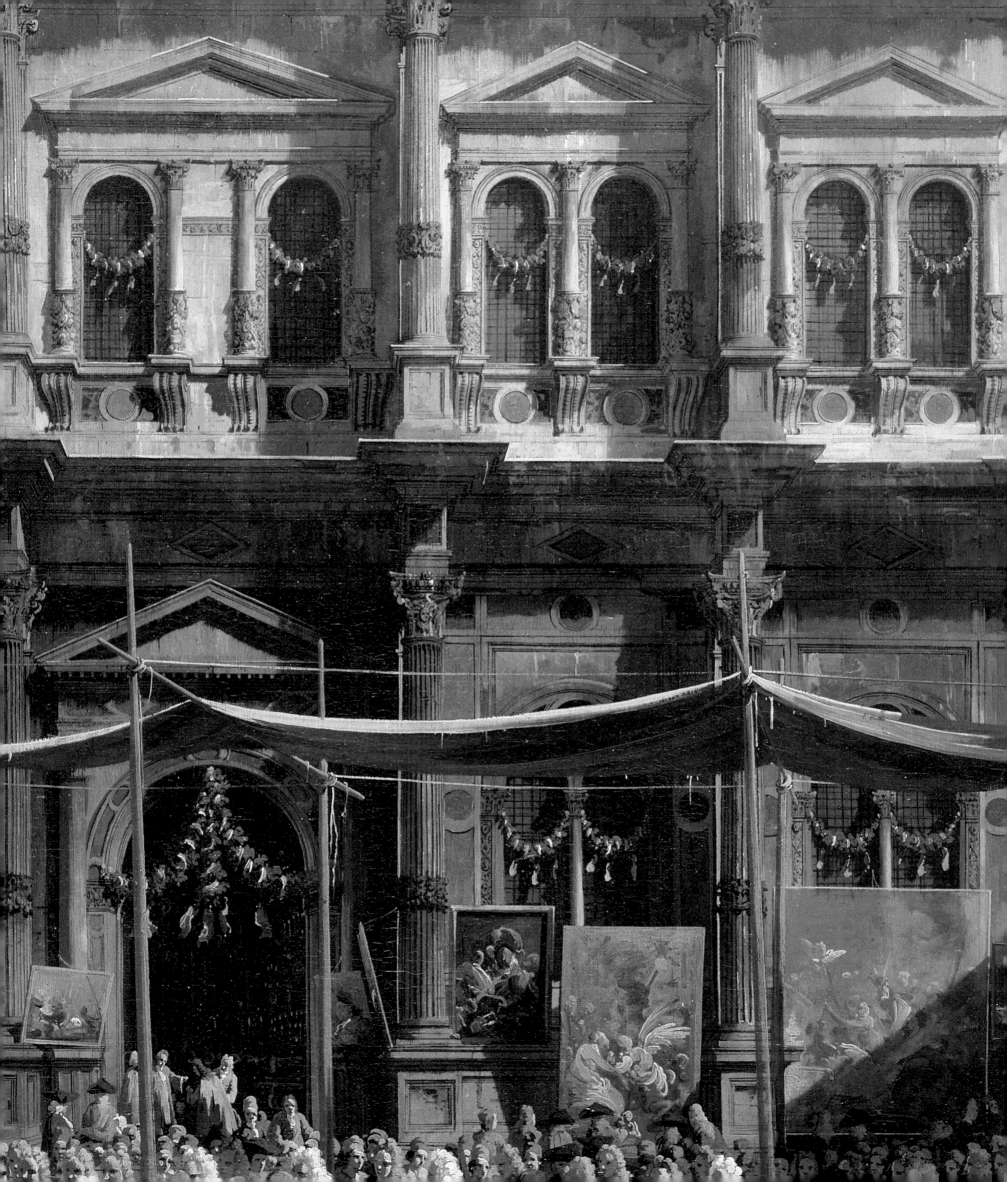

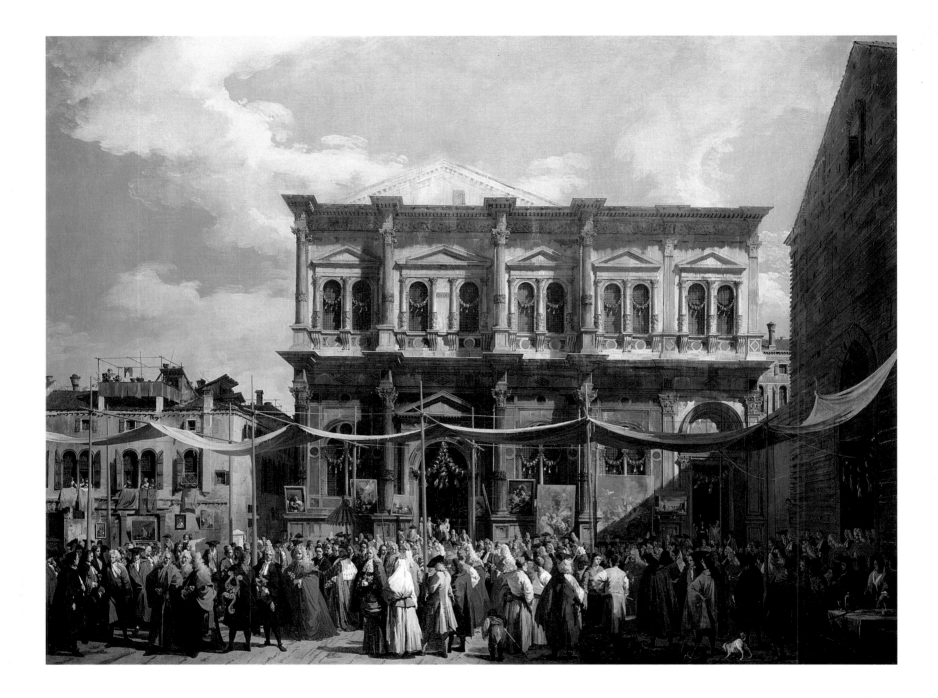

34 (opposite) *Feast of San Rocco* (detail ill. 35), ca. 1735

Canaletto depicts the Feast of San Rocco and the Doge's visit to the square in great detail. He records the architectural details of the Renaissance façade of the Scuola di San Rocco exactly. The same applies to the festoons in front of the windows and doors, as well as to the sunshade that is draped over the entire square. Numerous paintings on canvas adorn the façade of the Scuola, though none of these can be attributed to major 18th-century artists, and they do not quote any motifs.

35 (above) *Feast of San Rocco*, ca. 1735
Oil on canvas, 147 x 199 cm.
The National Gallery, London

This depiction of the Feast of San Rocco is one of Canaletto's main works of the 1730s. The small square in front of the church of San Rocco, complete with the crowd of people who have gathered there, looks wider than it really is. The incomplete church façade casts its shadow on to the square. The rest is flooded in streaming sunlight. Canaletto, however, chose the Scuola San Rocco – one of the six large lay brotherhoods in Venice – as his pictorial center. The Scuola San Rocco, which has a magnificent 16th-century Renaissance façade, houses many masterpieces by Titian and Tintoretto.

The viewer's standpoint is almost the same: a slightly raised, imaginary position in the lagoon. The Doge's Palace has been moved back into the distance. In the foreground, we see the pathway down to the Molo, complete with a small bridge, only a section of which is visible in the first picture. The columns on the Piazzetta therefore look smaller. Like the houses in the background, they are also shown set deeper into the picture. On the other hand, the church of Santa Maria della Salute appears larger and more distinct than in the first picture. A comparison of these two paintings clearly shows us how Canaletto approached the matter of perspective. Once again, his treatment of chiaroscuro is important. In both pictures, clouds cast shadows on to the left-hand side of the Doge's Palace. In both views, the sun illuminates the scene from the left: we can see this clearly in the shadows the figures cast. In the second painting, the shadow on the Doge's Palace is given a more three-dimensional shape and is enclosed by a curving, irregular line that corresponds to the shape of the clouds. The clouds themselves are more massive, and look as menacing as thunderclouds. They darken the surface of the water and give the painting dynamic presence. By this means, Canaletto strove to achieve the "drama" of the atmosphere, letting light and shadow become the picture's protagonists. These are no longer sharply differentiated, as was the case with the chiaroscuro of Canaletto's early works. Instead, they flow into one another.

Canaletto frequently depicted Ascension Day as a large-scale Venetian celebration. On this day the Doge would sail out to sea in the "*Bucintoro*", the official state galley, in order to throw a ring into the waters. This custom – by this time centuries old – derived from an historic event in 1177. It commemorates Venice's diplomatic master stroke – the reconciliation of Emperor Friedrich Barbarossa with Pope Alexander III through the mediation of Doge Sebastiano Ziano, whom the Pope honored with a consecrated ring. The treaty ensured that Venice remained independent. To commemorate this distinction, Venice annually celebrated the symbolic union of the city on the lagoon with the sea. The boat used was the *Bucintoro*, the official galley of the Doge and his ruling retinue. The painting *The "Bucintoro" by the Molo on Ascension*

Day (ills. 30, 31), from the Crespi Collection in Milan, gives the viewer a good impression of the bustling activity in the Bacino di San Marco. The *Bucintoro*'s massive dimensions and festive red decoration make it easy to see. It is still lying by the Molo, directly in front of the Doge's Palace. Numerous splendidly adorned gondolas accompany it. In contrast to the pure *vedute* of the Bacino di San Marco, here the many figures and the elaborate decoration give the picture a totally different, almost narrative, character. Yet it is not only the mobility of the painting's figures that gives it its exceptional expressive power – it is also the colors Canaletto used, in the subtlest of tones, for clothes, ornaments, and decoration. The Pushkin Museum in Moscow houses another variant of this subject, of almost the same size and similar in composition (ill. 33). Here, the throng of gondolas and people in the Bacino di San Marco pushes the *Bucintoro* even further into the background. In this picture, too, Canaletto has emphasized the character of a popular celebration. Nevertheless, the second painting seems more restful than the first, as the gondolas are grouped more or less in a circle. Neither picture can be dated exactly, though the choice of colors, the lively depiction of the figures, and also the breadth of perspective, with its unencumbered view over the surface of the water, all point to a date of around 1730. Presumably, Canaletto completed these works between 1732 and 1735, before publication of the "Prospectus", since Smith failed to mention them when he wrote to the English collector Samuel Hill in Staffordshire on 17 July 1730 praising Canaletto's skill.

In the *Arrival of the French Ambassador at the Doge's Palace* (ill. 32), Canaletto selected another moment of the celebration. This time, our gaze moves from the far side of the Bacino di San Marco, along the Molo, and past the Doge's Palace as far as the church of Santa Maria della Salute. The returning gondolas, which are moving towards the Doge's Palace, are the determining factor in the picture's dramatic development. The space that lies in front of the viewer seems broad and open. The lightness of the scene, the clarity with which Canaletto has depicted the atmosphere, created by the sun and the water, are characteristic of his paintings from around the mid-1730s (ills. 34, 35).

36 (opposite) *Piazzetta Towards the Torre dell'Orologio*, 1730
Oil on canvas, 172 x 135 cm
Windsor Castle, Royal Collection, Windsor

This painting is one of a group of 12 pictures for Smith, the English Consul, which can be dated to 1730. With its brown tones and impasto brushwork, the painting must be regarded as one of Canaletto's early works. The animated figures in the foreground bring the Piazzetta to life. The contrast between the monumental buildings and the proportionally much too small figures are more reminiscent of Baroque stage sets than a realistic depiction of a square.

37 (following double page) *Piazzetta Towards the Torre dell'Orologio* (detail ill. 36), 1730

This view of the Piazzetta with the Torre dell'Orologio (the Clock Tower), is mainly animated by the figures in the foreground. Today you can no longer see the detail on the columns. The gentleman wearing his official scarlet uniform and a wig is particularly striking. Another gentleman in black, holding a rolled-up scroll, is apparently following him.

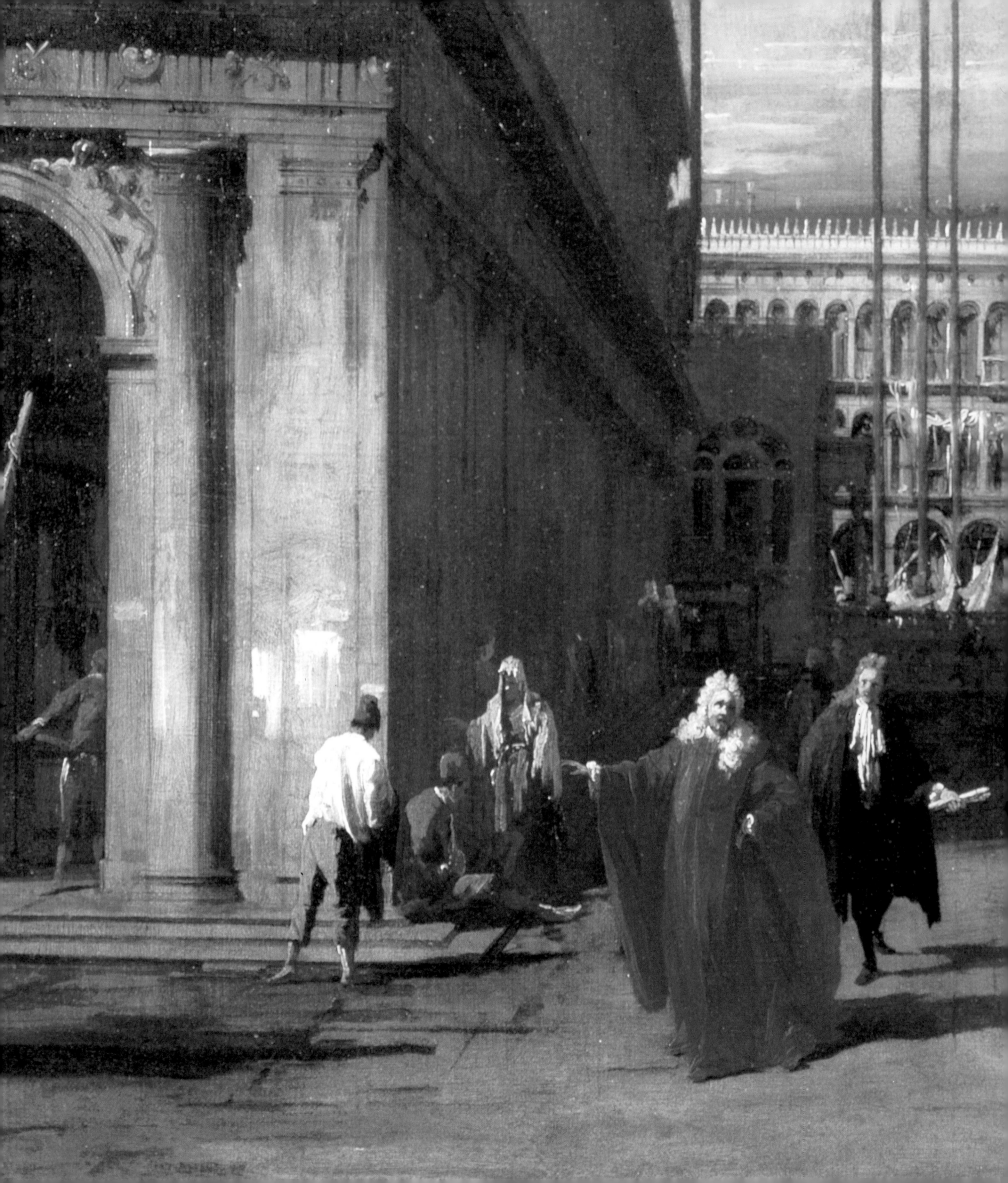

38 *Campo Santa Maria Formosa*, 1730
Oil on canvas, 47 x 80 cm
Woburn Abbey Art Gallery, Private Collection, Woburn

After completion, this painting also entered the
Collection of the Duke of Bedford. The artist has
broadened the square's perspective in such a way that he
has been able to observe individual details of the houses
on both its sides exactly. In attempting to achieve the
desired perspective, Canaletto is aiming to give his picture
structural integrity. He began by depicting the square
from several viewpoints at once, then put all these
impressions together into this picture, so that he finally
had a viewpoint of especial keenness and depth.

We can see his *Piazzetta Towards the Torre dell'Orologio*
(ills. 36, 37) as one of the high-points of his creative
work. Once again, Canaletto subordinated topo-
graphical detail to artistic imagination. In this picture,
the distance between the Procuratie and the cut-off
column with its marble statue of St. Theodore, seems
greater than it is in reality. Nevertheless, this depiction
allows us a clear view towards the Torre dell'Orologio at
the opposite end of the Piazza San Marco. Until we reach
the shadow cast by the Procuratie, the Piazzetta lies in
glittering light. The fall of the light makes the ornaments
on the upper sections of the portals of San Marco seem
almost alien. In the foreground, light is reflected not
only by the column but also by the bright clothes the
figures are wearing.

Apart from the masterpieces we have already
mentioned, between 1730 and 1740 Canaletto also
painted numerous pictures of varying quality. Moreover,
it is impossible to date many of his paintings exactly,
even though their characteristic perspective or lighting
tend to group them chronologically.

Despite his success as an artist, we actually know very
little about Canaletto's life at this period. He worked for
a number of different patrons, and accordingly was
often able to return to the same subjects. Even so, he
always knew how to vary these – by adapting the
viewpoint or the topographical details to his own ideas.
What is particularly astonishing here is that each one of
these paintings is extremely realistic, almost photo-
graphic, in fact.

As well as his views of important sights in Venice,
Canaletto also painted a large number of the city's small
squares, including their churches. He painted the two
small pictures of the *Campo Santa Maria Formosa* (ill.
38) and the *Campo San Rocco* (ill. 39) on commission
from the Duke of Bedford. In the first painting, the
church of Santa Maria Formosa is in the pictorial center.
By contrast with the dark terrace of houses lying in
shadow on the left-hand side of the square, the church
façade reflects bright sunlight. Though in fact quite
small, here this square seems larger than life, and the
figures – even the couples – look isolated and, as it were,

frozen. In the other picture, the *Campo San Rocco* (ill. 39), the sun is lower but it has lost none of its intensity. The degree of sunshine and the shadows cast by the projecting columns make the building of the Scuola di San Rocco, which occupies most of the picture, look strikingly three-dimensional. The atmosphere is full of light, and the breadth of the square is emphasized by its depth. Both these squares, or *campi*, as the Venetians call them, are in reality much smaller and narrower than Canaletto depicted them here. Venice was often short of building space – it had first to be wrested from the sea. By careful use of perspective, Canaletto was able to make spaces seem much larger than they really are. With the help of the *camera obscura* he completed sketches of various locations, put these together, and created a unified, natural-looking picture out of them. It is only in this way that the viewer is able to grasp the square in its entirety. It was not so much in achieving a photographic reproduction of a city view that Canaletto so excelled, but in depicting a scene by a process of

synthesis – though many patrons criticized him for neglecting specific detail.

Much the same applies to the *vedute Campo Santi Apostoli* (ill. 40). In this picture, Canaletto skillfully painted the various buildings in the square together without making them seem cramped. We can see a large number of architectural details, while loosely placed figures, absorbed in various activities, evoke an impression of everyday life. The light is also interestingly handled: in the foreground, for example, he has selected an area of shadow that leads the viewer's eye into the sunlit background (ill. 41). Here, Canaletto achieved his desired effect of pictorial depth not by his use of perspective but solely by his superb construction of chiaroscuro areas. His *Campo San Giuseppe di Castello and the Chiesa San Niccolò di Castello* (ill. 42) is characterized by the same playfulness with the perspective of light. Here, however, Canaletto concentrated the shadow area on one small strip in the foreground of the square, which makes the water of the canal all but

39 *Campo San Rocco*, after 1730
Oil on canvas, 47 x 80 cm
Woburn Abbey Art Gallery, Private Collection, Woburn

The façade of the 16th-century Scuola, at the end of the square, serves as the fixed point from which Canaletto calculated his intersecting perspectives. This makes the square look broader and more open than in reality it is. Canaletto consciously accepted certain topographical inaccuracies in order to achieve his breadth of perspective.

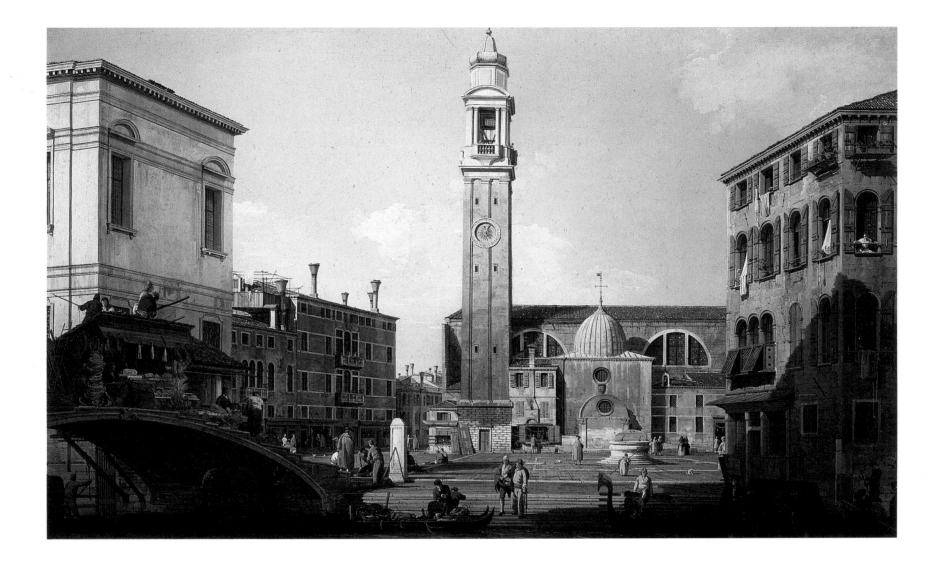

40 (above) *Campo Santi Apostoli*, 1735–1740
Oil on canvas, 45 x 77.5 cm
Private Collection, Milan

This view of the Campo Santi Apostoli is dominated by
the tall 17th-century Campanile. In the early 18th
century Andrea Tirali provided the Campanile with a
lantern that served as a belfry. Whilst the foreground lies
in dark shadow, the square, complete with all its
buildings, is shown flooded with light. Here, basing
himself on Baroque chiaroscuro technique, Canaletto was
attempting to achieve a stronger sense of spatial depth by
accentuating the depiction of light.

41 (opposite) *Campo Santi Apostoli* (detail ill. 40),
1735–1740

The shadowy bridge on the Campo Santi Apostoli offers
us a very lively glimpse into everyday life in Venice. Up
on the bridge itself, we can see a roofed-over market stall,
with a pair of scales and wooden barrels, where pans,
cheese, and vegetables — all of which are spread out as far
as the steps – are offered for sale. Two men are carrying
out repairs to the roof. Beneath the bridge, a gondola and
a fishing boat are making for the quay. Here, though we
cannot make out any details, a fisherman has already
stopped and is selling his wares from baskets.

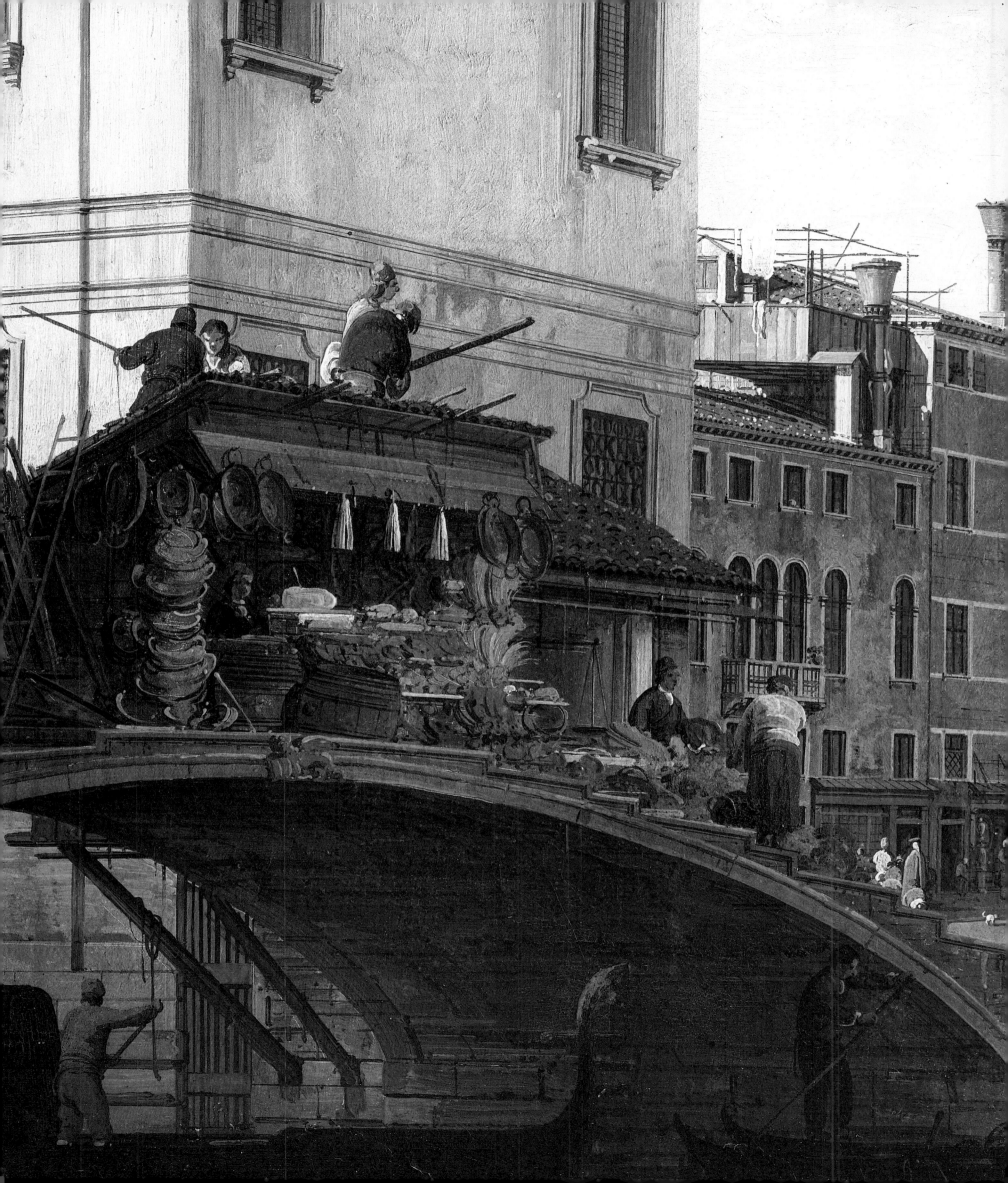

42 *Campo San Giuseppe di Castello and the Chiesa San
Niccolò di Castello*, 1735–1740
Oil on canvas, 46 x 77 cm
Aldo Crespi Collection, Milan

This painting is one of a group of 21 *vedute* the last Duke
of Buckingham purchased in Venice in the middle of the
19th century. After his death, the pictures were absorbed
into the Harvey Collection in Langley Park. Most of the
paintings, however, found their way back to Italy in the
mid-20th century. This view of the Campo San Giuseppe
is further proof of Canaletto's special skill with
perspective.

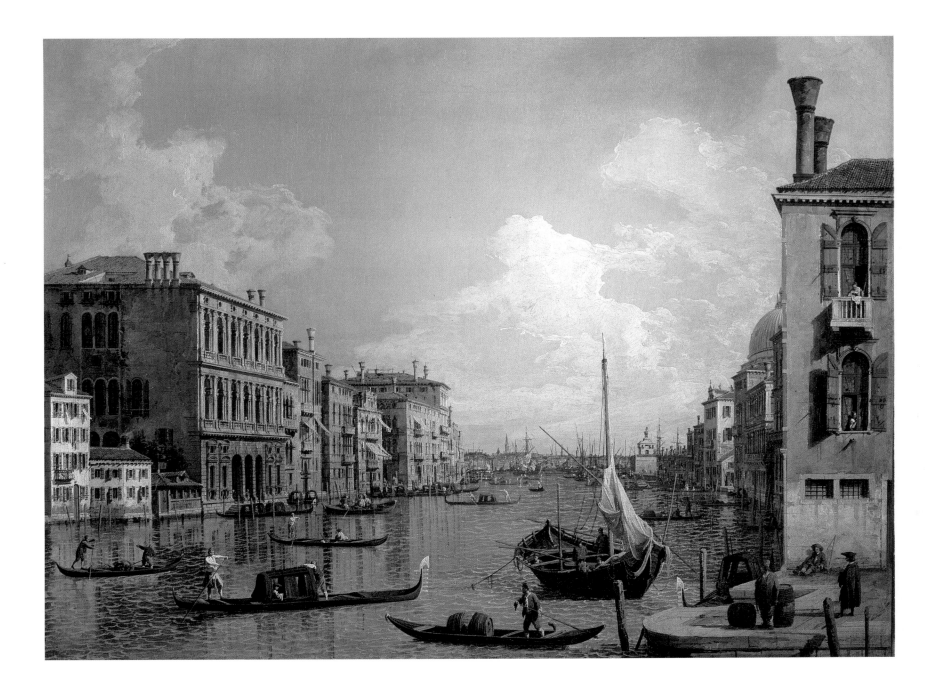

43 *Grand Canal Near the Campo San Vio, Looking Towards the Church of Santa Maria della Salute*, ca. 1730
Oil on canvas, 50 x 70 cm
Pinacoteca di Brera, Milan

Canaletto made another painting of this view up the Grand Canal as far as the church of Santa Maria della Salute in a small-scale picture, which is now in the Royal Collection, Windsor. The perspective is broadly similar. That said, our view of the buildings reveals subtle differences, as do the location of the boats and the figures. Canaletto changed the way he depicted these, along with the house fronts in the foreground on the right.

invisible. Buildings on the right-hand side give the adjoining square a sense of spaciousness, even though only a narrow section of it appears – only to disappear again behind the little bridge over the canal, which forms another horizontal. The square itself has had its surface removed. Pipes are lying everywhere, and individual figures and groups of figures are dotted about. The subject matter is distinctly unusual. Both of these paintings are small. Their charm lies in the intimate nature of the scenery depicted, which may well reflect the patron's wishes.

About 1730, Canaletto again painted the view from the Grand Canal near the Campo San Vio towards the church of Piazza Santa Maria della Salute (ill. 43). Compared with his first picture, this view has a layout that is far more open. The terraces of houses arching away in the background are smaller, and our view towards the canal is interrupted by the flagpoles on the gondolas. This time, Canaletto placed the viewer's standpoint further forward, so that only the end of the quay wall remains visible from the Campo San Vio. Moreover, the angle of vision seems slightly oblique,

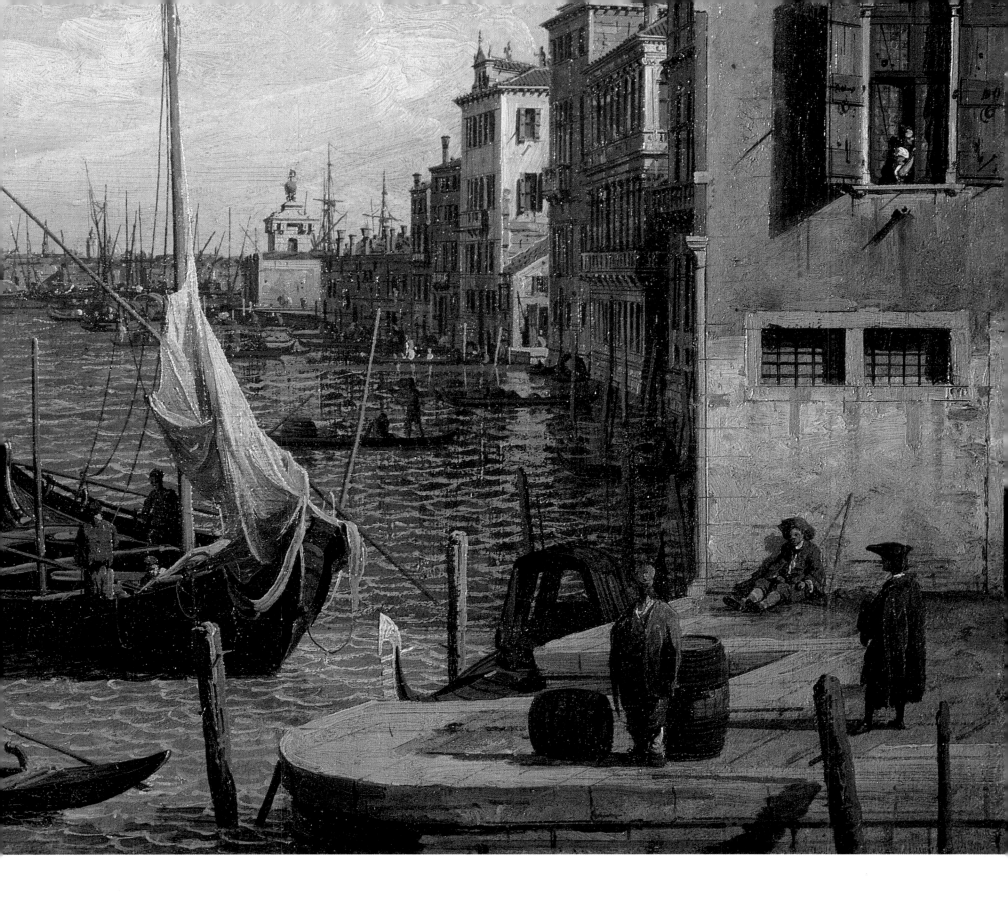

44 *Grand Canal Near the Campo San Vio, Looking Towards the Church of Santa Maria della Salute* (detail ill. 43), ca. 1730

This picture achieves its idyllic character thanks to the sparingly placed figures. On the Campo, a rather well-dressed gentleman is waiting, presumably for a gondola. Another man is watching some wooden barrels being transported across the canal. A third man is leaning against the wall of a house as he looks out over the canal.

There is very little activity on the water, apart from a few boats, gondolas, and a small sailing ship in the foreground. The disposition of the figures and their activities are varied in the other pictures on the same subject. Different lighting from painting to painting changes the atmosphere.

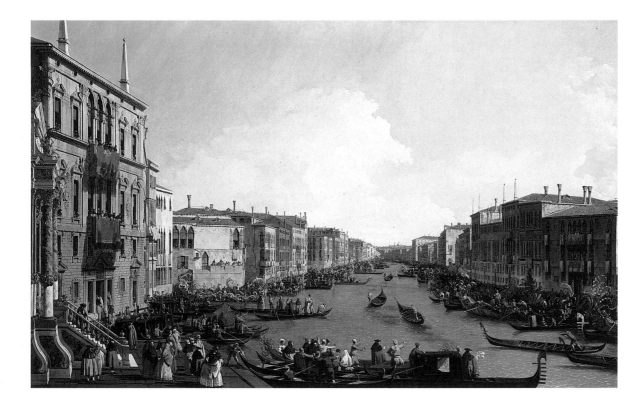

45 (left) *Regatta on the Grand Canal*, 1733/34
Oil on canvas, 77.2 x 125.7 cm
Windsor Castle, Royal Collection, Windsor

In his painting of the Regatta on the Grand Canal, Canaletto has adopted the same viewpoint as that used by the artist Carlevaris, who had tackled this subject as early as 1709. Both artists have slightly raised the viewpoint, roughly to the height of the first floor of the palace in the foreground – a vantage point only a few could have had. Canaletto's picture borrows heavily from his predecessor's painting, not only in perspective, but also in composition.

which extends the diagonal lines of perspective. Various architectural details are depicted differently in this second picture; for example, he places the dome of Santa Maria della Salute, which rises up beyond the palace-façades on the right, slightly further back. The colors are noticeably stronger, and delicate nuances of color bring the surface of the water to life. On this water, Canaletto skillfully depicts the reflections of the palace-façades. Water and land flow into one another (ill. 44).

The *Regatta on the Grand Canal* (ill. 45) is closely connected with the picture mentioned earlier, the *The "Bucintoro" by the Molo on Ascension Day* (ill. 31). If the coat of arms really is that of Doge Carlo Ruzzini, then the picture can presumably be dated to about 1732. This is probably another work commissioned by Joseph Smith, who published it in his collection of engravings, the "Prospectus", because of its superlative quality. Despite his artistic skills, Antonio Visentini, who made the engravings from the pictures, was nowhere near able to re-create the original's effects of light or its lively presence. Nevertheless, Smith was more taken with the 12 Grand Canal pictures he commissioned after Canaletto had completed the Piazza paintings to Smith's entire satisfaction. We do not know when the artist began work on these views of the Grand Canal. It is also unclear how long he spent on the pictures or in what order he painted them. They vary in quality, but this may have been a result of the overwork from which

Canaletto repeatedly suffered at the height of his creative output (ill. 46). This makes it virtually impossible to deduce his artistic development from the chronological sequence of individual works. When painting a given picture, he used to follow whatever preparatory drawings he had himself made on the spot, and these have come down to us in his sketchbook. The paintings' pictorial structures were carefully worked out. Even in those cases where the final paintings differ from the sketches, the changes were also prepared in advance rather than added later. Canaletto painted these pictures with strong, confident brushstrokes. As a final task, he always used to rework the areas of sky. This was the best way to achieve the effect of "realism" that his contemporaries regarded so highly in his *vedute*. Canaletto would bring the blue tone of the sky down as far as the buildings. As a result, the sky shines through every gap in the background, creating a clear division between land, water, and air. The figures, boats and gondolas he added later were meant to add spontaneity and immediacy to the picture, and so increase its apparent realism.

Canaletto's painting style transformed the canvas into a kind of window. Only rarely does the viewer's eye remain caught up in the canvas's surface. Canaletto has applied so many layers of paint that the surface of the picture is scarcely recognizable any more. Our eye is immediately directed to the picture's depths, which

46 (opposite, above) *Grand Canal from the Palazzo Balbi*, 1735
Oil on canvas, 45 x 73 cm
Galleria degli Uffizi, Florence

This painting from the mid-1730s shows again the view to the *Grand Canal from the Palazzo Balbi* that Canaletto had captured in his first *vedute* for Joseph Smith. Comparing the two pictures illustrates Canaletto's artistic development. This second view of the canal seems broader, more open, and clearer. Canaletto achieved all this by choosing a viewpoint in the center of the canal, far away from the palaces that stand close to the water, and by lowering it further than in the first painting.

47 (opposite, below) *Molo with the Library (Molo Looking Towards the Zecca)*, before 1740
Oil on canvas, 110.5 x 185.5 cm
Private Collection, Rome

We should include this view of the Molo with the Library in the mature phase of Canaletto's creative work around 1740. Here he has chosen the central point of the canvas, which also indicates the entrance to the Grand Canal, as the picture's vanishing point. Our eye glides from the Bacino di San Marco and along the gondolas lying beside the Molo. In the background, the only building that towers up – at the mouth of the canal – is once again the church of Santa Maria della Salute. The whole composition is captivating because the artist has clearly divided it into areas of water and terra firma.

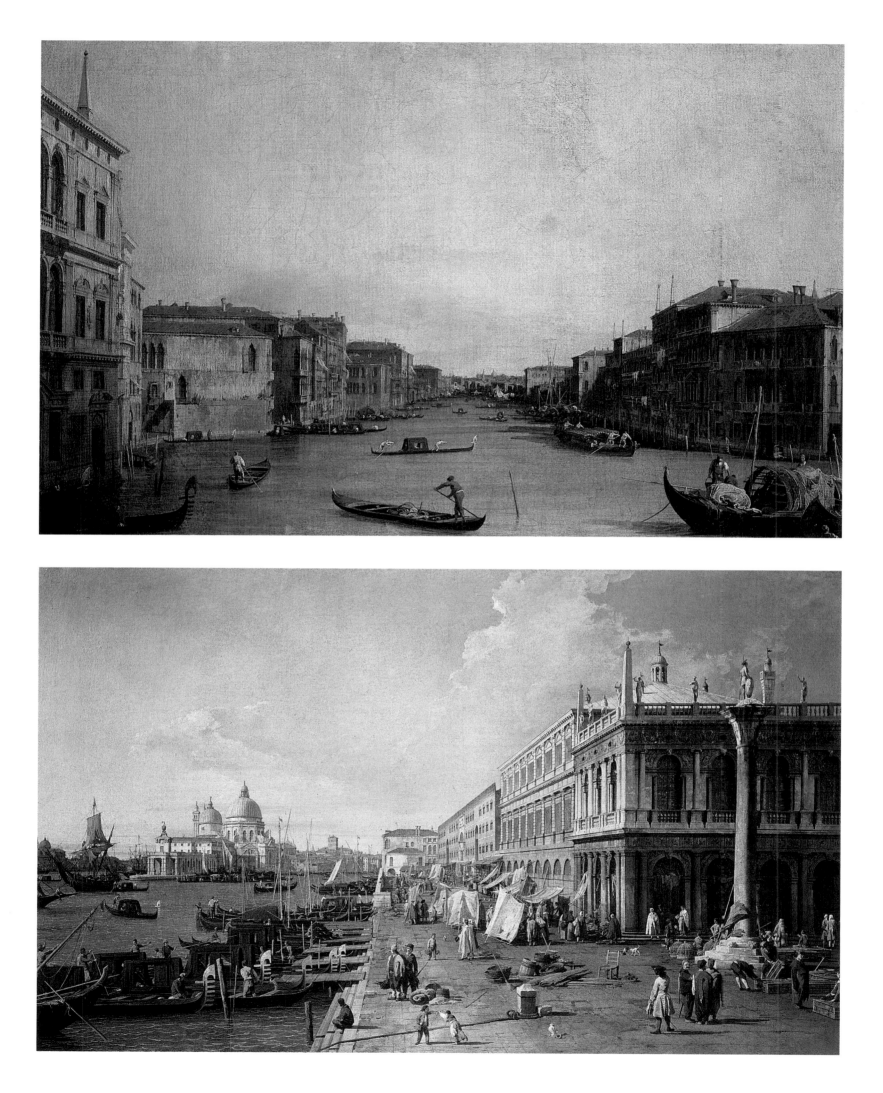

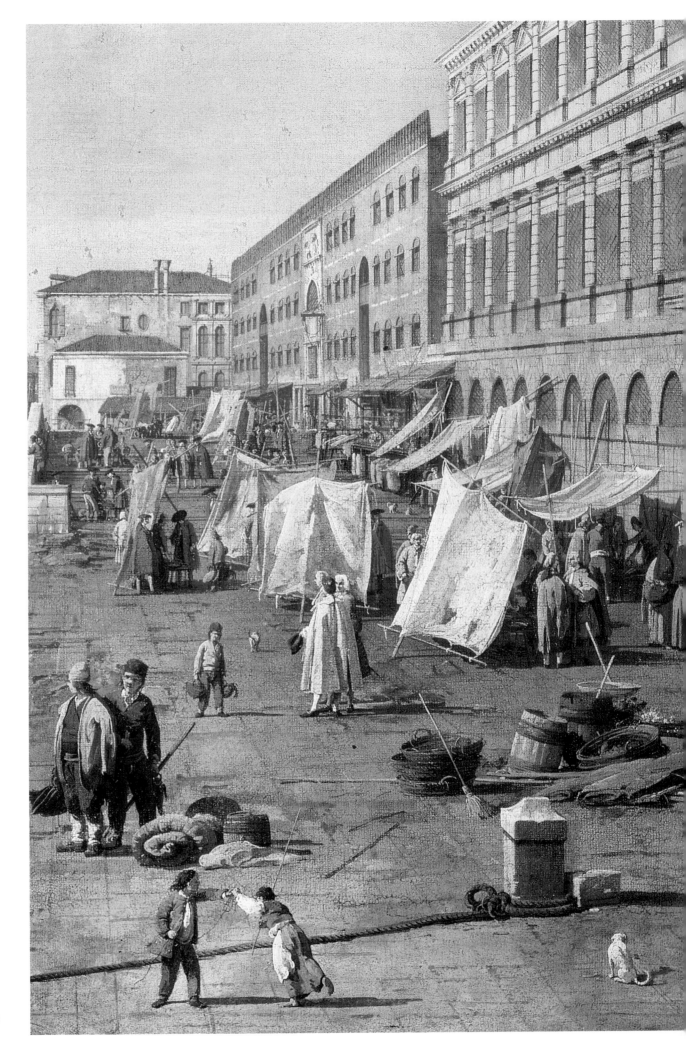

48 *Molo with the Library (Molo Looking Towards the Zecca)* (detail ill. 47), before 1740

The figures, who dominate the bustling market in the foreground and on the bank side, are painted with considerable variety. These figures – especially the quarrelling children in the foreground and the sellers of birds and poultry around the column – give the picture a narrative, genre-like character.

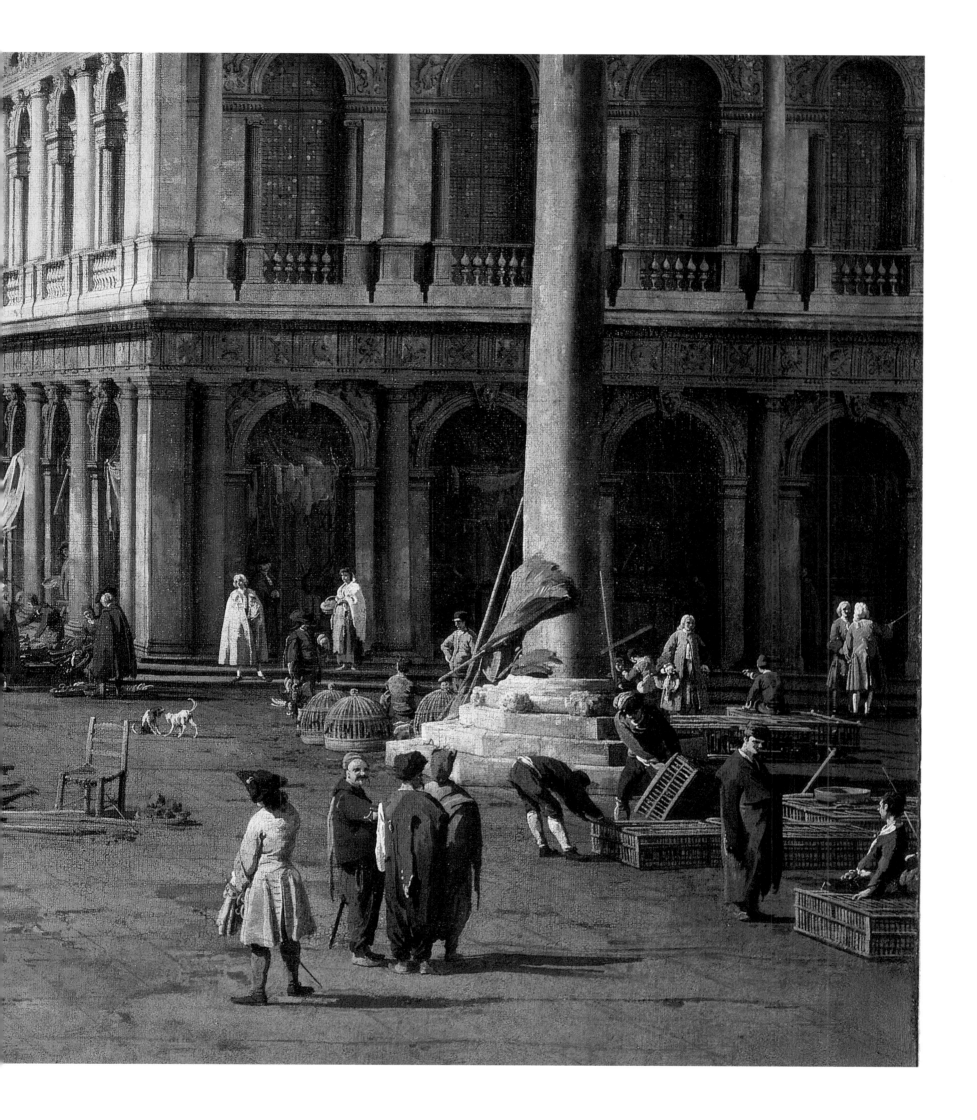

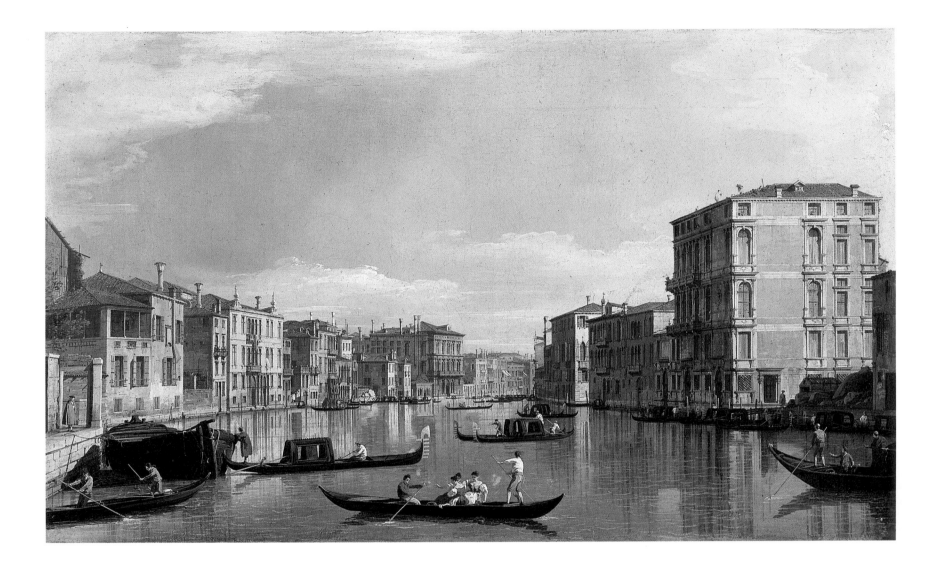

49 *Grand Canal Between the Palazzo Bembo and the Palazzo Vendramin*, after 1730
Oil on canvas, 47 x 80 cm
Woburn Abbey Art Gallery, Private Collection, Woburn

This view across the Grand Canal between the Palazzi Bembo and Vendramin is one of a series of 22 commissions for the Duke of Bedford. Many English aristocrats like him commissioned *vedute* from Canaletto during the 1730s. Generally, these depict the best known sights of the city as visitors to Venice would like to remember them.

resemble a photograph even though Canaletto's paintings are something quite different (ills. 47, 48).

There were sound financial reasons behind the commission for a series of pictures of the Grand Canal. Smith displayed them in his palace in order to introduce the great Venetian *vedutà* artist to English merchants and so persuade them to purchase Canaletto's work. With this in mind, he decided to publish the Grand Canal paintings in the second edition of his "Prospectus". Its title page mentions the merchant's apartment – on the Grand Canal – as the place where one could see the pictures of the canal. Success was not long in coming. Very soon, several paintings shown in the "Prospectus" were sold to English aristocrats such as the Duke of Bedford, the Duke of Leeds, and the Duke of Buckingham (ill. 49). None of the pictures that found their way into these ducal collections depicts the same subject matter. Ultimately, the Duke of Bedford purchased 22 paintings – 12 views of the Grand Canal and 10 of the Piazza San Marco, as well as various *campi* and their churches (ill. 50). The collection owned by the

Duke of Buckingham, which was later purchased by Sir Robert Greenville Harvey (who gave the collection his name) comprised 21 pictures. Eleven of these were views of the Grand Canal. Among the paintings in the Bedford Collection were the pictures of Venetian festive occasions and the regatta on the Grand Canal.

The superbly painted, crystal-clear *Entrance to the Arsenal* (ill. 51) also formed part of the Duke of Bedford's Collection. The painting is animated by its powerful coloration on the canvas's mirror-smooth surface. Comparing this with the related pen and ink drawing now in the Royal Library at Windsor Castle clearly demonstrates Canaletto's great skill with canvas and color (ill. 52). The pen and ink drawing has none of the oil painting's inner luminosity. This can only be rendered convincingly in oil paint, even though the cross-hatching in the area of sky in the pen and ink drawing add a touch of vitality. The portal, in the form of a triumphal arch, on the left in the Arsenal wall, was one of the first pieces of Renaissance architecture in Venice. The small Oratory, which was dedicated to the

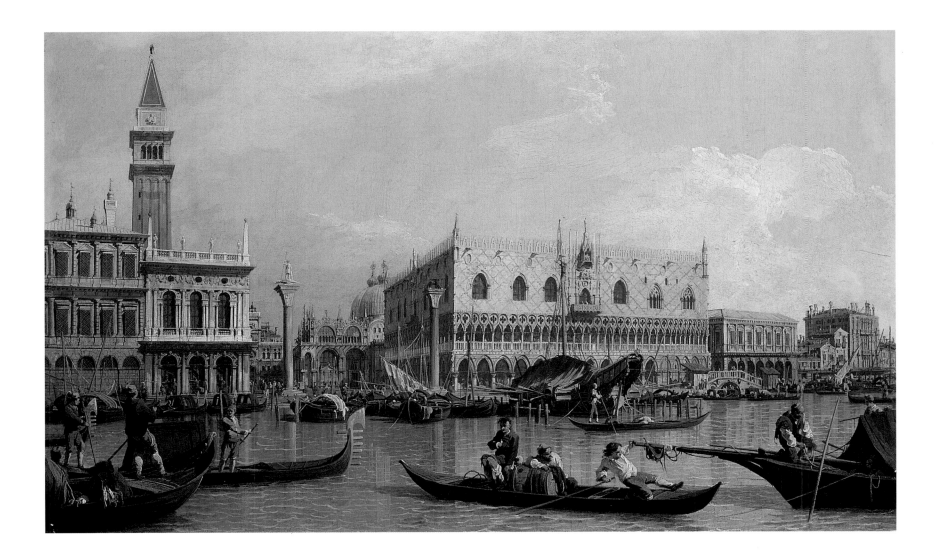

Virgin Mary, was destroyed by French occupying troops in the 19th century. Legend has it that the whole complex, with its Water Entrance and the walls of the Water Basin in the background, inspired the poet Dante (1265–1321) to create his Gate of Hell in the "Divine Comedy".

The superlative view of the *Riva degli Schiavoni* was sold for the princely sum of 120 zecchini to the German Field-Marshal, Johann Matthias von der Schulenburg. He had fought with distinction for Venice in the Turkish War and now, an old man loaded with honors, he had begun collecting art. Schulenburg thought highly of Canaletto's *vedute*, even though his collection reflected a fairly broad taste. Since 1738, he had been advised by Giovanni Battista Piazzetta. Schulenburg purchased some important works by the Old Masters of Mannerism, the Renaissance, and the Baroque. Among contemporary artists, he took a special interest in historical painters like Ricci, Pittoni, and Piazzetta. He owned 70 war paintings and 62 *vedute* by Carlevaris, Canaletto, Marieschi, Cimaroli, and Bellotto, among

others. Schulenburg had a very acute eye for the best art of his day. It is therefore surprising that his collection included only one picture by Tiepolo. He planned to display the Venetian paintings alongside his impressive Dutch collection in a large-scale museum in the Palais Schulenburg in Berlin. However, this plan was not realized after his death. Samuel Hill, the English collector and merchant, bought a further *vedutà*, the *Riva degli Schiavoni* (ill. 53). Smith also owned a smaller version of this subject. Examples of the other version exist in the Gemäldegalerie, Vienna, and the Museum of Art, in Toledo, Ohio. The view of San Marco from the Bacino was obviously very popular.

Like Marshal von der Schulenburg, the English aristocrat, Lord Carlisle, preferred to buy his paintings direct from Canaletto instead of acquiring a selection through Smith. Carlisle managed to assemble a substantial collection of high quality – 17 *vedute* in total. These were all displayed in Castle Howard, Lord Carlisle's seat, until some of them suffered bomb damage in 1940. One of the surviving paintings, the

50 *Piazzetta and the Doge's Palace from the Bacino di San Marco*, 1735–1740
Oil on canvas, 40 x 80 cm
Woburn Abbey Art Gallery, Private Collection, Woburn

This small view – also once owned by the Duke of Bedford – shows the Piazzetta on the Piazza San Marco from an unusual viewpoint. Canaletto chose to view the scene from the sea, immediately above the surface of the water. This means that viewers are really drawn into the picture, especially as they find themselves on the same plane as the gondolier rowing his boat in the foreground.

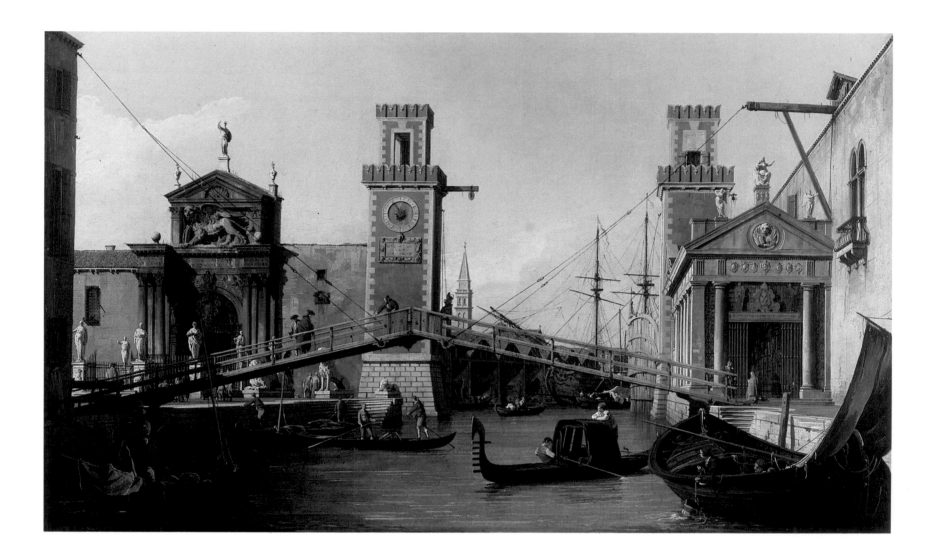

51 *Entrance to the Arsenal*, after 1730
Oil on canvas, 47 x 78 cm
Woburn Abbey Art Gallery, Private Collection, Woburn

This crystal-clear view, with its rich blue tones, presents an exceptional view of the entrance to the Arsenal from the harbor basin. On the right, we see the 16th-century Oratorio della Madonna, which Napoleon's troops destroyed in 1809. The three marble lions, which we can see on the portal entrance in the background, were brought to Venice from Piraeus in Greece as war booty. A winged lion is the heraldic animal of Venice.

Bacino di San Marco, Looking East (ill. 54), is now in Boston, Massachusetts. Like *The Stonemasons' Yard*, it is one of Canaletto's masterpieces. This picture brings together the whole breadth of the Bacino. From the Doge's Palace as far as the island of San Giorgio we can easily make out all the buildings on the bank. The space seems at once real and unreal. Here, Canaletto demonstrates his supreme mastery of pictorial construction and perspective by making the immense breadth of the whole lagoon his subject matter. The painting's coloration reflects the blue of the water, which occupies most of the pictorial surface. Boats and buildings are little more than staffage figures. The panorama is much more than simply a view of the Bacino – hyper-realism and poetry flow into one another in superbly.

As well as paintings (ill. 56), Canaletto left us a great many drawings (ills. 55, 57, 58). These were not intended for sale. They served the artist as sketches, in order to capture the most important architectural and formal details of his subject. Many of these drawings are incomplete and only roughly sketch in the main

buildings. Some, however, are finished in a very subtle and detailed way. Apart from these, there are also a great many preparatory drawings, which already anticipate the final paintings in their composition. The artist's contemporaries did not think these sketches or preparatory drawings worth mentioning alongside the paintings and engravings. They were aids to Canaletto's working method, and thus of secondary importance to the art market of that time. Joseph Smith was the first collector to take any interest in them, and included them in his collection. He owned between 50 and 60 of these drawings, though none of them bore a close resemblance to any of the paintings he had purchased. In the course of time Canaletto took the step of applying wash to his sketchy pen and ink drawings (ills. 55, 57), thereby creating chiaroscuro effects.

In the sketchbook, which is today readily accessible to everyone in Terisio Pignatti's facsimile edition, the artist has already made marginal notes regarding the picture's brightness. *Scuro* means dark; *cenerino*, ash-gray. A series of little strokes indicate distances and proportions. Beneath the sketches, we can also see

52 *Entrance to the Arsenal and the Ponte del Paradiso,*
1733/34
Pen and ink, 27.1 x 37.6 cm
Windsor Castle, Royal Library, Windsor

This pen and ink drawing can be usefully compared with
the small-scale oil painting of the same subject. The latter
distracts attention from the topographical realities by dint
of its strong coloration and sun-drenched atmosphere.
Nevertheless, this drawing graphically emphasizes both
the details and the numerous figures who bring the
picture to life. Doge Pietro Orseolo is reputed to have
built the Arsenal, as well as the Venetian ships' wharf
complete with its weapons and munitions depot, as early
as the late 10th century. At the height of Venice's
importance as a maritime trading power, over 15,000
workers were employed here.

53 (left) *Riva degli Schiavoni*, ca. 1740
Oil on canvas, 46.5 x 63 cm
The Toledo Museum of Art, Toledo, Ohio

This view of the *Riva degli Schiavoni* is one of a series of
pictures dating from the late 1730s that can firmly be
regarded as high-points in Canaletto's paintings. We are
no longer certain who commissioned these pictures. In
the course of the 18th century, this *veduta* found its way
into the collection owned by the Prince of Liechtenstein.
He began to appreciate and collect Canaletto's *vedute*
from an early date.

54 (following double page) *Bacino di San Marco, Looking
East*, ca. 1738
Oil on canvas, 124.5 x 204.5 cm
Museum of Fine Arts, Boston, Massachusetts

This vista from Santa Maria della Salute across the Bacino
di San Marco and the Grand Canal is one of Canaletto's
most magnificent works. In the foreground, left, the
Doge's Palace catches the eye and forms a focal point. Our
gaze then moves along the buildings on the bank of the
Grand Canal towards the right bank – as far as the island
of San Giorgio with its famous Palladian church of San
Giorgio Maggiore. In contrast to Canaletto's other *vedute*,
topography plays a subordinate role here. The forest of
sailing ship masts in the foreground has a decisive effect
on the composition. The bustling activity on the sea
confirms Venice's belief in its supremacy as a maritime
trading power.

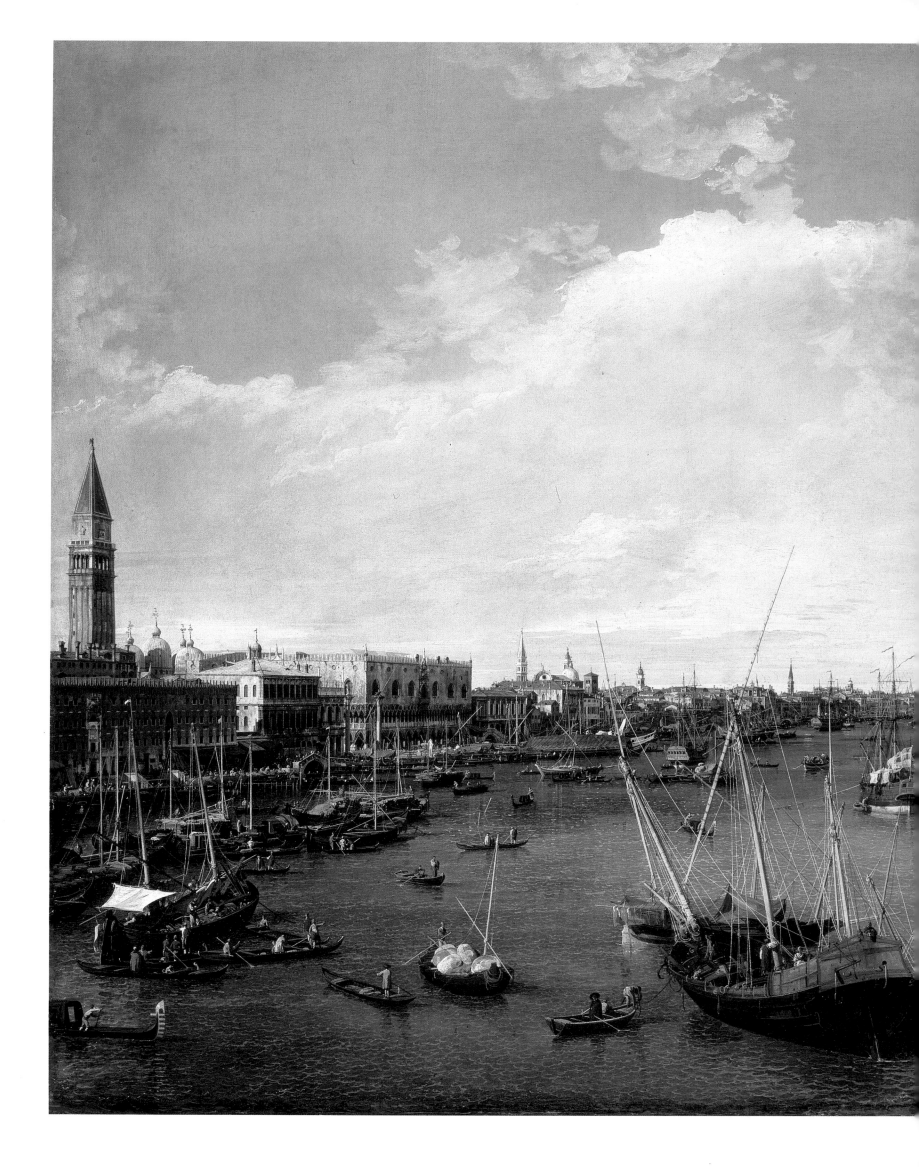

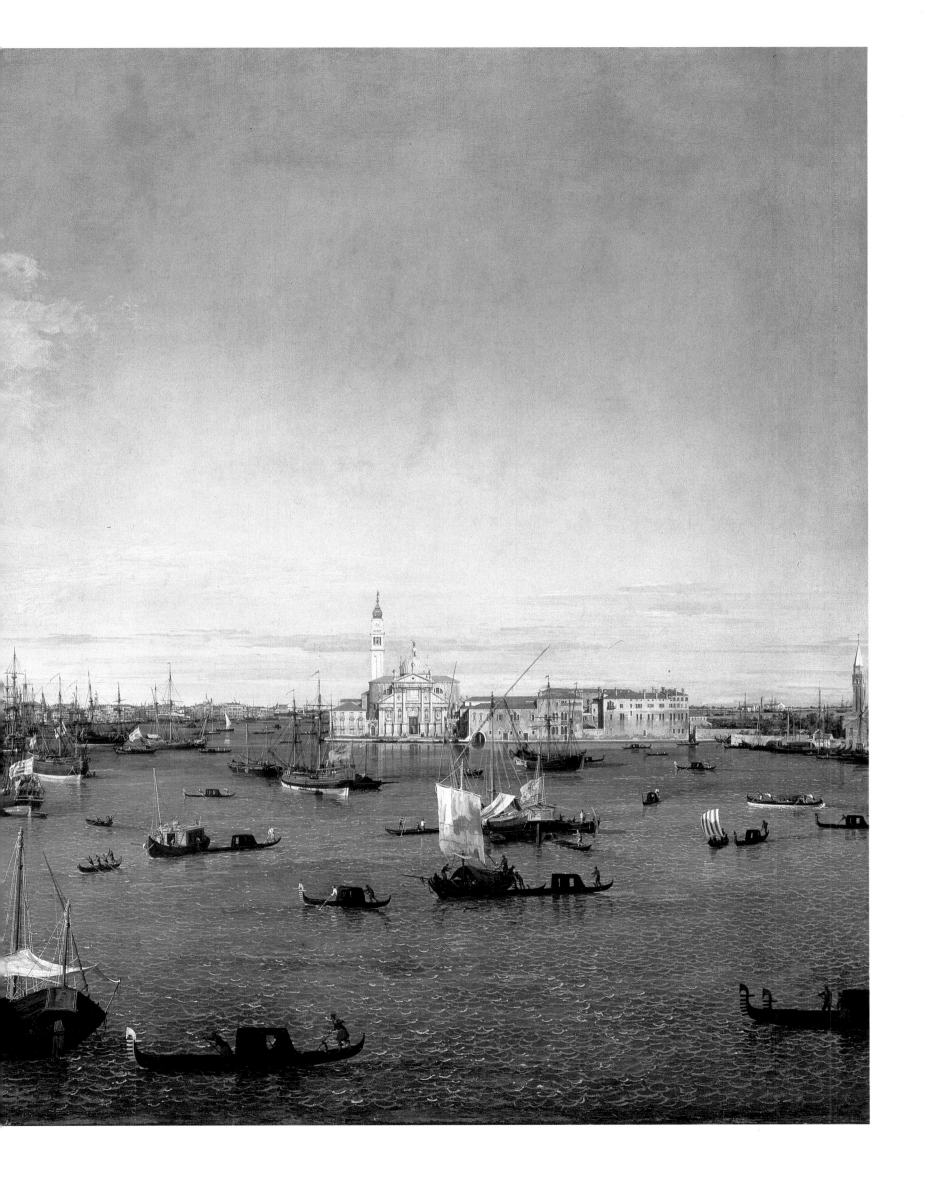

55 (right) *View of the Brenta: the Church of San Rocco and the Villa Zanon-Bon*, 1740/41
Windsor Castle, Royal Collection, Windsor

Canaletto succeeded brilliantly in depicting the rural scenery near the Brenta. The river calmly finds its way between the church of San Rocco and the villa in Palladian style, as it flows as far as three mills on the low-set horizon. Along the banks, we can see several people promenading, while fisherman are busy with their catches. On the water, we find gondolas, as well as boats for fishing and transport which are typical of Venice and its environs.

56 (below) *Piazza San Marco, Looking Towards San Geminiano*, 1735–1740
Oil on canvas, 68.5 x 93.5 cm
Galleria Nazionale, Rome

This painting is one of four *vedute* which are now housed in the National Gallery, Rome. They are all characterized by the clarity and sun-drenched atmosphere which are typical of Canaletto's works during the late 1730s. Canaletto concentrated the buildings that surround the square around a vanishing-point located in the right-hand corner of the picture. This allows the viewer to retain an uninterrupted view of the square, despite the buildings that close it off. Even at this late stage, Canaletto was still using techniques of perspective that originated in stage sets. By now, though, he was experienced enough to combine them with a perspective-structure which he could achieve only by means of sketches direct from nature and by letting several different viewpoints intersect.

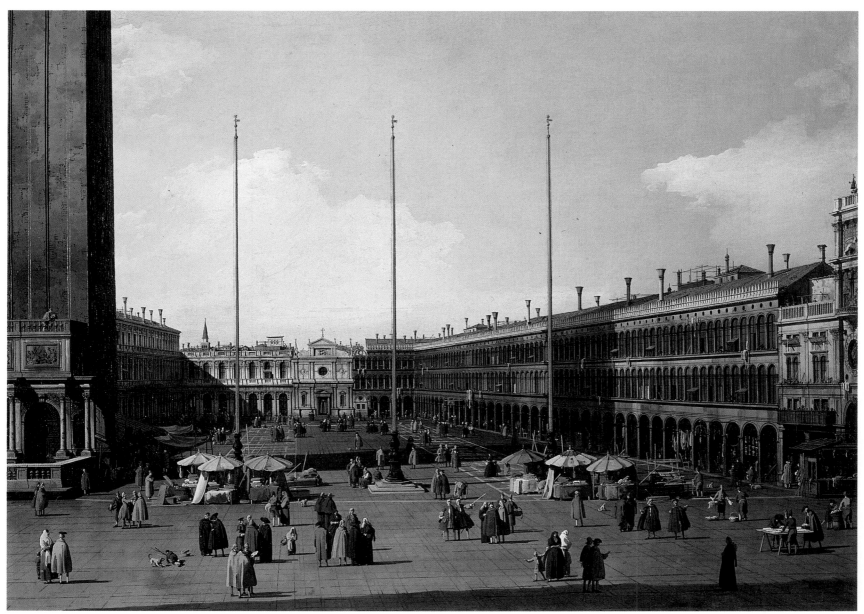

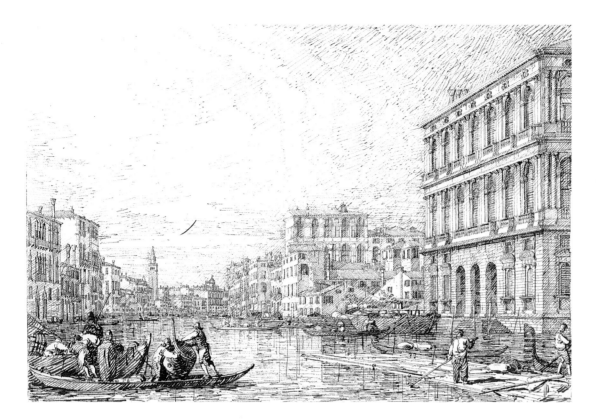

57 (left) *Grand Canal From the Palazzo Corner to the Palazzo Contarini*, 1733–1735
Quill pen and brownish-black, grayish-brown ink, 29.3 x 42.7 cm
Windsor Castle, Royal Library, Windsor

Canaletto's pen and ink drawings demonstrate the same exactitude as his paintings. Here, he has sketched the house fronts along the Grand Canal with a playful lightness of touch. For this drawing, the artist chose a viewpoint in the center of the canal. Edged by terraces of houses, the canal fades from the viewer's eye around a slight bend in the background. The magnificent Renaissance building on the right bank of the Canal is the Palazzo Corner della Ca' Grande, which was built by the architect Jacopo Sansovino (1486–1570). In the background, we can see the towering shape of the campanile of the church of Santa Maria della Carità.

58 (below) Canaletto (?)
Three Male Figures in Oriental Costumes, 1725–1727
Quill pen and ink, 19.2 x 27.4 cm
Galleria degli Uffizi, Florence

This drawing is neither signed nor dated. The way the figures are drawn is not typical of Canaletto's style. Yet these people, with their Oriental garments, are similar to his figure depictions – for instance, those in the foreground of his picture the *Fonteghetto della Farina* (ill. 26). Comparing this drawing with his sketches of figures on page 58 in his sketchbook also makes this clear. Only a few of Canaletto's figure studies have come down to us, though they confirm his interest in this area.

59 *Piazza di San Marco*, 1735–1740
Oil on canvas, 115 x 154 cm
National Gallery of Art, Washington

This *vedutà* offers an unusual view of the Piazza di San Marco, as well as a diagonal vista of the church of San Marco and the Piazzetta from an imaginary, slightly raised viewpoint. It belongs to a group of important commissions from the 1740s. The last Duke of Buckingham purchased the 21 *vedute* in Venice in the mid-19th century. After his death, the pictures found their way into the Harvey Collection. Visentini re-created nine of these *vedute* as engravings in "Prospectus", which Joseph Smith had commissioned. This means that all these pictures must have once been in the collection owned by Joseph Smith.

studies of the gondolas, boats, masts, and rigging. Canaletto seems to have known at least enough about boat building to be able to depict the sails and all the appropriate masts and ropes realistically. Individual figure studies are also interesting. They show that Canaletto painted the figures who populate his pictures, and who give them their characteristic vitality and everyday familiarity, with great care, even if it sometimes looks as if he had magically created them on canvas with just a few brushstrokes. The Uffizi collection of copperplate engravings contains an exquisite, highly detailed drawing, *Three Male Figures in Oriental Costumes* (ill. 58). It testifies to Canaletto's enthusiasm for the human figure and his attention to detail.

Moreover, the fact that he reworked many of his drawings confirms his interest in this medium. In Smith he had found a collector who appreciated their artistic value and was glad to purchase them.

Hardly any information about Canaletto's personal life has come down to us from the artist's most productive period, the years from 1730–1740 (ills. 59–62). Presumably, his studio was near the house where he lived, not far from the Campo San Lio, where he had grown up. Because of Canaletto's penchant for *vedutà*, his collaboration with his father had come to an end quite soon. From the 1730s onwards, his father, Bernardo Canal, had himself also been painting city-scapes. Thus, in 1987 at a Venice art dealer's, a view of

the Piazza San Marco appeared that was signed and dated on the back: "Bernardo Canal, fecit 1735". That very year Canaletto was refused entry to the Collegio dei Pittori, the painters' guild. Explaining their decision, the college authorities said that if father and son were collaborating, then only one of them could qualify for membership. At this time, Canaletto's studio included not only his father but also Bernardo Bellotto, the son of Fiorenza Domenica Canal, the artist's sister. Bellotto's name appeared in the guild lists from 1738 onwards.

In around 1740, on Joseph Smith's advice, Canaletto embarked on a short journey into the Venetian hinterland, with this nephew. They explored the countryside along the Brenta Canal as far as Padua. The

outbreak of the War of the Austrian Succession (1740–1748), which affected large swathes of Italy, caused the stream of tourists to Venice to dry up abruptly. Canaletto received very few commissions. At this period, however, he did complete more drawings, including four of the countryside near Venice. For a short while, gardens and country life in the provinces were his central interests. While travelling along the Brenta, Canaletto completed over 30 landscape sketches direct from nature. Much later, he used the material he had collected during his journey for the so-called *capricci*, imaginary landscapes, also known as *vedute ideate*. The most important work from this period, and, as it were, the end product of this journey, is his view

60 *The Doge's Palace with the Piazza di San Marco*, 1735
Oil on canvas, 51 x 83 cm
Galleria degli Uffizi, Florence

This view of the Doge's Palace from the Bacino di San Marco seems to have been a very popular commission from foreign visitors. There is another picture on this subject in similar dimensions. It is dated 1740 and is now in Woburn Abbey. In that picture, Canaletto has adopted the same structure and viewpoint. The boats and gondolas on the Bacino are also arranged in a similar fashion. The only difference is the way in which the figures are set out.

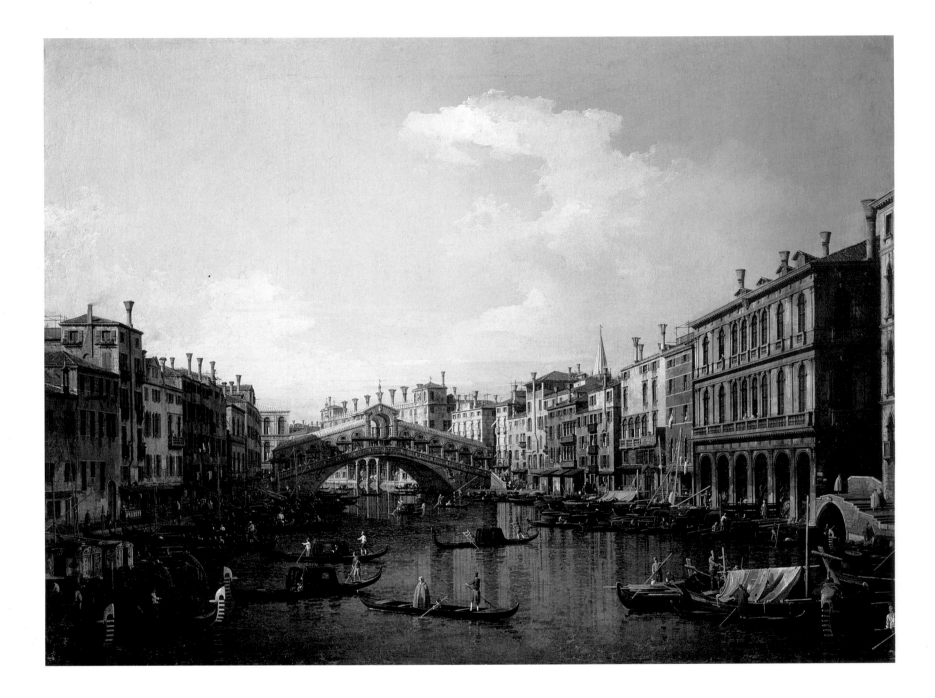

61 (above) *Rialto Bridge from the South*, 1735–1740
Oil on canvas, 68.5 x 92 cm
Galleria Nazionale, Rome

The Rialto Bridge is not one of Canaletto's main subjects.
In his views of the Grand Canal it often appears only in
the background. Here, however, we see a good view of the
bridge constructed by the architect, Antonio da Ponte (ca.
1512–1597). If we look at the bridge from the south, the
Grand Canal seems very narrow. However, Canaletto
counteracted any impression of tightness and constriction
by devoting the upper half of the picture to the sky, whose
brilliant blue is not jeopardized by the slight shimmer of
cloud.

62 (opposite) *Rialto Bridge from the South* (detail ill. 61),
1735–1740

In front of the bridge, which is the real subject of this
picture, both in motif and perspective, numerous
gondolas bring the canal to life. Part of the canal and the
bridge are lying in shadow, which makes our view of the
Grand Canal at this point seem even more constricted.
The water of the canal is tranquil, and the gondolas are
gently gliding past. Everything about this picture radiates
peace and calmness.

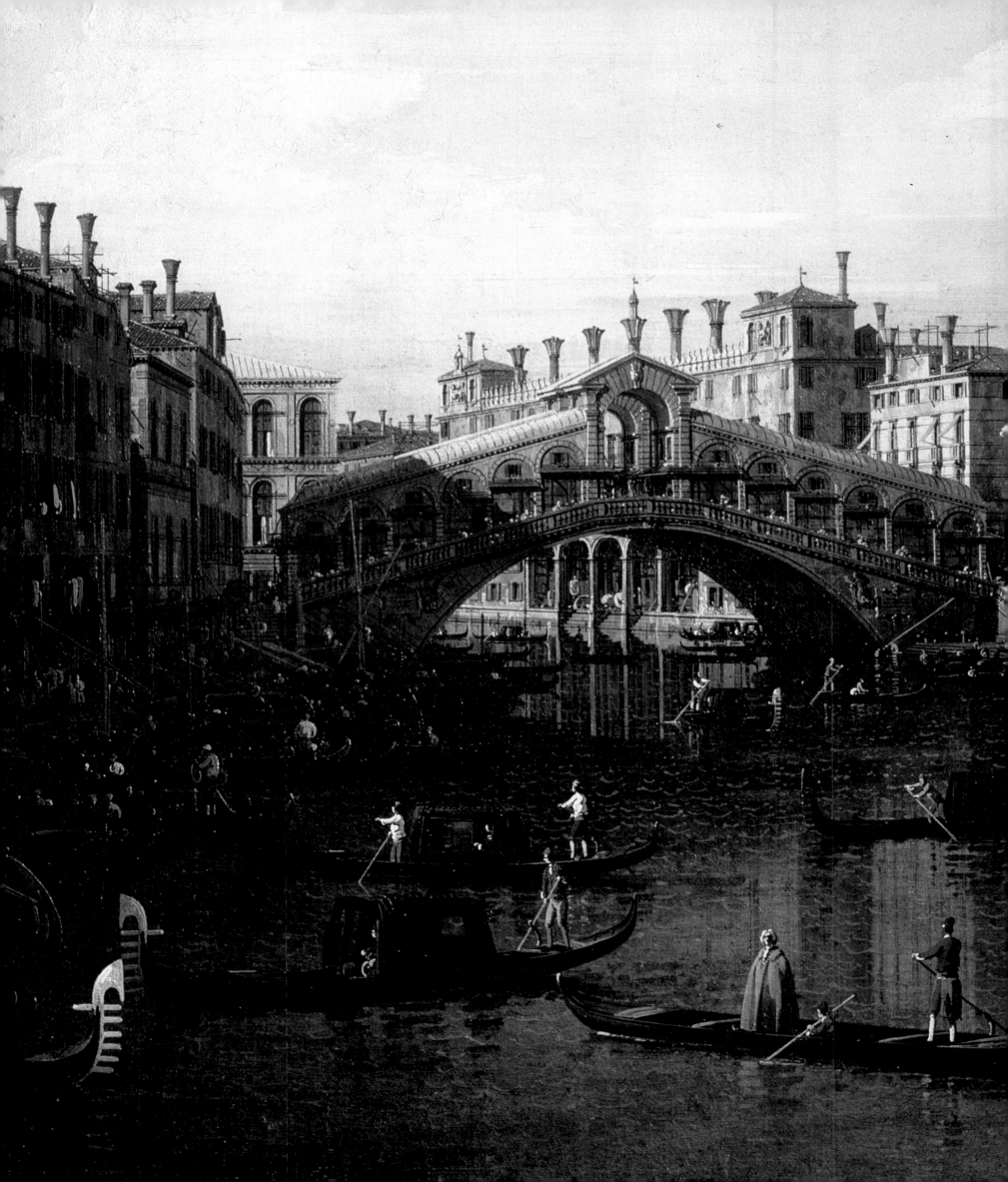

63 *Torre di Marghera*, 1741
Oil on canvas, 30.5 x 24.5 cm
Museo del Settecento Veneziano di Ca' Rezzonico, Venice

This ancient defensive tower absorbs the light like a large, immobile block, which blinds everything around it and dominates the pictorial surface through its radiance. It forms the central point of the pictorial composition. Canaletto has painted the water, the unfortified embankment, and the gently rising hills in the background in delicate shades of blue and green. These give the rural scenery an impression of tranquillity and melancholy. Canaletto often chose to depict this old defensive tower, but his drawings and watercolors do not record the intense impression of heat and light we see here.

64 *Landscape with Ruins*, 1740
Oil on canvas, 87.5 x 120.5 cm
Palazzo Vecchio, Florence

Landscapes with ruins are among the subjects to which
Canaletto kept returning. In his *vedute ideate*, or *capricci*,
as they are also called, the artist let his imagination take
control. In the overall composition, Canaletto would
mingle architectural games with his recollections of other
locations, combining the real and the imagined. This
vedutà has also sprung from the artist's imagination. It has
an almost mythological character, yet at the same time
seems totally real. The ruins in the foreground are
reminiscent of an old monastery. The triumphal arch in
the background has clearly been borrowed from the
Roman Forum.

the *Prato della Valle*, a large square in Padua, which presumably interested Canaletto in terms of perspective. The engravings and drawings that were subsequently made of this painting still exist. One of the engravings was acquired by no less a figure than Canaletto's great fellow artist, Giambattista Tiepolo. Canaletto completed the view, *Torre di Marghera* (ill. 63), an old 15th-century defensive tower – one of the artist's few rural scenes – after returning from the journey.

The views of Rome commissioned by Smith, signed and dated 1742, presented a fresh challenge. These five paintings create an imaginary picture of the Eternal City. Canaletto had first stayed in Rome over 20 years before. It is therefore more likely that in these pictures he was drawing on his memories, notions, and ideas about Roman buildings rather than trying to create specific *vedute* of the city. His nephew, Bernardo Bellotto, who stayed in Rome after the Brenta journey, may have inspired Canaletto to rework Roman motifs. The journey along the Brenta Canal and the pictures of Rome mark a turning point in Canaletto's work. From 1742 onwards, his pictures can be broken down into works he painted direct from nature or from actual city locations; and *capricci*, which are generally composed of real buildings and places, but fancifully recombined or relocated. In some cases, however, they may have sprung entirely from the artist's own imagination. Among these we should include several *Landscapes with Ruins* (ills. 64, 65). Those with a triumphal arch in the background vividly recall the Roman Forum.

65 *Landscape with Ruins*, 1740
Oil on canvas, 116 x 166 cm
Palazzo Vecchio, Florence

It is possible that Canaletto completed his first pictures of rural scenes with ruins after he had returned from Rome in 1720 and first became interested in *vedutà* painting. However, Canaletto does not seem to have concentrated on *capricci* of this kind until 1740, after his journey along the Brenta Canal. In 1742, as well as several rural scenes, he painted, signed and dated numerous views of Rome. We can thus date the landscapes with ruins in between the rural scenes and the pictures of Rome.

67 (above) *"Capriccio" of the Grand Canal With an Imaginary Rialto Bridge and Other Buildings*, 1744
Oil on canvas, 60 x 82 cm
Galleria Nazionale, Parma

This *capriccio* with an imaginary Rialto Bridge is linked with the *capricci* Canaletto completed for Joseph Smith. The artist had conceived these pictures as *sopraporta* paintings. Count Francesco Algarotti presumably saw these *sopraporte* and commissioned similar paintings for his palace. According to him, this introduced a new kind of picture, with buildings borrowed from various cities. The structure and layout of this picture are comparable with Canaletto's *capriccio* of an imaginary Rialto Bridge designed by Palladio, another *sopraporta* painting.

66 (opposite) *"Capriccio" of the Grand Canal With an Imaginary Rialto Bridge and Other Buildings* (detail ill. 67), 1744

The imaginary building to the side of the Rialto Bridge, which is also invented, is similar in structure to the Castelangelo in Rome. This may well have inspired it, for Canaletto loved to relocate buildings from other cities to Venice when devising his *sopraporta* paintings. The *vedute ideate* constitute a separate chapter in Canaletto's work. Many of these pictures are difficult to date, though, like this painting, most were completed after 1740.

Joseph Smith also commissioned Canaletto to paint 13 *capricci* for *sopraporte*. In the Baroque and late Baroque, *sopraporta* were painted above a door-lintel in palaces and grand houses – painted figuratively or simply decorated and framed. For this form of wall decoration, however, Canaletto designed not merely imaginary landscapes but also added real architectural motifs (ills. 66, 67). We can recognize, for instance, the Ponte della Pescaria and the Rialto Bridge along with the Fondaco dei Tedeschi and the Palazzo dei Camerlenghi. Canaletto did not select the motifs in his paintings simply because they would make good designs for a *sopraporta*. He also conceived their perspective for a viewer who would be standing beneath the paintings and some distance away. Canaletto included the four horses from the Cathedral of San Marco in one of these capricci (ills. 68, 70), like monuments in a forecourt. Individual figures stand around the equine sculptures, observing them with great interest. Although this scenery is freely invented, it seems completely authentic. Another exceptional *sopraporta* is the *capriccio* the *Basilica di Vicenza and the Ponte di Rialto* (ill. 69).

Canaletto effortlessly places the design created by the architect Palladio – whose design was runner-up behind da Ponte in the competition for the new bridge – between the two banks of the Canal Grande, and presents us the bridge as Palladio might have appeared if it had been built.

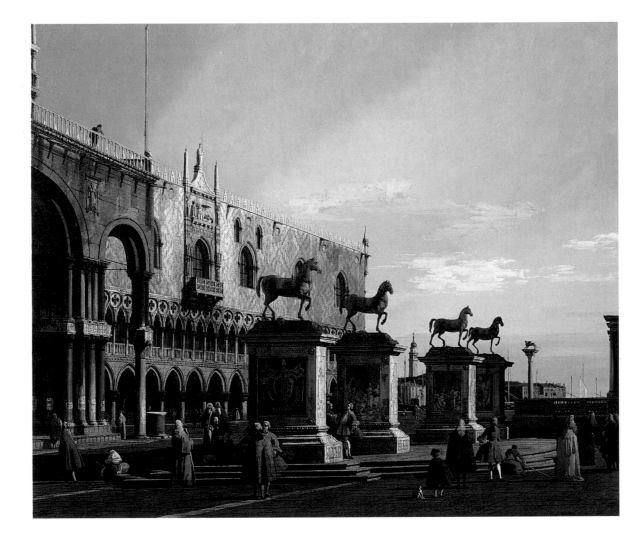

68 (left) *"Capriccio" With the Four Horses From the Cathedral of San Marco*, 1743
Oil on canvas, 108 x 129.5 cm
Windsor Castle, Royal Collection, Windsor

This painting is signed and dated 1743. It is one of the series of *sopraporte* that Canaletto painted on commission from Joseph Smith. The horses are normally positioned on the raised central section of the façade of the cathedral of San Marco. Canaletto has placed them on the forecourt, near the Piazzetta, setting them on high pedestals and with a set of steps beneath, the line of horses forming a strong diagonal. Although this positioning is unusual, it looks quite convincing.

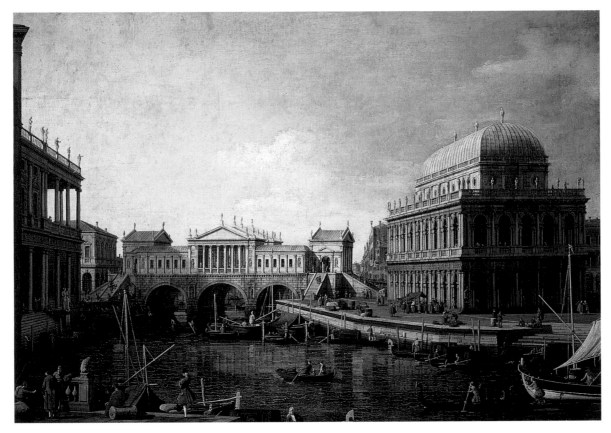

69 (left) *Basilica di Vicenza and the Ponte di Rialto*, 1740–1744
Oil on canvas, 60.5 x 82 cm
Galleria Nazionale, Parma

In this *capriccio*, Canaletto very skillfully inserts the Basilica of Vicenza into a cityscape featuring the Grand Canal. He easily combines this with Palladio's model of the Rialto Bridge. The artist mingles invented material with real objects from other locations, and composes them all in a magnificent *capriccio*. This picture should be seen in the context of the 13 *sopraporta* paintings that Joseph Smith had commissioned. Like many English people at this time, Smith was a great admirer of the architect Palladio, and he also thought highly of Palladio's architectural fantasies. Like the painting *"Capriccio" of the Grand Canal With an Imaginary Rialto Bridge and Other Buildings*, this picture was presumably commissioned by Algarotti.

70 (opposite) *"Capriccio" With the Four Horses from the Cathedral of San Marco* (detail ill. 68), 1743

The figures accentuate the monumental character of these four horses on the forecourt of the cathedral of San Marco. As if surprised, these figures, who seem tiny against the horses on their high pedestals, gaze upwards. One even touches a pedestal in disbelief – as if to reassure himself that the monument really is here.

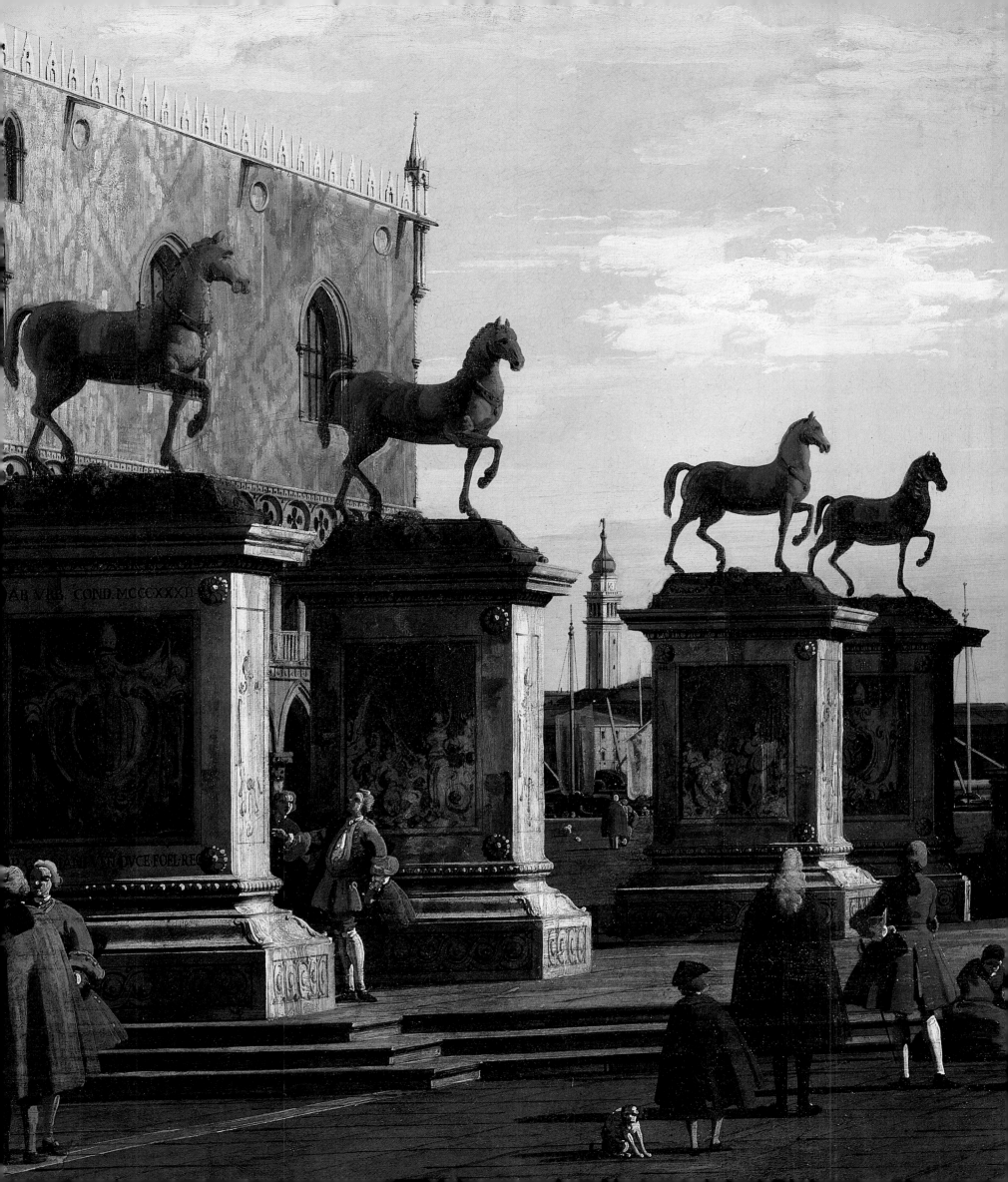

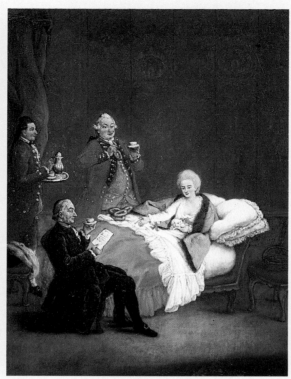

71 (far left) Pietro Longhi
The Sagredo Family, 1734
Oil on canvas, 61 x 50 cm
Biblioteca, Museo della Fondazione Querini Stampalia,
Venice

Pietro Longhi (1702–1785) was the leading genre artist
of 18th-century Venetian life. In this painting he has
portrayed three famous Venetian aristocratic ladies. They
are Cecilia Grimani, widow of Sagredo – on the left-hand
side – and her two daughters, Marina and Catarina.
Marina, who was much courted and admired, was
married to Almorò Alvise Pisani, and allegedly came into
conflict with the Inquisition as a result of her friendship
with Casanova.

In the 18th century, Venice's supremacy as a marine and
trading power came to an end as new sea lanes were
discovered and Britain, France, and the Netherlands
increased their world wide trade links. Moreover, in mid-
century the City Republic suffered pressure from various
factions in the War of the Austrian Succession (1740–1748)
and the Seven Years War (1756–1763). At one time Venice
had been famous for its diplomacy and its prudent policy
of making sound alliances. Moreover, a former Doge's policy
of what Gustav Pauli called "cool level-headedness" had
made Venice great. Now, however, it seemed as if this
strength had ceased to exist. Unsure which side to take, and
too indecisive to make alliances, the city opted for unarmed
neutrality. However, this did not prevent belligerent parties
abroad from marching through sovereign Venetian territory,
and the price of neutrality was political isolation.

Venetian society was not immune to these changes.
Ship building experienced competition from docks in the
Netherlands and Britain, and there was no money to
underwrite the once famous Venetian fleet. The Venetian
seafarers turned into landed gentry, who concentrated their
attention on administering their estates. The aristocracy
withdrew further and further from public life, and became
increasingly private. Twice a year, in spring and autumn,
society went out into the country for *villeggiatura*, summer
holidays. One lived in one's villa on the Terra Firma and spent
one's time at country parties, private theater performances,
at playing cards, and festive banquets. Tables of rich noble
families often kept 30 places free in case unexpected guests
suddenly turned up. A great many people benefited from

this custom – not only family friends and acquaintances, but
also parasites and confidence tricksters who regularly
appeared at meal times and tagged along with the holiday
makers as they moved from villa to villa, and from one
amusement to another. If boredom loomed, the whole
company would make an excursion into the city in ornately
decorated gondolas, and indulge in whatever novelties
presented themselves there. People dressed in the latest
French or Spanish fashions. The women used to wear
whalebone bodices and enormous crinolines, as well as
bejeweled gloves and heavy ear-rings (ill. 71). Fans and lace
were much in evidence, as was make-up. Baths and
washing, however, were frowned upon, though perfumes
and scented water were widely used. Women played an
important role in social life – frequenting casinos and
holding salons. Hot chocolate and coffee were drunk, and
icecream was eaten (ill. 72). Both sexes enjoyed wearing
masks: the mask, which enabled one to change identity at
will, became a kind of trademark for this society, which
turned life into a party.

The economic consequences of developments such as
this became apparent only by degrees. Luxury goods
produced in Venice still enjoyed great prestige. Venetian
wax was exported as far afield as Russia. Sealing wax, soap,
pharmaceutical goods, and optical instruments, as well as
silk brocade, tapestries, and Venetian glass from Murano
were sought-after export articles all over Europe. Moreover,
Venice was a center of the production of fine books.
Important scientific works and editions of classics were
printed there, the volumes being finished by Venetian

72 (above right) Pietro Longhi
The Morning Hot Chocolate, 1774
Oil on canvas, 60 x 47 cm
Museo del Settecento Veneziano di Ca' Rezzonico, Venice

Chocolate had been manufactured in Italy from 1606
onwards. During the 17th century, along with coffee and
tea, and drunk with sugar, it had established itself in
Europe as a stimulant. In the 18th century, it grew to be a
fashionably popular drink. Whilst still lying in bed,
Venetian society ladies used to take chocolate at breakfast-
time as they received their first visitors of the day.

craftsmen in gold and leather until they were de luxe articles. The city continued to live off its accumulated wealth and countless art treasures. Consequently, until Napoleon's invasion at the end of the century, which spelt disaster, the city's decline in political and economic importance was a gradual process.

The city still seemed like one huge unstoppable party (ill. 73). State and church holidays determined the rhythm of daily life for nearly six months of the year. Highlights included the Doge's receptions, the feast of the *sensa* on Ascension Day, when the *Bucintoro* set sail, banquets and regattas, feasts of churches' patron saints, processions and church consecrations, as well as the investiture of an aristocratic young woman or a young patrician's entry into the Grand Council – and, above all else, the Carnival. These apparently endless celebrations, often arranged by the wealthiest families, created the distinctive character of *La Serenissima* and made it the most desirable of destinations for innumerable tourists and travellers seeking to broaden

their education. As well as the theaters, there were many public institutions that served no other purpose than entertainment and distraction. In 1683, the first coffee house was opened in the Procuratie; in 1715, a state-run lottery followed. There were numerous gambling casinos: the Ridotto (the major gambling house) had existed since 1638 (ill. 74).

Although *La Serenissima* was a class-conscious society, the numerous celebrations ensured that social strata were mixed – unlike court circles in the absolutist countries of Europe (ill. 76). Naturally, the population as such had no political influence – neither the *popolo menudo* (soldiers and sailors), nor the *popolani* (80 per cent of the population); neither the members of over one hundred guilds, nor the upper stratum of the middle class (the *cittadini*), officiated as a *segretaria* in government authorities and offices.

Both the internal and external destinies of the city lay exclusively in the hands of the Venetian aristocracy, the

73 Gabriele Bella
The Women's Regatta on the Grand Canal, after 1764
Oil on canvas, 94.5 x 146 cm
Biblioteca, Museo della Fondazione Querini Stampalia, Venice

The Women's Regatta had been in existence from 1502 onwards, and took place at irregular intervals to mark special occasions. This painting by Gabriele Bella (1730–1799), which may seem naïve, has enormous documentary value. It depicts the Regatta held in honor of the Duke of York on 4 June 1764. The Duke, who is in the boat with six oarsmen on the left, was considered a libertine and lady-killer.

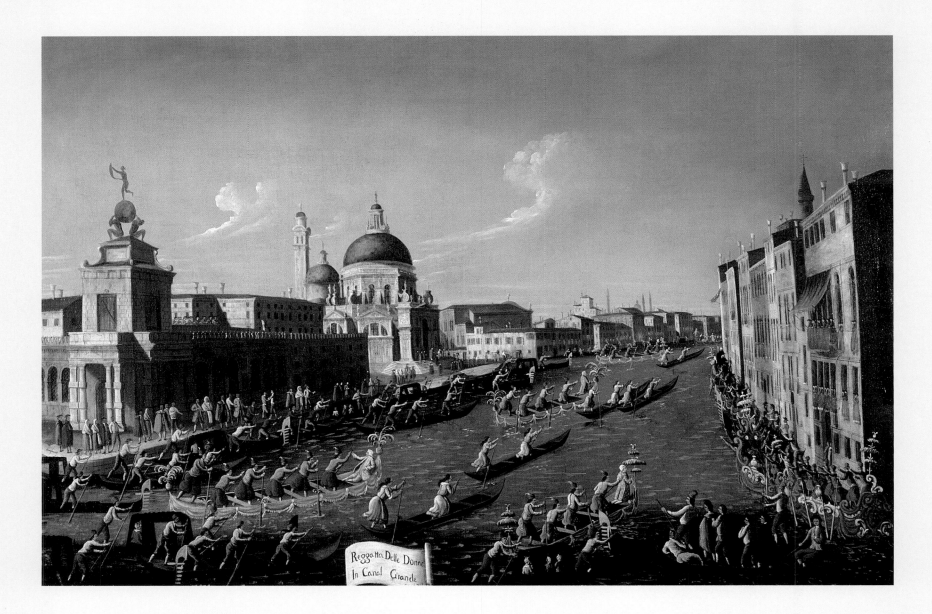

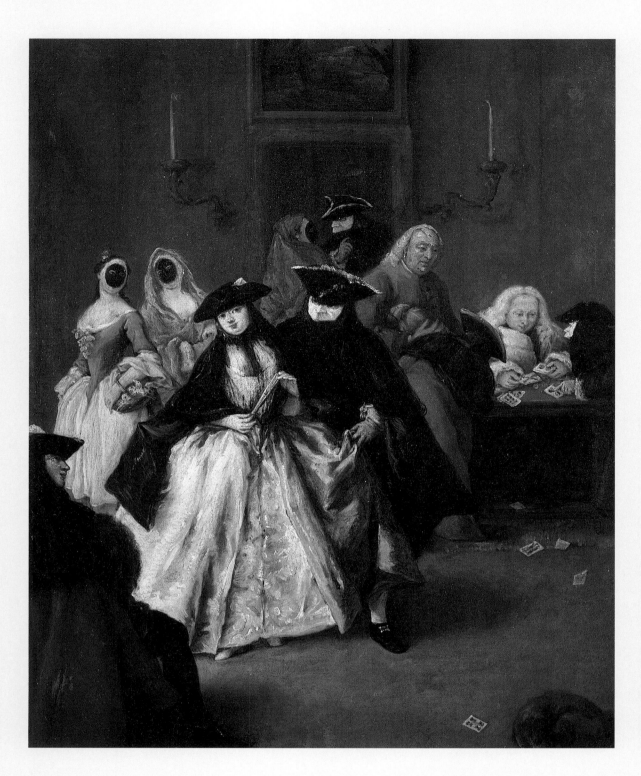

74 (left) Pietro Longhi
Al ridotto
Oil on canvas, 60 x 47 cm
Biblioteca, Museo della Fondazione Querini Stampalia,
Venice

This scene depicts the Ridotto, the gaming house opened
in 1638, in the Palazzo Dandolo San Moisé. In the
foreground, we can see an aristocratic *beau*, wearing a
bautà (the characteristic white mask), and wooing a
"Venus", a courtesan. The two women in black masks are
presumably also aristocrats. In the background on the
right, we can see a gaming table. On this, people are
playing the "pharaoh", so-called after the king in a card
game that was notorious because players very often
cheated while playing it.

nobili, who were organized into a complex system of committees headed by the Ministry of the Doge (ill. 75).

State and Church law existed in Venice: they were separate, and the upper echelons of the Republic only rarely intervened in Church affairs. Even Giacomo Casanova, the quintessential cavalier seducer, was condemned by the Inquisition – not because of his many amorous escapades but because of his contacts with the Freemasons and because he was thought to be spying for France. Moreover, so long as politics was not involved – only business affairs or matters of pleasure – the *signoria* (about 20 members of the Senate) did not shrink from taking dubious decisions. Thus, the death of the Doge, Paolo Renier, on 13 February 1789 was kept secret until 2 March so as not to disturb the Carnival celebrations.

The prosperity that was still in evidence, as well as the apparent stability of life, may explain why social tensions in Venice itself remained relatively insignificant. It was a different story, however, in the Venetian hinterland or in the university city of Padua, where the revolutionary ideas of the Enlightenment were able to take hold at an early stage. Attempts to reform the City Republic's power structure, which was concentrated in the hands of fewer and fewer families, fell foul of general indecision and the panic induced by the threat from outside. In 1797, almost 30 years after Canaletto's death, pressure from Napoleon caused the Senate to dissolve itself. After twelve centuries, Venice finally lost its independence.

Eva J. Heldrich

76 (opposite, below) Joseph Heintz
Piazza San Marco at Carnival Time
Oil on canvas
Galleria Doria Pamphilj, Salone Verde, Rome

Joseph Heintz (1600–1678), a *vedutà* painter of German
extraction, depicted popular entertainments on the Piazza
San Marco. Puppet plays and "commedia dell'arte" shows,
bull-baiting, music, and the recitation of gruesome street
ballads all happen at the same time on the square, painted
red for the occasion, as if it were one large stage in a
theater.

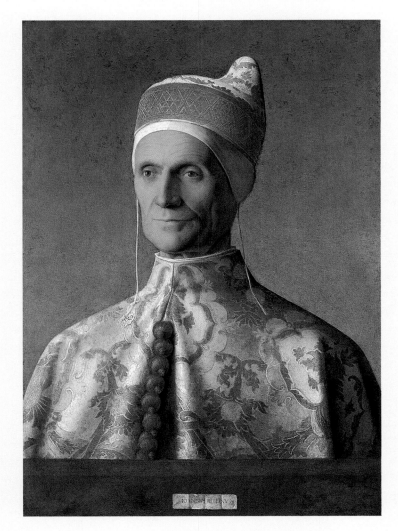

75 (right) Giovanni Bellini
Doge Leonardo Loredan, between 1501 and 1505
Oil on wood, 61.5 x 45 cm
The National Gallery, London

Bellini's masterly portrait depicts the Doge in the traditionally restrained but costly garb of Venetian brocade. The Doge's head covering consisted of a metal coronet encrusted with jewels, which was attached to a brocade cap, and worn above the white under-cap with a pair of ear flaps. The round peak, which fell forwards, was based on the classical Phrygian cap. This head covering worn by the Doge had been customary since the 14th century, and it also features on the City Republic's coat of arms as a symbol of his power.

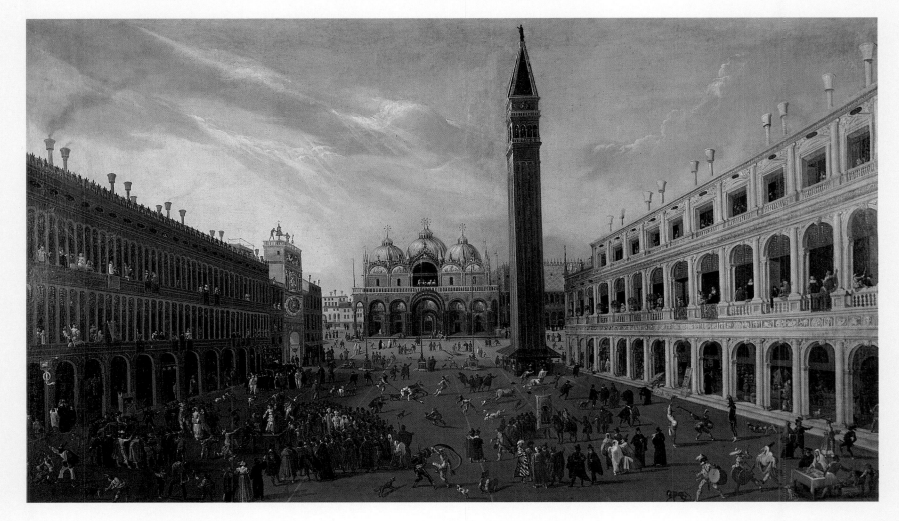

CANALETTO'S YEARS IN ENGLAND

During the 1740s, Canaletto had few patrons who regularly commissioned paintings from him apart from the merchant banker, Joseph Smith. Smith, who was concerned about his protégé's lack of commissions, advised Canaletto to maintain contact with his English patrons and, since they no longer came to Venice because of the Austrian War of Succession, to look them up in their homeland. Accordingly, early in the summer of 1746 Canaletto travelled to London. Smith found himself unable to arrange any further contacts for him, since his friends had already bought the artist's works from him in Venice, so Canaletto once again asked McSwiney for assistance. McSwiney did help, and introduced him to the Duke of Richmond. The latter did not live permanently in England, but was nevertheless a possible patron since several years before McSwiney had sold him the two copperplate engravings of allegorical tombs, on which Canaletto had been collaborating at the time (ill. 17). This approach was successful, and the Duke of Richmond soon became a great admirer of Canaletto's art. The artist was admitted into his London house, which offered an excellent view of the city. Here, Canaletto painted one of his first English pictures, *The Thames and the City of London from Richmond House* (ill. 77). This panorama is reminiscent of the view across the Bacino di San Marco. The paved bank in the foreground, running diagonally to the edge of the picture, makes the view over the river seem even broader and more extensive. The painting is exceptionally brilliant in its color and clarity: it is as if Canaletto had transferred the Venetian climate to the city on the Thames. A short time after this, the Duke commissioned him to paint further views of London – the view towards Whitehall and the Privy Garden, as well as another picture of the Thames and the inner City of London.

Until the Duke's return from a trip, however, other patrons had to be found. Canaletto was lucky enough to discover in the Bohemian, Prince Lobkowitz, a purchaser of two large-scale views of London and the Thames. Prince Lobkowitz was in London on business in the summer of 1746, but still found time to look around for works of art. It is not certain whether he also influenced the artist's choice of subject matter, or whether Canaletto had already painted the pictures in question. Lobkowitz took them back to Prague with him, and they are still in the Lobkowitz Collection in the National Gallery of Prague. *The Thames with St Paul's Cathedral* (ill. 79), seen from the church of St Mary's, and showing Westminster Bridge and Westminster Abbey in the background, offers a fascinating impression of Georgian London. The bridge, which was still in the process of construction at the time, has not yet been given masonry edgings to face the arches, nor its balustrades. Compared with the skies in his Venetian *vedute*, the sky over London is cloudy, and the lighting is also different. The second picture Lobkowitz bought was a picture depicting the ceremonies on Lord Mayor's Day, when the Lord Mayor of London takes his oath of office in Westminster Hall. Both these pictures attest to the Venetian vedutist's skill, even though several contemporaries objected that they were not to be compared with Canaletto's Venetian views.

One contemporary, an antique dealer and engraver called George Vertue, was collecting material for a history of English art at the time. To him we also owe a great deal of information about conditions of life at that period. He noted in 1746 that "Canaletti", the vedutist who was well known in England, and whose pictures many English aristocrats owned, had arrived in London. Vertue was especially interested in the construction of Westminster Bridge: after lengthy public discussion, the city authorities had decided to build a second bridge over the Thames. Vertue documented every stage of the bridge building, which was begun from the middle of the river. We still have a drawing and a painting by Canaletto which show the bridge with five of its arches, and which indicate the direction of the building work – sideways from the Thames bank at Westminster Abbey towards the center of the river. Canaletto, however, clearly seems to have "corrected" the real construction in favor of an idealized composition which struck him as more appealing. During 1746, he completed several copperplate engravings of the bridge. His main patrons at this period were those publishers of engravings and prints who always needed good city views and who were presumably very interested in a documentary record of the building of the bridge.

78 (left) *London, Seen Through an Arch of Westminster Bridge*, ca. 1747
Oil on canvas, 57 x 95 cm
Collection of the Duke of Northumberland, London

Throughout his time in England, Canaletto remained interested in the building of new Westminster Bridge. Because of its technical problems, the construction of this bridge had been a public talking point for several years. Sir Hugh Smithson, later the Duke of Northumberland, was one of the bridge's main backers. Canaletto completed a painting for him with a view of London in which the viewer is standing immediately beneath one of its arches, whose wooden structure Canaletto records in detail.

79 (below) *The Thames with St. Paul's Cathedral*, 1746
Oil on canvas, 118 x 238 cm
Roudnice Lobkowitz Collection, Nelahozeves Castle, Prague

Canaletto painted this view of London right at the start of his time in England. We cannot be certain whether he completed it speculatively or on commission from Prince Lobkowitz. It is certain, however, that this picture soon came into the possession of the Bohemian prince, once he had returned to his homeland after his business trip. Canaletto had painted it as a broad vista of the city, and in its way it is very different from his Venetian *vedute*.

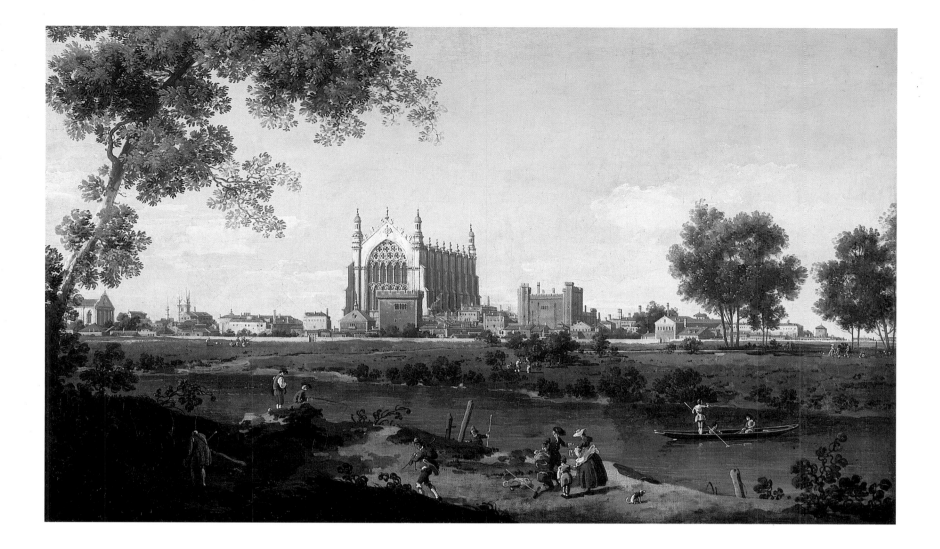

In one of the engravings of the Lord Mayor's Day celebrations, held in October 1746, Canaletto depicted the bridge in a finished state. According to Vertue's information, however, one arch and the balustrades were still missing at this stage. Canaletto also provided the bridge with statues of river gods. Accordingly, John Bradley, the publisher of the engravings, delayed publication for six months; the bridge, however, was not completed by this time. One of the piers had not been anchored properly, which impaired the stability of the whole structure. Two years later, the authorities decided to hollow out one of the bridge arches. Canaletto completed a drawing of that, too.

Vertue went on to write that Canaletto was one of the few Italians who had found his way to England in the thick of war, in order to continue working. Vertue was at pains to point out that Canaletto was so well known by art dealers that he could easily earn money in England, too. How successful the artist's period in England really was in commercial terms is hard to say, however. His reputation as a vedutist and his contacts through McSwiney must have helped him enormously. Nevertheless, between 1746 and 1747 Canaletto appears to have worked mainly for publishers of engravings and printed graphics, which did not pay as well as large-scale paintings. In his search for patrons, Canaletto also met Sir Hugh Smithson, later the Duke of Northumberland, whose wife's inheritance had

brought him a considerable fortune. As one of the owners of the new Westminster Bridge, he was presumably very interested in Canaletto's pictures of it. In 1747 he bought a painting showing a view of *London, Seen Through an Arch of Westminster Bridge* (ill. 78). The wooden bridge construction forms a semi-circular frame around the banks of the Thames, and Westminster Abbey. This is one of Canaletto's bridge pictures that shows he is more interested in the unusual viewpoint and the viewer's perspective underneath the bridge than in depicting a view of London.

John Brindley presumably had an engraving made after the painting. He then sold it to Sir Hugh Smithson, who in turn commissioned a second picture, a view of Windsor Castle. Canaletto probably completed the painting *The Chapel of Eton College* (ill. 80) in the same year. With its colossal Gothic architecture and immense proportions the Chapel is a focal point that seems so massive it is almost unreal or supernatural. However, Canaletto has painted the rural scenery in the foreground on the other bank of the Thames in a totally different way. Here we again see the artist's penchant for bringing a picture to life by introducing numerous small figures in everyday situations.

From 1749 onwards, Canaletto was able to count several English aristocrats among his patrons. For the Duke of Beaufort, for instance, he created views of Badminton, and for Lord Brooke he painted Warwick

80 *The Chapel of Eton College*, 1747
Oil on canvas, 61.5 x 107.5 cm
The National Gallery, London

During his visit to Windsor in 1747, Canaletto could scarcely ignore the Chapel of Eton College on the other side of the river. Nevertheless, he conceived his picture as a rather mysterious *capriccio*. He made the Chapel itself immensely large, so that it towers over the surrounding houses, chapel and palace. On the other hand, the rural scene in the foreground on the far side of the river, which depicts a family making a country excursion, appears totally realistic.

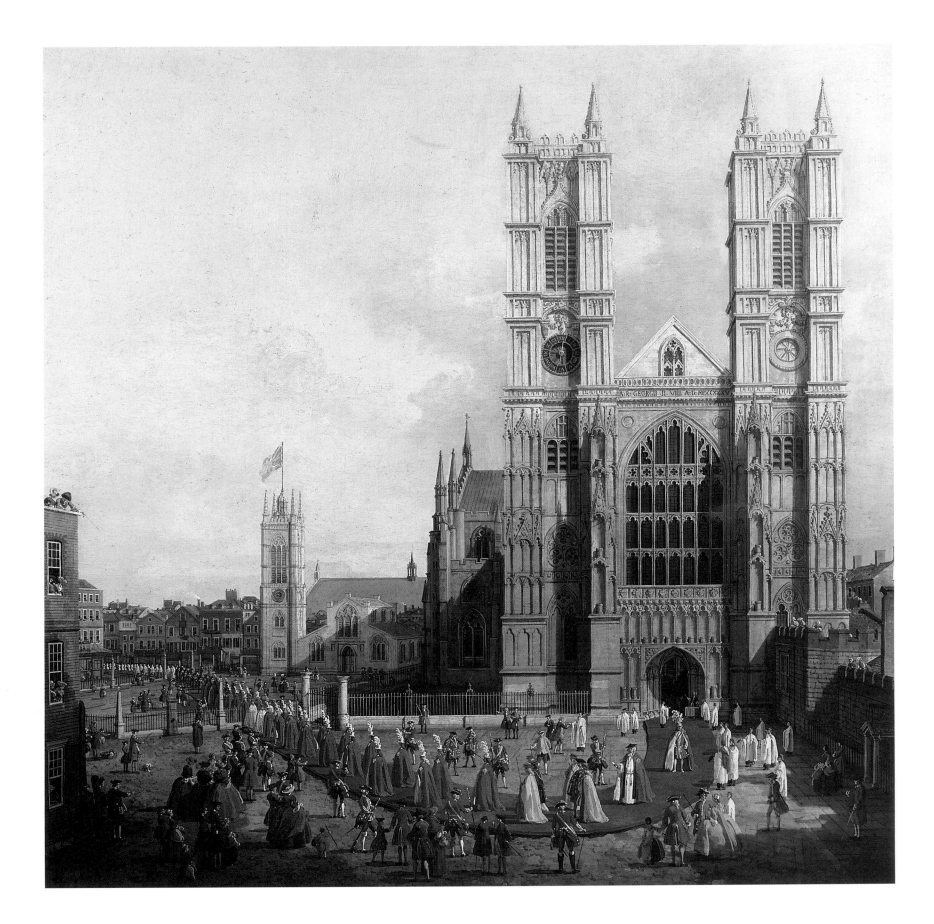

81 *Procession of Knights of the Bath*, 1749
Oil on canvas, 99 x 101.5 cm
Westminster Abbey, Westminster Abbey Museum,
London

Shortly before Canaletto's first journey back home to
Venice, the Dean of Westminster commissioned him to
depict the ceremonial procession of the Knights of the
Order of the Bath. The Gothic façade of the Abbey,

painted with great clarity and subtlety, stands in the
foreground. The nave and towers cast their broad
shadows towards the chapter house. The picture's subject
is the procession of the Knights, who are just emerging in
solemn procession from the Abbey. The painting gives us
a fascinating insight into Georgian London.

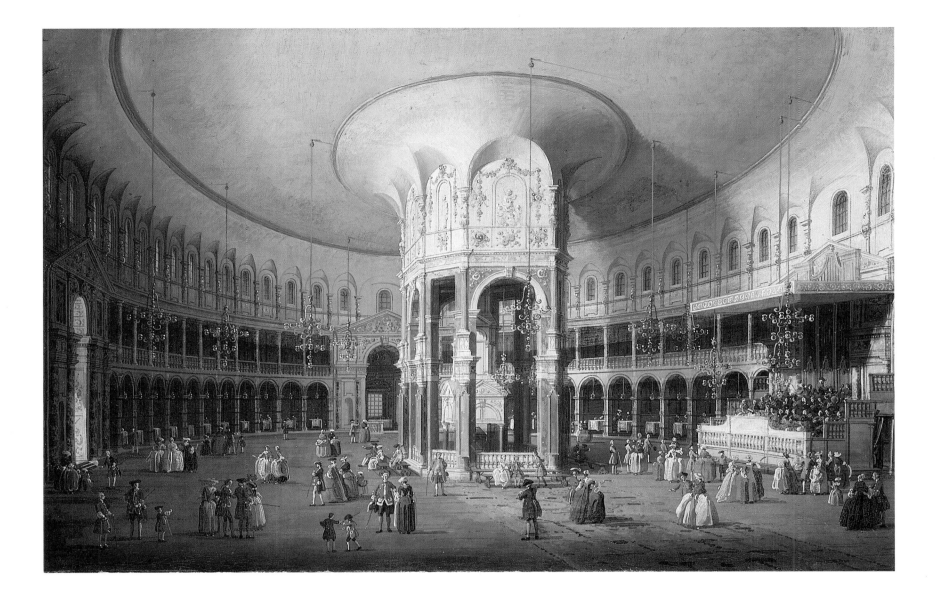

Castle. This castle, which Canaletto depicted several times, later became the main seat of Lord Brooke, who was distantly related to Sir Hugh Smithson.

Vertue tell us that he was not impressed by Canaletto's pictures. His English *vedute*, Vertue continues, lacked the quality of those he had painted in Venice. Vertue even suspected that Canaletto had not himself painted these pictures but left them to some unknown assistant from Venice. He later believed that Canaletto's nephew, Bernardo Bellotto, who had already produced art under his uncle's name, had created these views. Before long, so many rumors of this kind were circulating that Canaletto finally felt obliged to insert a notice in the newspaper the *Daily Advertiser* inviting art lovers to come to his studio in Silver Street and see his painting of St James's Park for themselves. In fact, Bellotto never visited London. He stayed in Venice until 1747, then travelled directly to Dresden, where he spent a long time working successfully for the Elector of Saxony. This incident, however, makes it quite clear that Canaletto's London paintings were not as convincing as his Venetian *vedute*.

In 1749, the Dean of Westminster Abbey commissioned Canaletto to immortalize the procession of Knights of the Bath (ill. 81). Then, in May, 1750, the Guild of Goldsmiths asked him to document the formal attestation ceremony of Master Goldsmiths. However, for reasons that are not clear, Canaletto travelled back to Venice for a while shortly after. Perhaps he intended to invest the money he had earned in England; possibly he merely wished to try his fortune in his native city once again. In Venice he bought a house in the Zattere district, which he was due to occupy and use as a studio once he had finally returned from England in 1756. He probably took several views of the Thames with him, all of which found their way to Smith's collection. After this collection had been sold to George III, however, the pictures landed back in England. Around the middle of 1751, Canaletto returned to London and moved back into his rented apartment in Silver Street. He inserted another notice in the newspaper, informing any interested members of the public that several views of London he had completed – principally a view of Chelsea College with Ranelagh House and the Thames – could be inspected. Meanwhile, Samuel Scott (1702 – 1772), an artist well known for painting cityscapes, did not offer Canaletto much competition. Scott, a self-taught artist, initially concentrated on marine paintings. During the building of Westminster Bridge, however, he found that he enjoyed depicting it, and from then on

82 *The Rotunda of Ranelagh House*, 1754
Oil on canvas, 46 x 75.5 cm
The National Gallery, London

Very soon after he had returned to London, Canaletto began a view, without any commission, of Ranelagh House. He placed an advertisement in a newspaper to say that the painting was on public exhibition and available to be seen in his studio. This interior of the Rotunda is one of six pictures that were painted for Thomas Hollis. Canaletto rarely painted interiors.

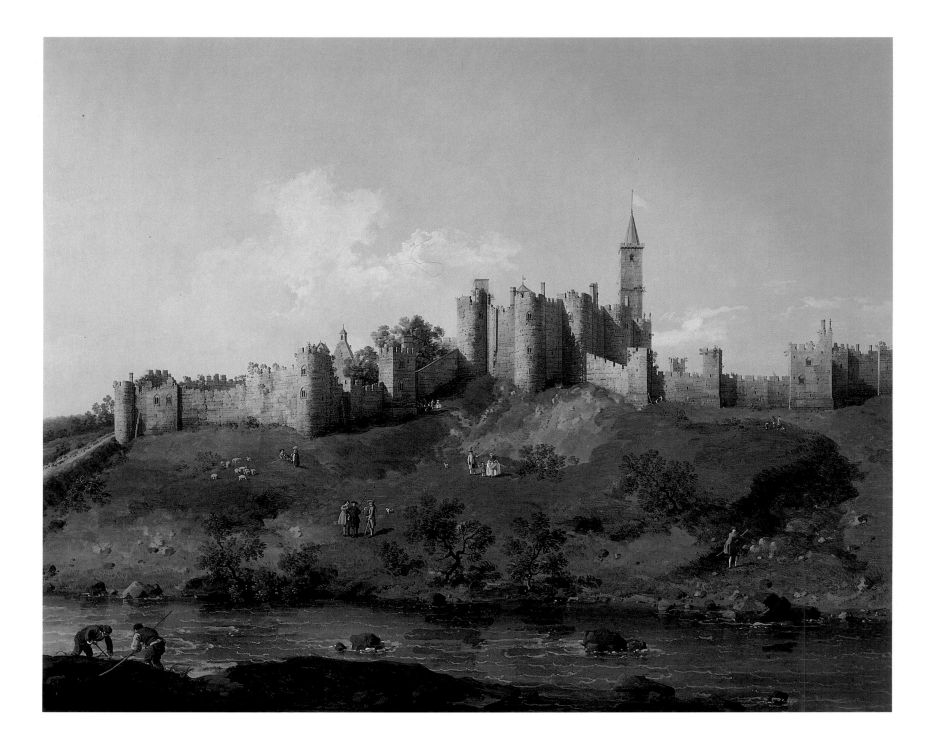

83 *Alnwick Castle*, 1746
Oil on canvas, 113.5 x 139.5 cm
Collection of the Duke of Northumberland, London

In England, Canaletto worked for several aristocratic patrons. Among his favorite subjects were the countryseats of the various patrons commissioning the painting. *Alnwick Castle* was the largest and most important countryseat of the Duke of Northumberland, who would always consider Canaletto for new commissions until the artist went back to Venice in 1756. Some of these pictures served to decorate the dining room.

created more views of London and the Thames. His early works look a little clumsy and often stiffly composed. In time, however, he overcame these problems. So much so, that he became a skilled *vedutà* painter, and in later years he was even known as the "English Canaletto".

During the second phase of his stay in England, Canaletto again had to search out patrons. Between commissions, he used to complete paintings speculatively, hoping to sell them later. One such painting was the interior view, dated 1754, *The Rotunda of Ranelagh House* (ill. 82), which is now in the National Gallery, London. Out of Canaletto's former patrons, only two stayed loyal to him. Lord Brooke commissioned another view of Warwick Castle in 1752, and the Duke of

Northumberland, who had commissioned works from him regularly from 1747 onwards, asked for several views of his country estates, beginning in 1752. His largest residence, Alnwick Castle (ill. 83) was situated in the country, several days' journey from London. By 1752, Canaletto had completed the view of *Northumberland House* (ill. 84).

Whether Canaletto again returned to Venice in 1753 – as the Venetian chronicler Pietro Gradenigo maintains – is still a matter of conjecture. At that time, Thomas Hollis, an eccentric citizen of London who was a friend of Joseph Smith's, commissioned Canaletto to execute six paintings, which were to depict views of Rome as well as London and its neighborhood. Without any doubt, the finest of these pictures is his view of the old Walton

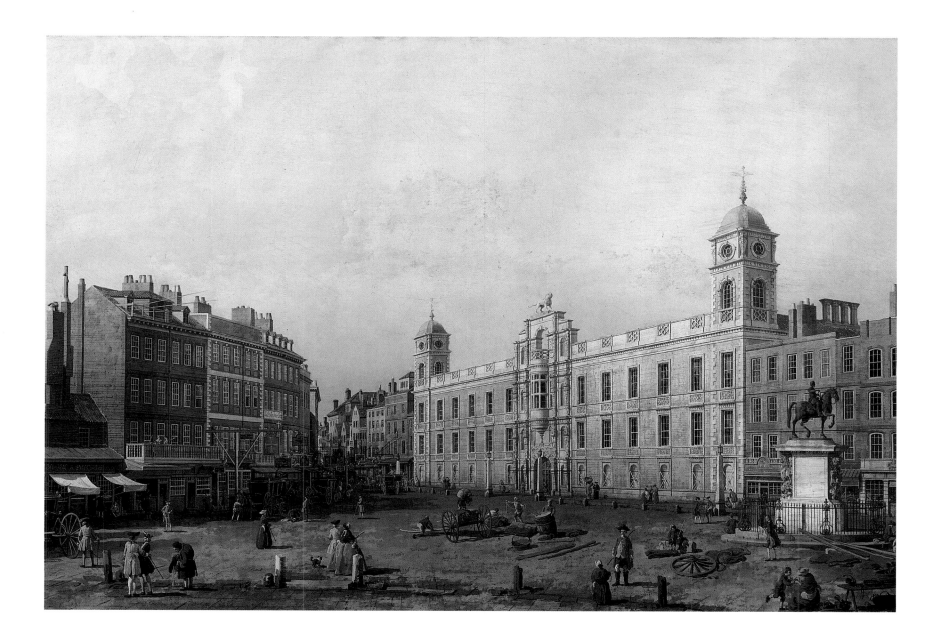

Bridge, whose elaborate wooden structure rises strikingly out of the rural scenery around it. Samuel Dicker, a Member of Parliament, was so impressed by this picture that he commissioned Canaletto to complete another painting of the bridge, which he had helped to finance, though his view depicts the Walton Bridge made of stone, which makes it lose much of the charm of the earlier picture. Thomas Hollis also purchased another view of Westminster Bridge. This painting is structured very much like the one completed in 1750. This time, however, Canaletto concentrated on the repair work to the bridge arch.

At some point between 1755 and 1756 the artist, now almost 60 years old, returned to Venice for good. The fruit of his years in England was a series of superb views

of London and its neighborhood, which gives us a vivid impression of the life and the architecture of the Georgian age. Nevertheless, his English works are relatively few: we know of some 40 paintings with English subjects.

84 *Northumberland House*, 1752
Oil on canvas, 84 x 137 cm
Collection of the Duke of Northumberland, London

On becoming the first Duke of Northumberland in 1752, Sir Hugh Smithson also inherited the Northumberland family seat in Charing Cross, London. He had the house renovated and commissioned Canaletto, who had often painted pictures for him, to depict the house in its renovated state. The Duke of Northumberland was one of Canaletto's most important patrons during his years in England. He also remained a staunch ally in the second phase of his time in England, from 1751.

Since the Middle Ages, the stratum of society interested in buying art had changed radically. From the Renaissance onwards, the middle classes had grown increasingly influential in the art market. Supply had tended to follow their tastes and interests. Moreover, artists had adapted more and more to the economic opportunities they presented. Collections were springing up everywhere. Agents, representing potential purchasers, wandered through artists' studios. People travelling to broaden their education mainly wanted to have their portraits painted in front of the classic sites. Many artists worked exclusively to satisfy these needs. Genre paintings, portraits, and *vedute* all developed into artistic genres in great demand. As early as the 17th century, especially in the Netherlands, the influence of a predominantly middle-class culture totally transformed both purchasers and the kind of art they helped to create. This transformation shifted to Italy in the 18th century.

Canaletto sold his *vedute* primarily to English buyers. From around 1600 onwards, once Puritan views carried less weight, a new ideal of education had been developing. It was characterized by a strong desire to travel – on the part of both the aristocracy and the upper middle classes. In 1713, the Peace of Utrecht brought the War of the Austro-Spanish Succession to an end. Sir Robert Walpole played a key role in peace negotiations. The outcome offered new opportunities in trade, and was therefore much welcomed

by middle-class and aristocratic English entrepreneurs who were struggling for prosperity and higher social status. Supported by the spread of neo-Platonism and its ideal of education as embodied at the University of Cambridge, which based its teaching closely on ancient Rome and the classical world in general, a universal interest in ancient art began to take hold in England. Good taste and *virtù* (fine discrimination) were now regarded as moral duties, giving rise to what became known as the "gentleman virtuoso".

For any person of distinction, it was imperative to journey to the classical sites of Italy. This educational journey had another function: to separate the different social strata from one another, since only the wealthy could afford to make the so-called Grand Tour (ill. 85). The principle destination was Rome, but Venice and Florence were *de rigueur* as staging posts. In Rome, it was classical art that commanded most interest. In Venice, however, the "classics" of regional painting, including Titian (1476/77–1576), Tintoretto (1518–1594), Veronese (1528–1588) and Bassano (1517/18–1592) occupied visitors most. At the same time, Venice was a center of pleasure, and the numerous visitors also enjoyed the energetic pace of the many traditional festivities. The most popular souvenir for visitors to Venice was a view of the city, a *vedutà*.

The great art patrons in 18th-century Venice itself were also English. Most of them had already been active in business there for several years – like the merchant banker,

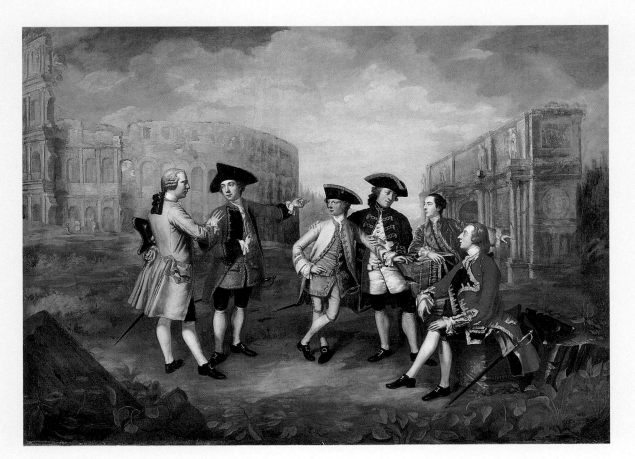

85 James Russel
British Connoisseurs in Rome, ca. 1750
Oil on canvas, 94.5 x 134.5 cm
Paul Mellon Collection, Yale Center for British Art, New Haven

In England at around the middle of the 17th century, mainly because of increasing trade, interest in foreign countries and people grew markedly. Travel concerned with education, study and pleasure all became more popular – a factor reflected in the varied travel literature of the period. Travellers also became more interested in souvenirs of their journeys, which included 18th-century city views – *vedute* – as a picture-genre in its own right.

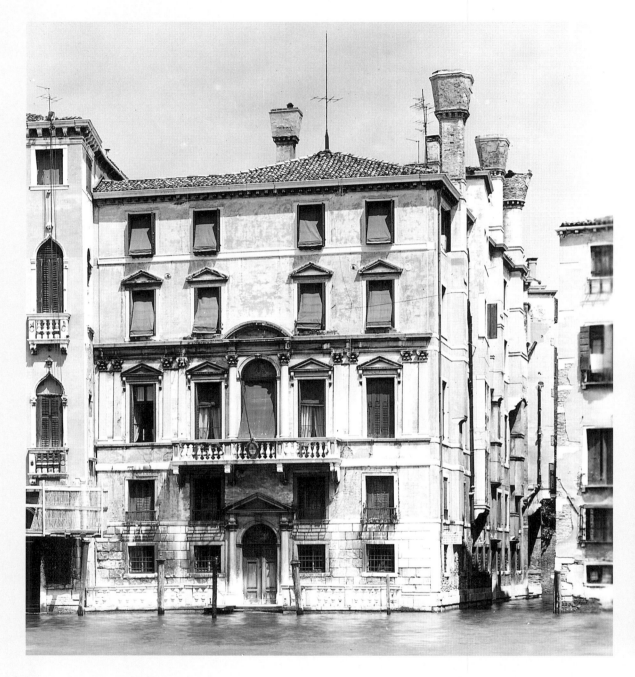

86 (left) The Palazzo Mangilli-Valmarana
Venice

Joseph Smith's collection was on display in this palazzo.
At this period, it was usual to hang paintings close
together right up to the ceiling. Major collectors, like
Marshal von der Schulenburg, owned well over 100
paintings.

87 (above) Jacopo Amigoni
Portrait of Sigismund Streit Aged 52, 1739
Oil on canvas, 96 x 79 cm
Staatliche Museen zu Berlin – Preußischer Kulturbesitz,
Gemäldegalerie, on loan from the Streit Stiftung, Berlin

From 1739 to 1747, Jacopo Amigoni (1682–1752), the
Italian painter of frescoes, altarpieces and portraits,
worked for Sigismund Streit, the German collector. Streit
had the following to say about his portrait: "My *ritratto*
by the artist, Amigoni, when I was 52 years old. The face
is a little too short and a touch too friendly."

Joseph Smith. Owen McSwiney, an Irishman, had gone bankrupt in England and wanted to try his luck again in this city of theaters. There were also a number of Germans, such as Sigismund Streit, the merchant (ill. 87). High-ranking military men, like Marshal von der Schulenburg, were in Venice to prepare themselves to fight the Turks. Personalities like Carl Gustav Tessin, the Swedish architect, were there to extend their knowledge of art. The circle of people who could afford to buy art regularly, and who showed an interest in building up a collection, came for the most part from the aristocracy and the wealthy middle classes. Their most frequent advisers in art purchases were artists: Visentini, for example, advised Joseph Smith, and Piazzetta advised Marshal von der Schulenburg.

Many figures in the art market were not buying for their own collections but acting as agents for various patrons. Joseph Smith established himself as a major art dealer by presenting Canaletto's paintings in his palace on the Grand Canal in exhibitions open to the public (ill. 86). His album of copperplate engravings after paintings by Canaletto, the "Prospectus", was also primarily aimed at promoting his art internationally and so helping to sell it. Copperplate engravings were an effective means of advertising art since they could travel as far as England without any transportation problems. There, people who stayed at home could decorate their stately homes and castles with the views and *vedute* of Venice they could either commission or purchased ready painted.

THE ARTIST'S LAST YEARS IN VENICE

This picture is one of a series of *vedute* for Sigismund Streit, the German merchant. All the paintings Canaletto completed for Streit are broad and large-scale. The subjects he depicted are unique to Canaletto's work. Moreover, these are the artist's last documented *vedute*. In the foreground of this painting, on the left bank of the canal, we can see the Palazzo Foscari, a 15th-century building in which Streit lived. The fifth building to the rear of this is the Palazzo Mangilli-Valmarana, with its classical façade, the residence of Joseph Smith, the art dealer and merchant. The Fondaco dei Tedeschi, the business headquarters of German merchants, is situated further down the canal.

In the last years of his life Canaletto devoted more of his time to *vedute ideate*. These fantasy landscapes, also known as *capricci*, were made up of several different architectural components. Some of the buildings depicted are real, others invented. As we have already seen, at first these consisted of landscapes with ruins, imaginary cityscapes like the view towards the Prato della Valle in Padua, or an invented view of Venice. Other well-known *capricci* by Canaletto are the 13 *supraporta* pictures commissioned by Joseph Smith. Presumably, Canaletto had enjoyed success with his *capricci* as early as 1740, success which allowed him to take more liberties with their execution. At this period, the artist also completed several landscapes that are hard to classify topographically. They evoke landscapes and locations in the Venetian hinterland, though without any specific, recognizable buildings. Despite all this, the main focus of Canaletto's work – undoubtedly for financial reasons and the need to fulfill existing commissions – remained *vedutà* painting.

The year 1756, when Canaletto returned from England, marked the beginning of the Seven Years War, which was soon to involve half of Europe. England, on the other hand, which was neutral in Europe, waged a colonial war against the French on sea and land for supremacy in North America. These two wars, both of which continued until 1763, had a very detrimental effect on tourism and on commissions for painters in Venice. It was dangerous to travel in Europe, and the wars consumed huge sums of money. Even though we know very little about Canaletto's exact situation, we can take it that lack of commissions made him turn increasingly to his *capricci*. Of these, more than 50 paintings and over 100 drawings have survived, and they can quite possibly throw some light on Canaletto's psychic state and moods. Several of the numerous landscapes with ruins seem a little lightweight. Others, however – and these include the allegorical paintings of tombs – have a seriousness that may indicate inner tensions and anxieties. All these assumptions are, however, sheer speculation.

What is beyond doubt is that Canaletto's situation was far from straightforward. Joseph Smith was the only patron to remain as dependable as ever. Not long after

the death of his wife, Catherine Tofts, in 1755, Smith, though nearing 80 now, married again. His second wife, Elizabeth Murray, was the sister of Joseph Murray, the English governor. In 1760, Smith planned to give up his business, see other parts of Italy, then return to England for good. Contemporaries maintained that he had spent all his fortune and suspected that he was about to go bankrupt. In 1762, financial pressures forced him to sell most of his collection to the English king, George III. Yet, despite these financial problems, Smith continued to support Canaletto. As ever, he was able to inspire the artist to create new, potentially successful works. Smith himself, however, commissioned very little else by that time. One of the last pictures intended for him depicts the interior of the church of San Marco. Canaletto approached the view through the nave to the high altar as he would the view of a square. He has depicted the space inside the church as something open and broad. Canaletto reflects all the detail of the mosaics and murals in the interior. This final commission marked the end of almost 30 years of collaboration between the Venetian artist and his English art dealer. In 1766, Smith – now almost 90 – briefly assumed the office of British Consul once again. He died in 1770 (two years after Canaletto), and, as a Protestant, was buried on the Lido, where his grave can still be visited.

It is difficult to assess and classify Canaletto's late works. From a technical point of view, he had reached his artistic peak back in the 1740s. This makes it difficult to date any picture he completed before or after his period in England. However, some individually dated engravings or drawings, as well as documented topographical circumstances, allow us to draw some conclusions about the chronology of his work. Even in Canaletto's later years, the quality of his work remained uneven. As well as works which one is inclined to regard as later creations because of their technical weaknesses, there are some paintings and drawings – of the Piazza San Marco, for instance – whose composition and light continue to confirm the enduring skill of an artist now over 60 years of age.

One of the last patrons Canaletto had was the German merchant, Sigismund Streit, who had emigrated to Venice as a young man in 1709, and, after several

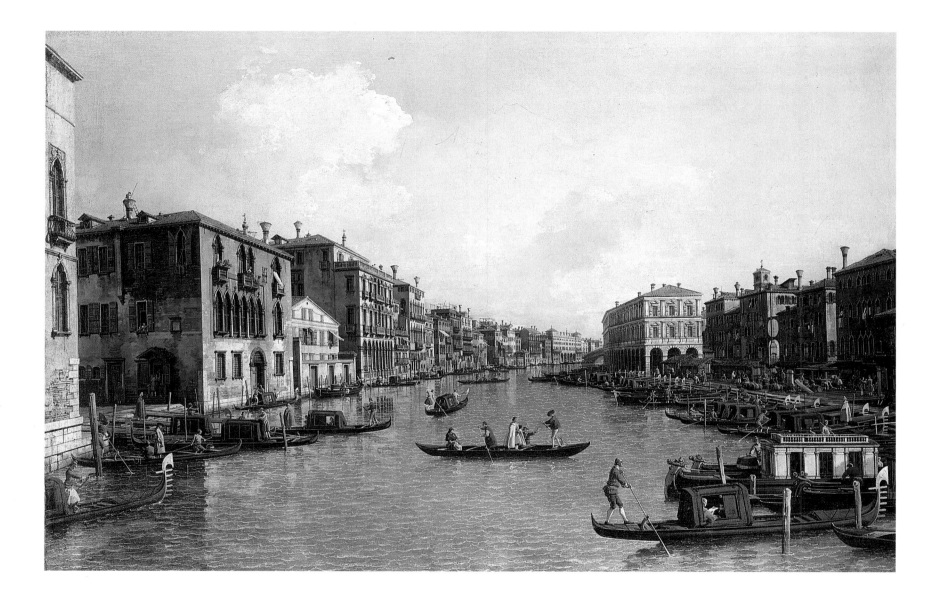

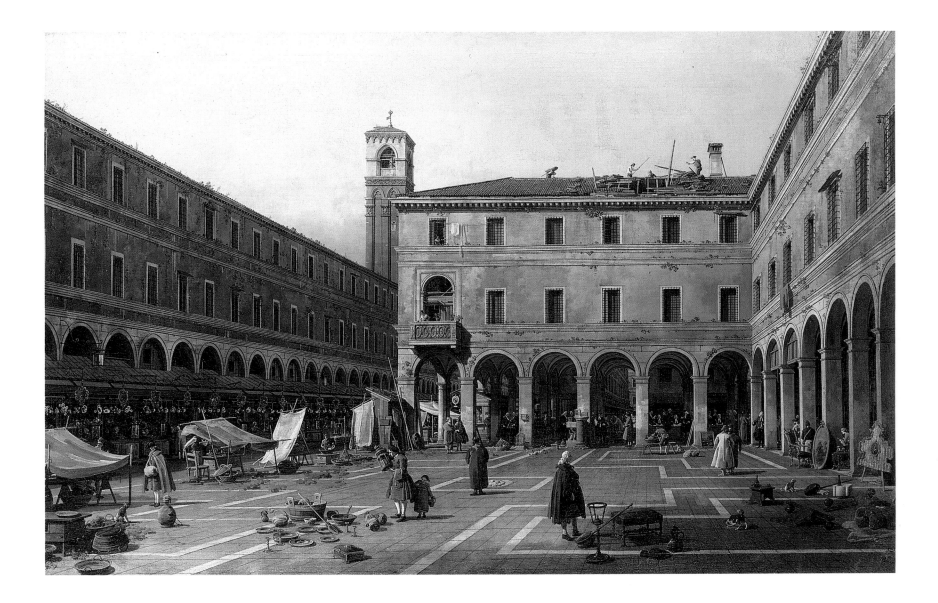

89 *Campo di Rialto*, ca. 1756
Oil on canvas, 119 x 186 cm
Staatliche Museen zu Berlin – Preußischer Kulturbesitz,
Gemäldegalerie, on loan from the Streit Stiftung, Berlin

Sigismund Streit commissioned this view of the *Campo di Rialto*. Streit intended to donate his own collection to his former grammar school in Berlin. In 1763, he gave the school headmaster the first catalogue of his picture collection. This *vedutà* captures the bustling activity in Venice's central market. On the left-hand side, we can see the *Ruga degli Orefici*, the street in which the goldsmiths of Venice have their shops. The black-clad bank officials of the "Banco Giro" are at work under the arcades at the end of the square. Official news about the Republic used to be read out from the small, low plinth by the Porticato del Banco Giro.

decades of business dealings there, had achieved considerable prosperity. He retired in 1750 without any heirs. He therefore decided to bequeath the art collection he had assembled in his old age to his former school in Berlin, the Gymnasium zum Grauen Kloster (The Gray Monastery Grammar School), so that a museum, bearing his name, could be opened there. Among his pictures were *vedute* by Canaletto. One view, probably completed in 1758, depicts the *Grand Canal From the Campo Santa Sofia Towards the Rialto Bridge* (ill. 88). In the foreground, we can see the Palazzo Foscari, which was, for a time, where Streit used to live. A view of the *Campo di Rialto* (ill. 89) was also found in Streit's collection. Moreover, the paintings he had commissioned included two night-time scenes dating from 1758. They depict the celebrations held on the eve of the feast of the patron saints of the churches of San Pietro di Castello and Santa Maria (ill. 90). These night scenes – the only ones among Canaletto's works – are so unusual for the artist that we must assume that they were specified by the patron. Moreover, neither subject is painted very often, though there is one well-known depiction of the Feast of Santa Maria by Gaspare Diziani (1687–1767), a picture that must have been familiar both to Streit and Canaletto. In any event, Streit was not

happy with the final outcome. He was especially disappointed that the festivities on the water – the church is situated by the sea, in the western corner of Venice – were not depicted in enough detail in Canaletto's painting. In a letter to the headmaster of the Gymnasium zum Grauen Kloster, he complained: "In the painting of the Vigilia di Santa Maria all is not expressed in entirely as lively a manner as might be hoped. Namely, on the side facing the sea. For the painter has thought it fitting to cling so firm to the landward side, that he has given himself the more labor. Notwithstanding this, on the sea itself there is not sufficient intelligence given of what the artist has beheld." The upshot was that Streit gave Canaletto no further commissions.

In 1760, in one of his last pictures of the Piazza San Marco, Canaletto extended the angle of vision so far that it almost amounts to a *capriccio* (ill. 91). This is not his first picture of this square to be viewed from a wide angle, but in this work he seems to have experimented more than usual with the technique of intersecting viewpoints. The result is something approaching a semi-circular panorama, which would be hard to photograph even with a wide-angle lens. Canaletto was not the first artist to attempt panoramic views of this breadth. As

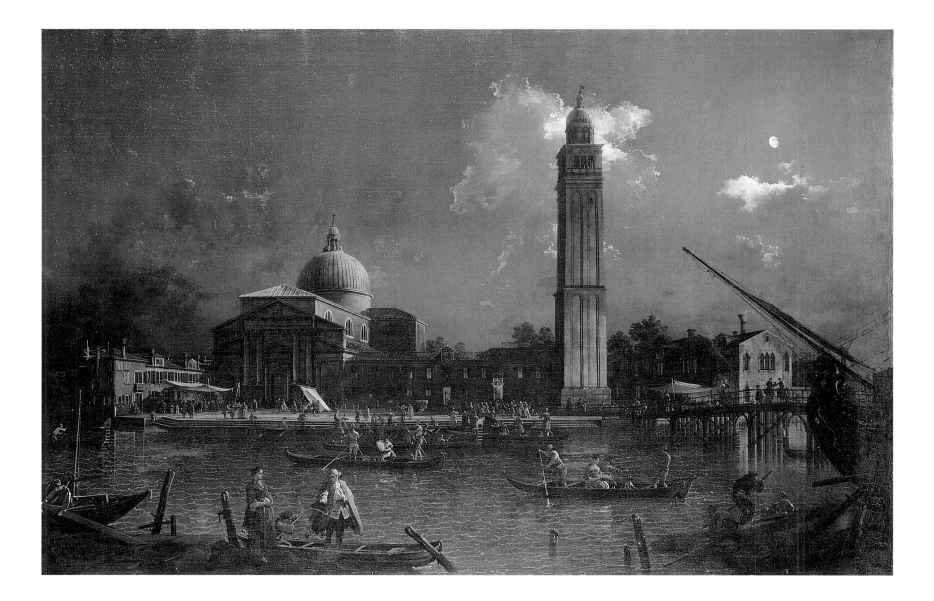

early as 1703, Luca Carlevaris had produced impressive examples of this kind of game with perspective in his engravings. Moreover, city panoramas – conceived in circular terms and meant to encompass the whole of a cityscape – already existed by that stage. The scrolls of paper or parchment depicting these cityscapes were rather long, and generally needed to be rolled up when stored. By means of his technique – different but intersecting viewpoints – Canaletto achieved a similar effect. His view of the Piazza San Marco appears real and natural, even though in actual fact no eye could take it all in at once.

All his life Canaletto remained active as an independent artist. Even though his father, Bernardo Canal, and his nephew, Bernardo Bellotto, occasionally collaborated with him, it is unlikely that he trained other pupils or was in charge of a studio. From the late 17th century onwards, artists were no longer associated with a craft guild. As self-employed artists, they subsequently banded together into academies. After lengthy public discussion, the Council of the City Republic of Venice permitted only the painters' guild, the Collegio dei Pittori to exist. From the early 18th century onwards, this body had served as an organizational focus for Venetian artists, with a structure similar to that of a

guild. Its headquarters were in an old grain warehouse, the Fonteghetto della Farina, which Canaletto had depicted so superbly in one of his early paintings. He had frequently applied for membership of the Collegio, but always been refused. By the time the Venetian Academy of Fine Arts was founded in 1750, Canaletto was living in England, and was therefore unable to apply for membership. The Academy was officially recognized in 1754, but the Collegio in the Fonteghetto continued to exist parallel to it. At this time, the Academy was not very active; members, who were appointed by the City Council, were responsible for decorating the Piazza San Marco for the Ascension Day festivities. In 1763, Canaletto applied for membership, but was again rejected. In his stead, Francesco Zuccarelli (1702–1788), who later became President of the Academy, was accepted. It is not clear why the Academy refused the illustrious *vedutà* artist membership, though it was probably connected with the genre's lack of prestige. Even though *vedute* were extremely popular, compared with other pictorial genres they were considered inferior. When, in the same year, another place in the Academy became free, Canaletto ventured to reapply, this time successfully. In 1756, for his Academy picture, Canaletto, advisedly, abandoned

90 *Night-time Celebration Outside the Church of San Pietro di Castello (La Vigilia di San Pietro),* ca. 1758
Oil on canvas
Staatliche Museen zu Berlin – Preußischer Kulturbesitz, Gemäldegalerie, on loan from the Streit Stiftung, Berlin

Night-time scenes are the exception in Canaletto's work. This picture shows the fair-like bustle outside the church of San Pietro, the bishop's seat in Venice, on the eve of the feast of the patron saints. San Pietro is on the island of Castello. Canaletto viewed the scene from the Arsenal side of the canal, so that he was able to depict all the architecture, including the secondary buildings. In this pitch-black scene, Canaletto added the moonlight and its reflections in the water in an almost coarse-grained style. We can make out women, playing music, in the gondolas floating on the water.

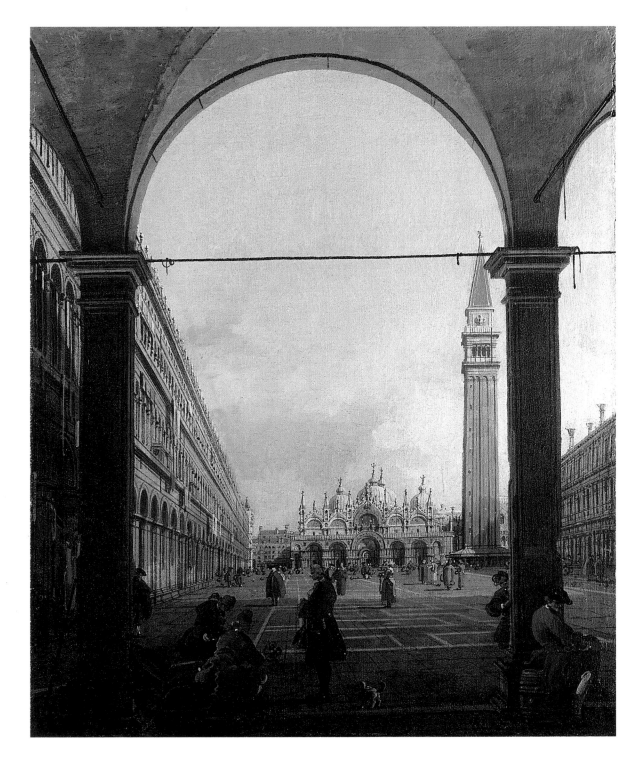

91 *Piazza San Marco, Looking East*, ca. 1760
Oil on canvas, 46.5 x 38 cm
The National Gallery, London

This small-scale view is painted from the south-west corner of the square, looking eastwards. Canaletto loved this viewpoint right next to the Café Florian. He often used to sit there to study the Piazza. Evidently, two Englishmen, called Hinchliffe and Crewe, reported that they were allowed to watch him painting there. However, since Canaletto always worked in the studio, here we are probably talking about only sketches and preliminary drawings that he completed on the spot.

vedute. Instead, he offered *Architectural "Capriccio" with a Colonnade* (ill. 92), which opens out from a two-storey palace into a courtyard. At about the same time, presumably, Canaletto completed the picture *Scala dei Giganti* (ills. 93, 94), whose composition is similar to that of the Academy picture. However, this is not a *capriccio*, but a view of the staircase of that name in the Doge's Palace. It is probably one of the artist's last works.

By 1765 he was almost 70 years old, and had only three years left to live. Even though we have no record of any paintings for this period, Canaletto continued to create drawings. Several engravings of ceremonies and official festivities, which appeared in 1763, may be based on these sketches. Canaletto died of smallpox on 19 April 1768, and was buried with full civic honors.

The inheritance he left his sisters consisted of his house in the Zattere district, his clothes, some worthless jewelry, and 28 unsold paintings. Although Canaletto had been regarded as mercenary during his lifetime, and although his contemporaries had complained about the high prices he charged for his pictures, he left behind nothing of great value at his death.

Canaletto's achievement, especially at the height of his creativity as an artist, was never disputed by his contemporaries. He was regarded as an exceptional artist who succeeded both in capturing reality in his paintings, and in reflecting the beauty and magnificence of his native city, Venice. In the course of his development, Canaletto made gradual progress from a compositional approach based on theatrical construction and set

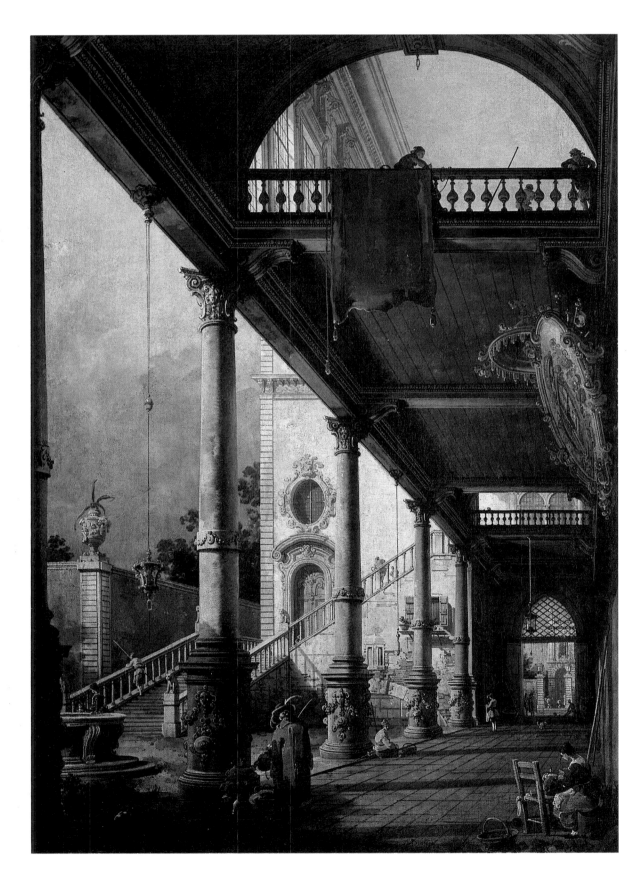

92 *Architectural "Capriccio" with a Colonnade*, 1765
Oil on canvas, 131 x 93 cm
Gallerie dell'Accademia, Venice

After applying to the Academy of Fine Arts in Venice
several times, in 1763 Canaletto was finally accepted as a
member. He was appointed Professor of Architectural
Perspective. He submitted his Academy picture, a
precondition of membership, two years later. It does not
show any views normally associated with Venetian *vedute*.
Instead, it is more of a perspective study with a
colonnade, which opens on to a garden and another
building. Canaletto arranged the uprights and diagonals
so skilfully that they increased the picture's depth. As in
the *scena dell'angolo* stage construction, the vanishing
point is in a corner of the picture.

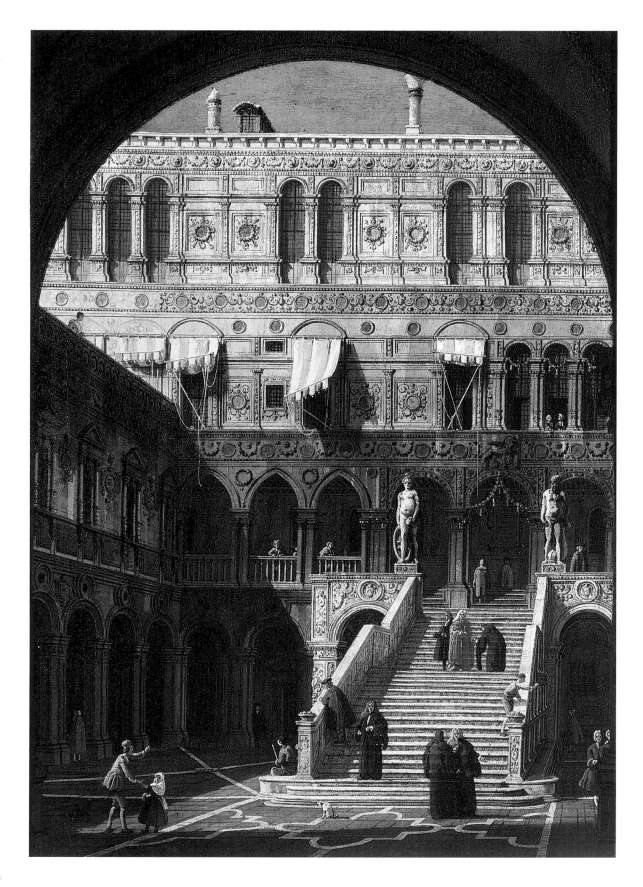

93 (left) *Scala dei Giganti*, 1765
Oil on canvas, 42 x 29 cm
Private Collection, Mexico City

Like the *Architectural "Capriccio" with a Colonnade*, the *Scala dei Giganti* is a study of architecture and perspective. In the Doge's Palace, the Scala dei Giganti leads to the loggia. Two colossal statues of Mars and Neptune that Jacopo Sansovino completed in 1554, and which give the staircase its name, stand higher up the stairs. Mars, the Roman god of war, and Neptune, god of the sea, are there to symbolize the independent and militarily successful Venetian maritime Republic of the 16th century.

94 (opposite) *Scala dei Giganti* (detail ill. 93), 1765

This detail shows the picture's center, as far as perspective is concerned. Staffage figures are always present, even in architectural studies. Either individually or arranged into small groups, they give the painting, which might otherwise seem rather static and two-dimensional, the appearance of everyday bustle and vitality.

painting to a form of pictorial composition in which his use of extreme foreshortening and spatial depth takes his pictures far beyond topographical detail. The way he depicted light and air with crystalline limpidity, the luminous blue-green tones of his *vedute*, as well as his superlative view of the Bacino di San Marco, not only testify to his mastery of the *vedutà*, but also confirm that he developed his own aesthetic within the genre.

Canaletto's approach to perspective – from structural depictions to wide-angle panoramas, in which fiction blends with reality, and *vedutà* and *capriccio* merge – shows his supreme skill. The festive gaiety and the luminous atmosphere that characterize many of Canaletto's paintings and make his pictures almost a synonym for the magic exercised by *La Serenissima*, are graphic proof of his poetic power and his uniqueness.

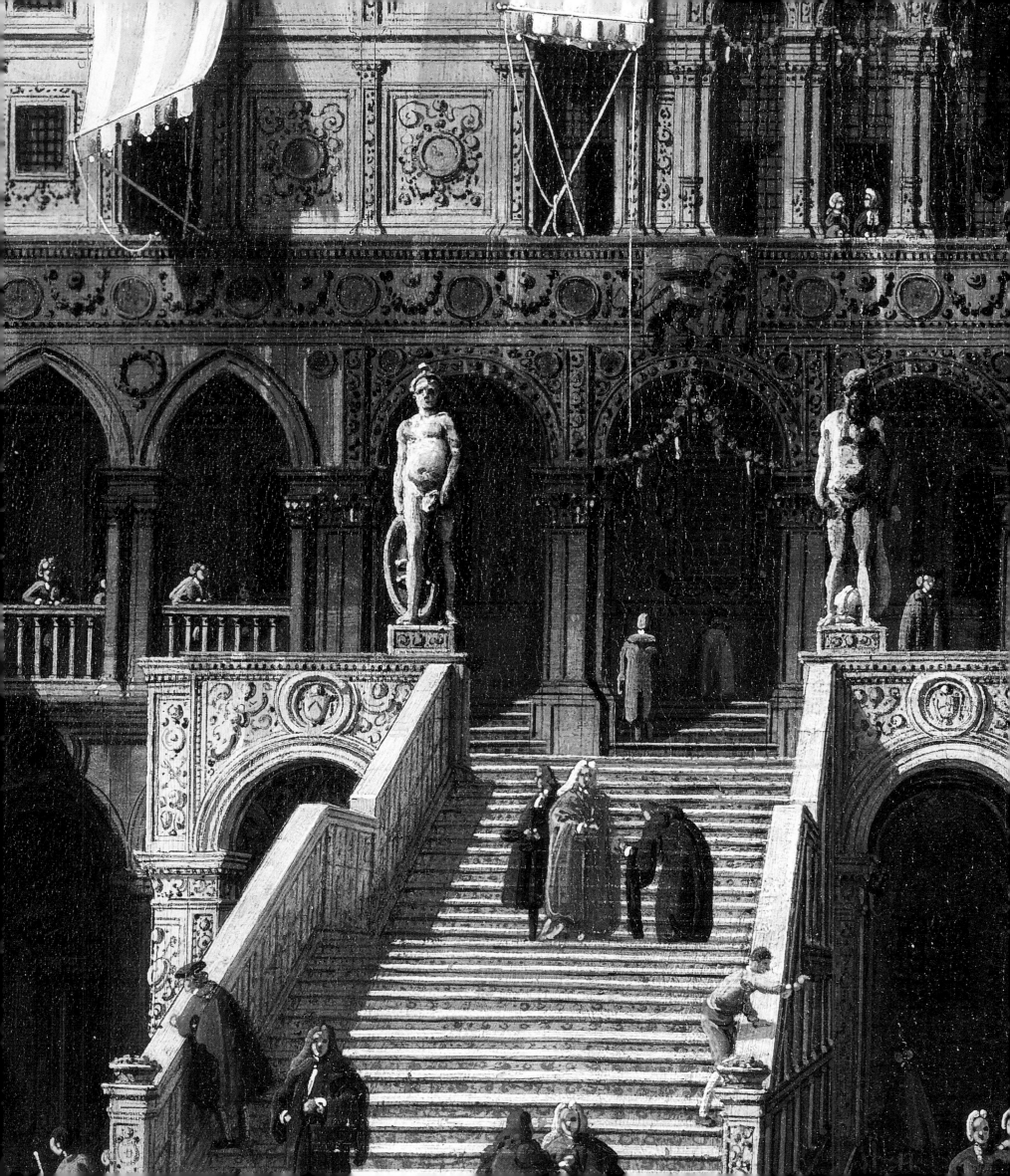

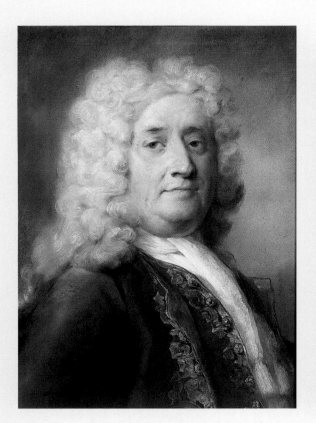

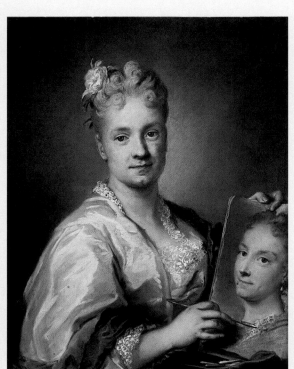

95 (far left) Rosalba Carriera
Portrait of Sebastiano Ricci, 1767–1770
Pastel on paper, 56 x 42 cm
Staatliche Kunsthalle, Karlsruhe

Sebastiano Ricci (1659–1734) was one of the leading
Venetian artists of the late Baroque and Rococo periods.
Ricci, who had collaborated with the Galli-Bibienas in
Parma, also trained his nephew, Marco Ricci, who, in
turn, influenced Canaletto.

The notion of the artist as an individual worthy of respect
developed from the Renaissance onwards. In the Middle
Ages, artists were considered craftsmen, and they were
organized into guilds according to the material they
worked. This form of organization continued until early
modern times, even though the status of the artist had
undergone great changes. By the 17th century, society had
generally accepted the new ideal of the artist that had been
developing during the Renaissance. Ever since Vasari's
"Lives of the Most Excellent Painters …" (1550), the subject
of the *Wunderkind*, the genius, had been popular and
widespread. The cult of the artist, however, did not reach
its apotheosis until the 19th century. Yet artists who enjoyed
some recognition in society could earn a good income even
in the 18th century, one which allowed them to live much
as the aristocracy did. They worked independently, often
without any direct commission, and generally followed
prevailing demand on the art market. Moreover, Italian
artists were highly regarded abroad, and were often greatly
valued for their origins, if nothing else. For German and
Dutch artists it was almost a duty to continue their training
in Italy, and in Rome in particular. In France, the so-called
Prix de Rome (Rome Prize) made it possible for gifted artists
to spend some time in Italy for purposes of study. Veneration
of the classics played an important role here, and this carried
over to the Italian artists.

From the beginning of the 17th century onwards, artists
in Venice made energetic attempts to detach themselves
from the various craft guilds in order to unite into one single
guild. The foundation of the French Academy of Painting
and Sculpture in the early 17th century also influenced
developments in Venice. The Republic did not, however,
approve of the idea of establishing an art academy specific
to Venice. In 1602, artists were allowed to join together
in the Collegio dei Pittori (Painters' College), thus
distinguishing themselves from other guilds. The Collegio
was a kind of professional association with a teaching role.
It had its headquarters in the Fonteghetto della Farina, an
old grain warehouse, which we know from Canaletto's
magnificent painting. The Collegio also continued to exist
even after the Academy had been officially founded – in fact
until the early 19th century, when Napoleon's troops
transferred the collection of paintings there to the Scuola
di San Marco.

Artists closely followed plans for the establishment of an
academy. Initially, Venetian artists tried hard to become
members of other academies, especially the French
Academy of Painting and Sculpture. In Paris in 1717,
Sebastiano Ricci (1659–1734) applied for membership of
the French Academy, and was accepted (ill. 95). In 1705,
Rosalba Carriera (1675–1757) was admitted to the Roman
Academy in Lucca, and in 1720 she successfully applied to
the French Academy (ill. 96). In 1720, Piazzetta was
accepted as a member of the Accademia Clementina in
Bologna.

It was not until 1750 that Venetian artists ventured to
take another initiative. They suggested the old flower store
on the Piazza San Marco, where several exhibitions had

96 (above right) Rosalba Carriera
Self-Portrait, ca. 1753
Pastel on paper, 71 x 57 cm
Galleria degli Uffizi, Florence

Rosalba Carriera (1675–1757) is regarded as the most
illustrious woman portrait painter of the first half of the
18th century. Her supremely delicate pastels appealed
greatly to the taste of a generation imbued with ornate
Rococo.

already been held, as the Academy's headquarters. In 1754, they were finally given the Senate's blessing, though for different premises. Piazzetta was appointed the first Academy director, though he died suddenly, which delayed the opening for another two months. It was agreed that Tiepolo should succeed him, and in 1756 the first official session finally took place.

Painters of historical pictures, portraits and landscapes, as well as decorators, architects, painters of illusionistic pictures and sculptors, were among its members. The most respected artists were the painters of history pictures, since they took responsibility for educating the bulk of the population. Upon entry, all members had to submit a male nude in a pose approved by existing Academy members. For the first time ever in Venetian art, drawing took pride of

place. The theories of Winckelmann and classical ideas were also reflected in the Academy's statutes. When Canaletto finally also became a member, the Academy did not accept him as a *vedutà* artist, but as a tutor of architectural perspective. Even as late as the 18th century, *vedutà* painting was still frowned upon as a genre. Canaletto had justified his claim to teaching by studying scene painting. Alongside the painters of history pictures, portrait painters also enjoyed considerable social importance. Landscape painters had won only grudging respect as late as the 17th century.

In Venice the arts enjoyed political influence, and they were treated accordingly. This makes it less surprising that it took a long time to establish the Academy, and that it depended on strictly imposed criteria (ill. 97).

97 View of the Accademia of Venice
Venice

The Academy of Venice was established in 1750, but was not officially recognized until 1756. The Gallerie dell'Accademia has been open to the public since 1817. The Academy's erstwhile collection is one of the best-known collections of paintings in the world. Among other pictures, it comprises leading works by Venetian painters and important Italian art of the 14th, 15th and 16th centuries.

CANALETTO'S SUCCESSORS

Canaletto did not train any pupils, though his father, Bernardo Canal, and his nephew, Bernardo Bellotto (1721–1780), occasionally worked in his studio. Canaletto was neither married nor had children, but was presumably concerned about the welfare of his nephew, and welcomed him into his studio.

Accordingly, Bellotto was given a thorough grounding in *vedutà* painting, initially copying Canaletto's painting technique and emulating his style. Presumably, he collaborated on several of Canaletto's paintings. In the early 19th century, this led to a whole series of paintings by Canaletto's circle being attributed to Bellotto at art auctions in order to raise prices. In 1747 – by this time Canaletto was already living in London – Bernardo Bellotto went to the Saxon court in Dresden. August III (1733–1763) and his art-loving Prime Minister, Count Heinrich Brühl (1700–1763), were both admirers of Italian art, and their generous patronage attracted Italian artists to the Saxon "Florence on the Elbe". In Dresden, Bellotto, who now also called himself Canaletto, was paid the highest annual salary of any court artist, at 1750 thalers. Between 1747 and 1755 he created the great city panoramas of Dresden – most of these 17 motifs exist in further variations, and 11 views of Pirna an der Elbe. The architectural detail of these Dresden *vedute* is itself entrancing, even if they seem a little impersonal. The 36 pictures he painted, including 15 views of the city, are still in the Gemäldegalerie, Dresden. Alongside the later works he completed during his years in Warsaw, these paintings are considered Bellotto's most important (ill. 99).

During his years in Dresden, Bellotto developed a style of his own, though his painting technique remained less accomplished than that of his uncle, Canaletto. In general, his palette tends more towards darker colors – especially in green and brown tones. Nevertheless, he was able to transform the compositional pattern he took over from Canaletto, and often chose a broad format for his pictures. His interest in landscapes, fostered by his frequent trips in Italy, needs no encouragement. His paintings of the country-side around Dresden, with their mutedly luminous coloration, look atmospheric, and seem to anticipate the landscape paintings of the Romantic period (ill. 98).

Moreover, the staffage figures he often introduces look more individual than is generally the case with other artists, and attest to his liking for depicting simple people.

During the Seven Years War, Bellotto spent two years at the court of Empress Maria Theresia in Vienna, and then a short period at the court of Maximilian III in Munich. In 1763, when the Saxon court had been impoverished by war, and the death of both August III and his Prime Minister, Brühl, had brought all patronage to an end, Bellotto left Dresden and moved to the court of the Polish king, Stanislaus Poniatowski, where he lived until his death in 1780. Here, he devoted himself more to history subjects and genre scenes, painted several views of Warsaw, and frequently turned to landscape painting. Today, after Canaletto and Guardi, Bellotto is regarded as the leading Venetian *vedutà* artist of the 18th century. He is also considered important in having popularized *vedutà* painting in Central Europe.

Antonio Visentini (1688–1782) was another member of Canaletto's circle. He was a painter, engraver, architect, and theoretician. In 1735, on commission from Joseph Smith, whom he had known since 1717, he completed a portrait of Canaletto for the album, "Prospectus Magni Canalis Venetiarum", for which he had created the engravings. For a very long time, Visentini worked for the publisher, Giambattista Pasquali, whose publications he adorned with vignettes and illustrations. Smith, who not only collected and sold art, but also kept a library with important bibliophile editions, was a leading patron in book collecting, too. As an architect, Visentini supervised the building of Smith's villa in Monigliano, as well as the interior decoration of his residence in the Palazzo Mangilli-Valmarana, on the Grand Canal. He was an expert in the genre of architectural *capricci* (ill. 100), and, together with Francesco Zuccarelli, he designed 11 *sopraporta* paintings with pictorial motifs derived from English Palladian buildings. Visentini completed the architectural work on these, whilst Zucarelli painted the staffage figures. In 1755, Visentini was one of the founder members of the Venetian Academy, and was a tutor in perspective there from 1761 until 1778. The

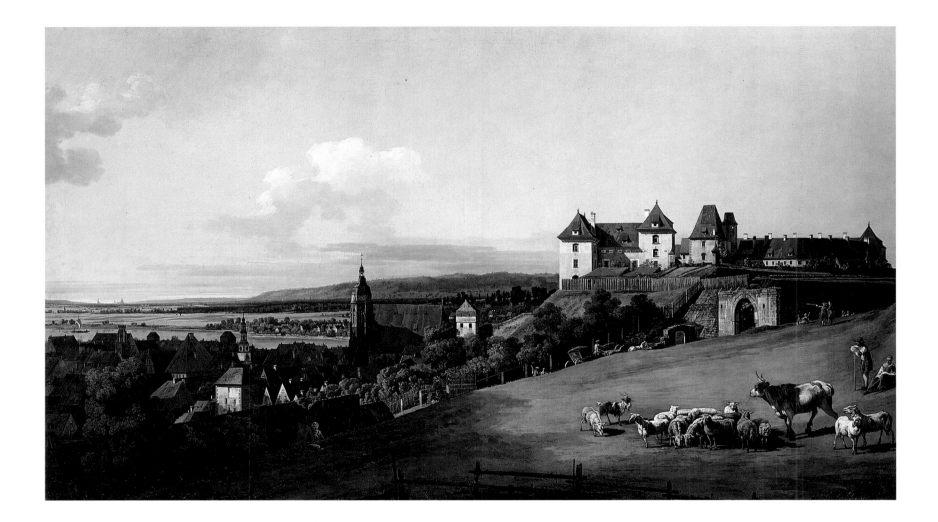

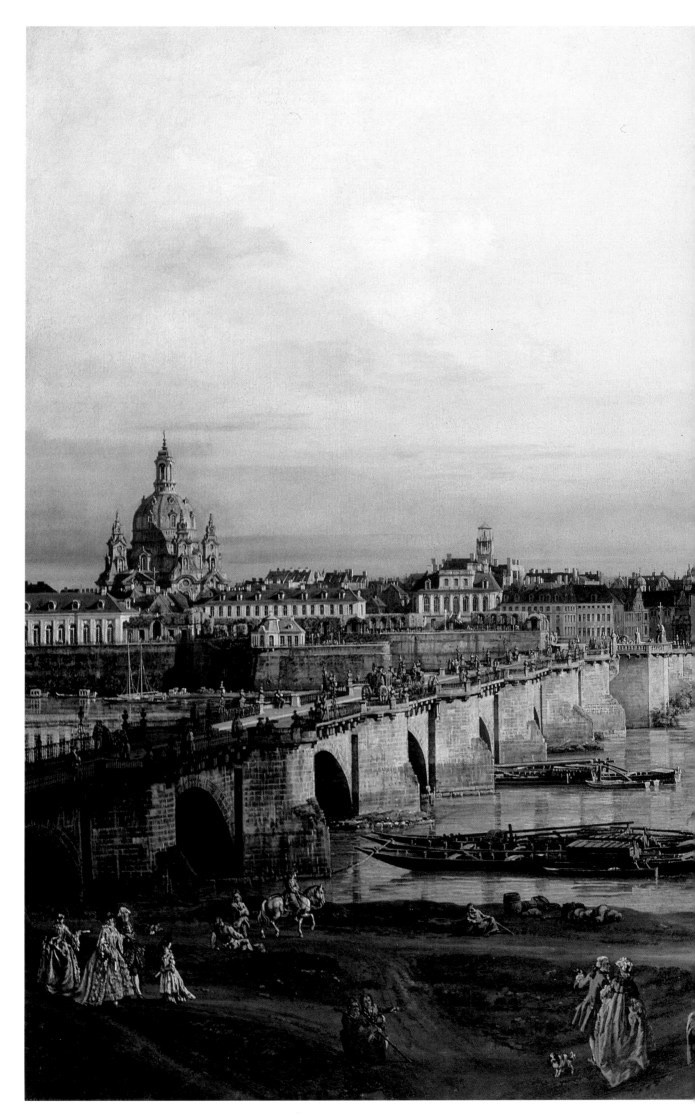

99 Bernardo Bellotto
Dresden in Front of the Neustädter Bridgehead, 1765
Oil on canvas, 99.5 x 134 cm
Staatliche Kunsthalle, Karlsruhe

In 1764, Bernardo Bellotto painted this picture – which is
signed underneath: BERNARD. BELLOTTO DE
CANALETTO – when applying for membership of the
Academy in Dresden. From a standpoint in the
Neustädter Wache district, Bellotto has painted a most
striking view of Dresden, in which we can clearly
recognize the Old Town. The magnificent buildings rising
out of the cityscape of Dresden by the Elbe impressively
incorporate the art of the late Baroque in the reign of
August III, the art loving Elector.

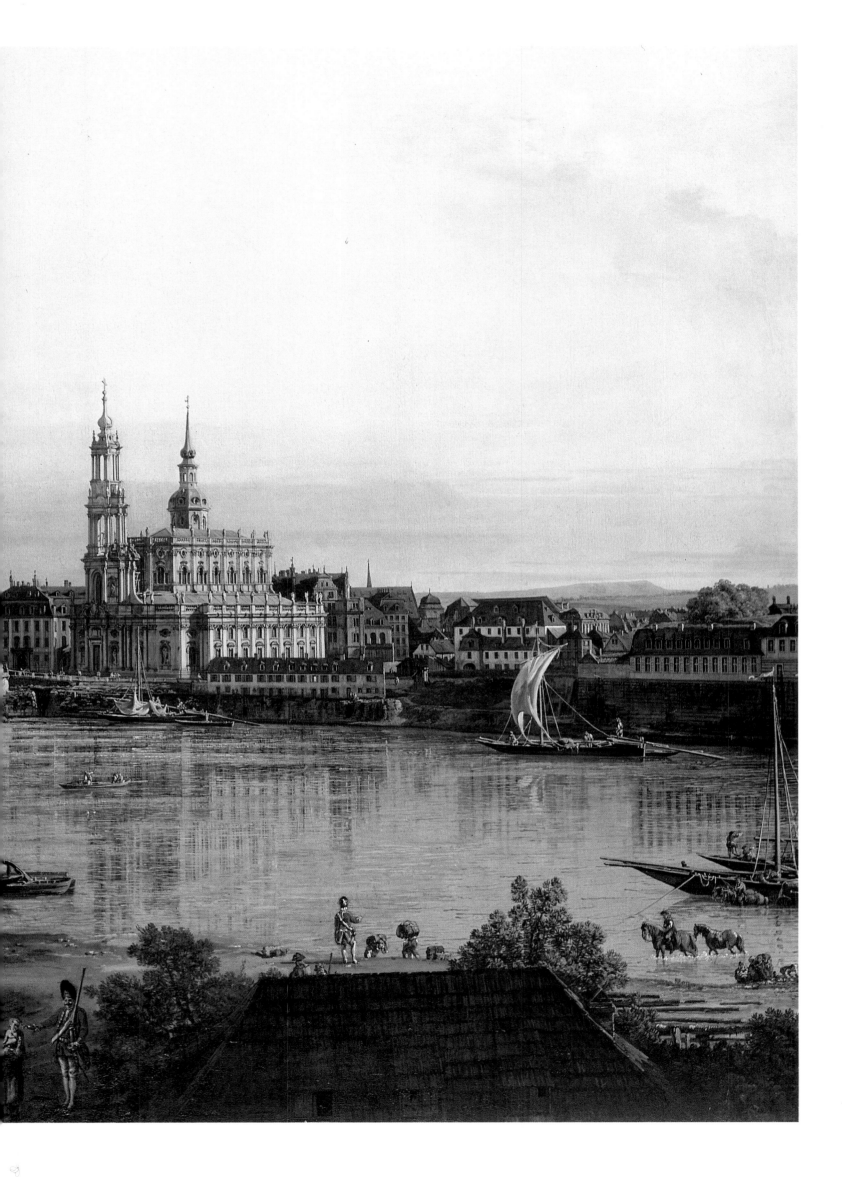

100 (left) Antonio Visentini
The Game of Skittles, 1739
Oil on canvas, 207 x 252 cm
Palazzo Contarini-Fasan, Venice (?)

This painting is one of the eight architectural fantasies that Visentini completed for the Palazzo Contarini-Fasan. Palladio, the architect whom he greatly admired, also inspired the rustic Roman columns, whose originals can be seen in the Villa Sagredo in Verona, which Palladio designed. The staircase, without a balustrade, which leads up on to the roof, is another peculiarity. The girls playing skittles were presumably painted by a different artist.

102 (opposite) Michele Marieschi
Vedutà of the Basilica della Salute, ca. 1737
Oil on canvas, 124 x 213 cm
Musée du Louvre, Paris

Marieschi's construction of the broad perspective here shows the unmistakable influence of the *scena dell'angolo* form of stage scenery, and it endows the sunlit Basilica della Salute with magically magnetic power.

Academy still owns numerous model drawings made by him and his pupils from studies of Palladio, the architect whom he so admired, as well as from classical subjects.

Michele Giovanni Marieschi (1710–1743) was another important *vedutà* artist, whose work was not fully catalogued and reappraised until the 1980s. Like Canaletto, Marieschi began his artistic career as a scene painter in the theater, turning later to the *capriccio* and to *vedutà* painting. In his painting technique, he was clearly influenced by Canaletto, but he retained an avowedly theatrical compositional style, which bears the hallmarks of stage design. He often preferred "diagonal views", which gave him not merely a larger space but also a degree of dynamism (ill. 103). His method of applying a loaded brush in crosswise strokes – especially in some of the *capricci* seems almost expressive. Moreover, Marieschi was a supremely gifted engraver. His 21 views of Venice, brought together in the collection "Magnificentores Selectioresque Urbis Venetiarum Prospectus", are some of the most outstanding works of his time (ill. 101). Marieschi died young, and so it is hard to appreciate his artistic development fully.

101 (left) Michele Marieschi
Piazza San Marco Verso la Basilica. 1741
Etching and copperplate engraving, 28.8 x 44.4 cm
(engraving), 30 x 44.6 cm (plate)
Museo Correr, Venice

This plate is one of the 21 etchings in the collection,
"Magnificentiores Selectioresque Urbis Venetiarum
Prospectus". Marieschi was presumably basing this picture
on an oil painting by Canaletto. He has pulled the long
sides of the Piazza San Marco so far apart that the
cathedral of San Marco and the Campanile appear to have
moved a long way back, making the composition look
like a stage set.

103 (following double page) Francesco Guardi
Santa Maria della Salute and the Dogana del Mare, 1783
Oil on canvas, 45.5 x 80 cm
Museum of Fine Arts, Houston, Texas

Guardi painted this picture from a viewpoint on the
Molo. From there, he presents an exquisite vista of the
Punta della Dogana on the mouth of the Grand Canal,
and the church of Santa Maria del a Salute. The buildings
seem to shimmer in the heat of the sun. In contrast to
Canaletto's crystalline *vedute,* Guardi mostly managed
without clear outlines. Instead, his painterly treatment of
the pictorial motif creates a highly individual,
Impressionistic effect.

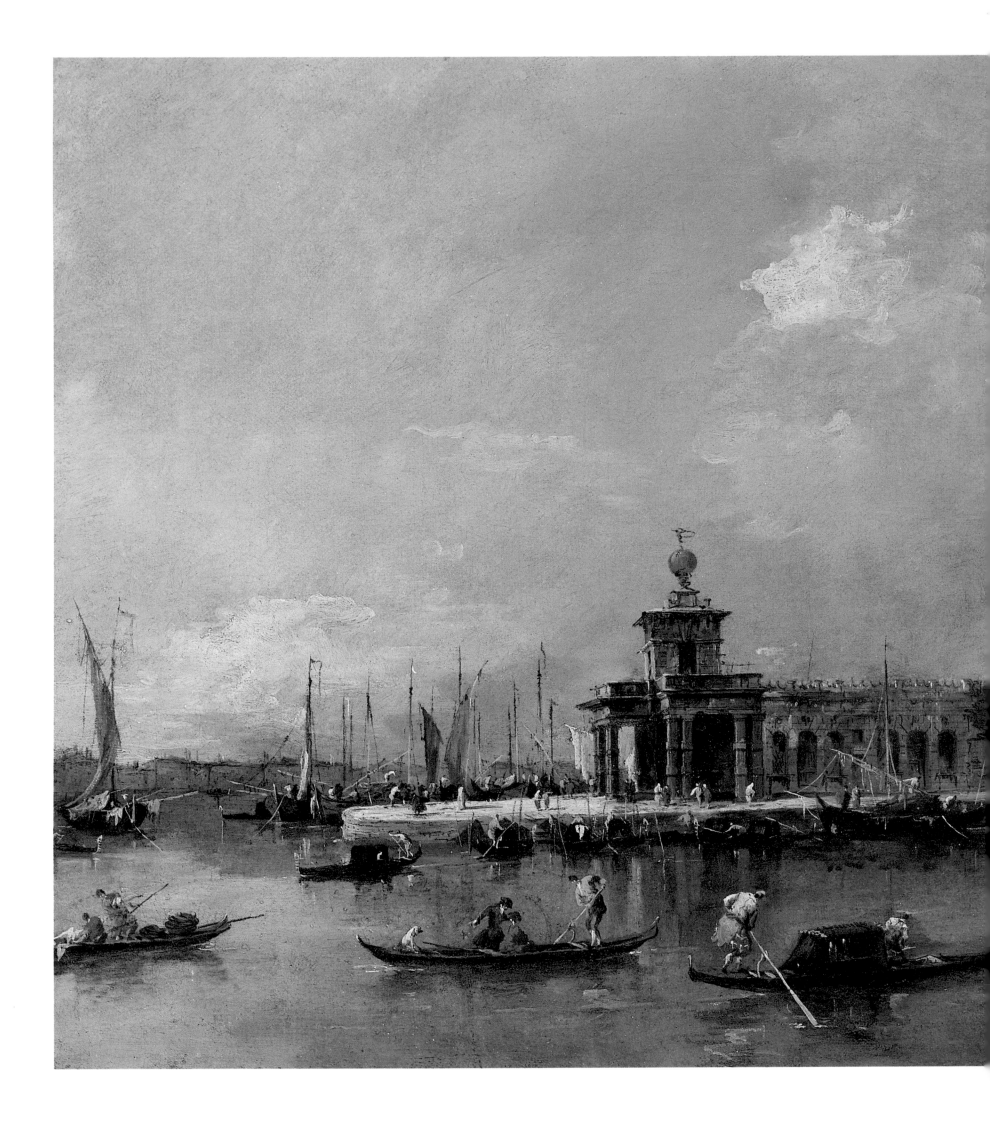

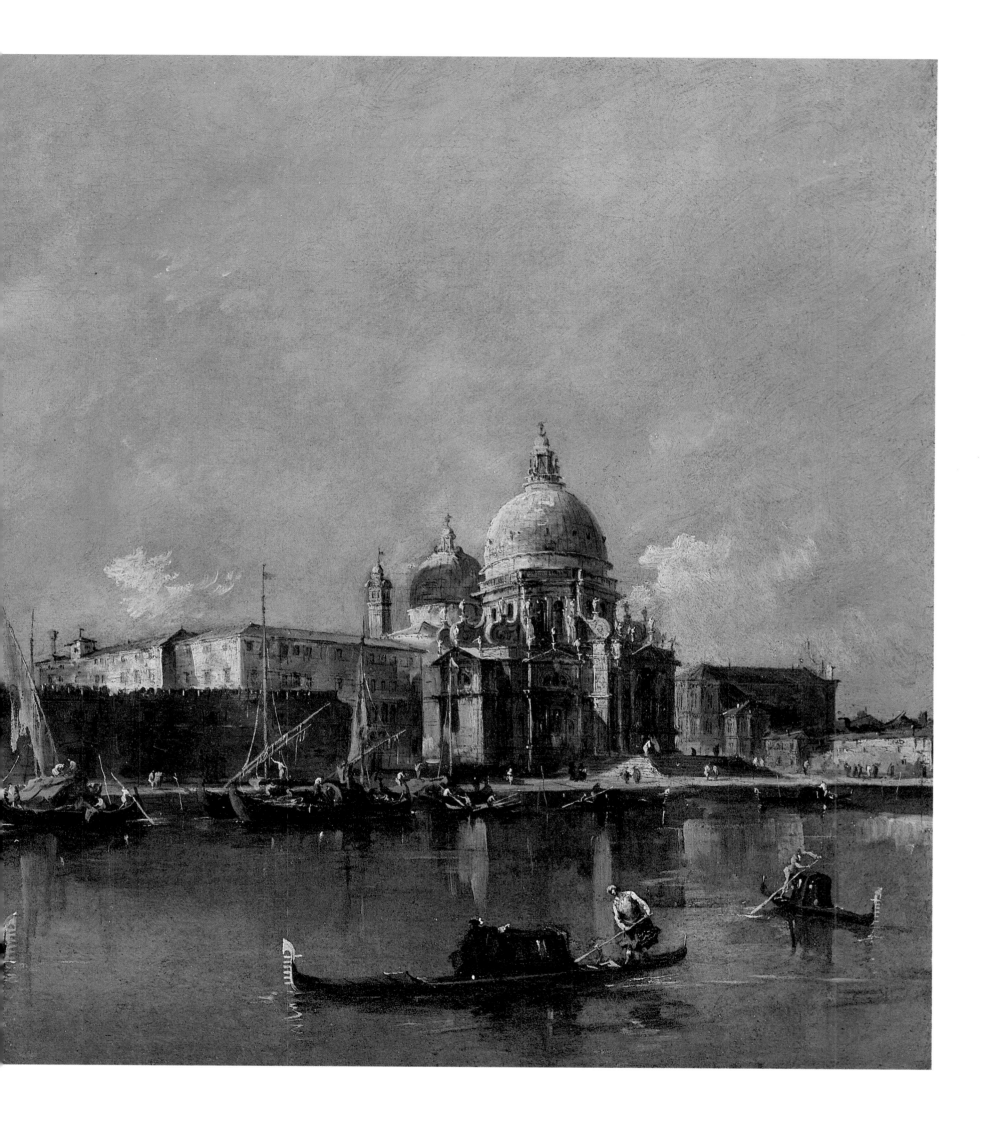

104 Francesco Guardi
from *The Cycle of the Legend of Tobias*, ca. 1750
Organ Gallery of the Chiesa dell'Angelo Raffaele, Venice

Among early examples of the independent development
of this artist, who had spent several of the previous years
copying old masters in his brother's studio, are the seven
scenes illustrating the Legend of Tobias, whose dramatic
depiction seems almost Impressionist in feeling.

Nevertheless, he was highly regarded during his lifetime, and sold his *vedute* for high prices to English collectors – as well as to the German soldier Marshal von der Schulenburg, whom we have already mentioned several times. Marieschi's pupil and successor, Francesco Albotto (1721–1757), was his heir in more ways than one. Not only did he take over his teacher's studio and painting technique, he also married Marieschi's widow, Angiola Fontana. Scholars nowadays doubt the authenticity of Albotto's own works and regard them as inferior in quality to those by Marieschi.

The most important of Canaletto's successors was Francesco Guardi (1712–1793), the son of Domenico Guardi, who had moved from Trient, northern Italy, and his Austrian wife, Claudia Maria Pichler. Guardi's father had been active as an artist in Vienna. He died early, so that Francesco's elder brother, Gianantonio (1699–1760), had to look after his mother, his two small brothers and his sister, Cecilia. She later married Giambattista Tiepolo. Francesco Guardi worked in his brother's studio until Gianantonio's death in 1760. The Guardi began by painting copies of Old Masters – for

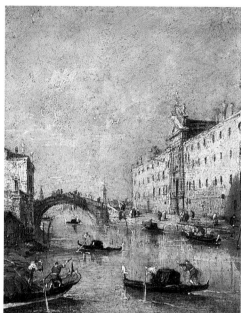

instance, Veronese's *Wedding at Cana*, Titian's *St. John the Baptist,* and *The Last Supper* by Sebastiano Ricci. The German collector Schulenburg, for example, owned over 100 copies from the studio of the Guardi brothers. In 1756, Gianantonio became a member of the Academy, of which Tiepolo was President. Accordingly, Francesco's name was entered in the guild records in his brother's stead.

At first, Guardi based his work closely on Canaletto's style, often copying his paintings. Only after his brother's death did he achieve his own pictorial language (ill. 102). An early example of his individualistic and ebullient approach to painting is the cycle on the legend of Tobias he completed in 1750 for the organ gallery of the church of Angelo Raffaele in Venice (ill. 104). About 1760, he created his principle works, which confirm a total break with Canaletto's style. From then on, he abandoned both his detailed depiction of architecture and his clear colors in favor of an almost Impressionist painting style. The same applies to the way he approached staffage. He began to accentuate these in a purely painterly way, rendering them as blurred and indistinct. Guardi succeeds in bursting through materiality in an almost magical manner. His coloration tends to be dark, and in Heribert Hutter's view this produces a "surface which, although vibrantly mobile, is still unified". Guardi was inspired by Canaletto's rich coloration and poetry, but – especially in his coastal views and lagoon landscapes (ill. 105) – he achieved an individual rhythm of color and light that points forward

to the work of J. M. William Turner (1775–1851) in the 19th century. In his later work everything appears morbid, decayed, and only apparently secure – all of which gives his pictures a trace of gentle melancholy (ill. 106). He depicts existence itself as a process of transformation, as what Luitpold Dussler has called "decaying and becoming".

Francesco Guardi's genius was not recognized by his contemporaries. Only very late, at the age of 72, was the artist accepted as a member of the Academy. He had no success at any point in his life. Moreover, as is clear from a letter he wrote to the Italian sculptor, Antonio Canova (1757–1822), he was avoided because his poverty allegedly made him use inferior canvas and cheap paints. The work of Francesco Guardi marks the end of the flowering of Venetian art in the 18th century: a decline that Guardi seems to have anticipated in his paintings.

105 (above left) Francesco Guardi
Gondola on the Lagoon, ca. 1793
Oil on canvas, 25 x 38 cm
Museo Poldi Pezzoli, Milan

This exceptional painting is presumably one of the artist's last works. The tones of gondola, sea and sky almost merge into one another in an almost infinite sense of breadth and emptiness.

106 (above right) Francesco Guardi
Rio dei Mendicanti, ca. 1793
Oil on canvas, 19.5 x 15 cm
Pinacoteca dell'Accademia Carrera, Bergamo

The charm of this very small painting of the Rio dei Mendicanti lies in the earthy way in which the artist overlays one tone with another, and applies thick white highlights in the figures of the gondoliers on the water.

CHRONOLOGY

1697 28 October: Birth of Giovanni Antonio Canal (Canaletto) in Venice.

1700 Birth of his sister, Fiorenza, the mother of Bernardo Bellotto.

1703 Publication of Luca Carlevaris's album of engravings "Le Fabriche e Vedute di Venezia".

1712 Birth of Francesco Guardi.

before 1720 Canaletto receives training as a scene painter in his father's studio.

1720 30 January: birth of Bernardo Bellotto. Bernardo Canal and Antonio Canal design the sets for Scarlatti operas in Rome. Canaletto decides to become a *vedutà* artist, and his father's name appears in the list of the Venetian painters' guild.

1723 The repaving of the Piazza San Marco, as designed by Andrea Tirali, is begun.

1725 Stefano Conti commissions a total of four *vedute* from Canaletto through his agent, Marchesini.

1726 Owen McSwiney asks Canaletto to collaborate on a series of allegorical tombs of famous Englishmen.

1729 Canaletto signs and dates two sketches for *vedute*.

1730 Joseph Smith tells Samuel Hill that he has commissioned two pictures from Canaletto. McSwiney complains that Canaletto is late with his work and keeps putting up his prices. Marshal von der Schulenburg pays Canaletto 62 zecchini for a painting of the Piazza San Marco.

1734 Canaletto signs and dates two paintings for Joseph Smith's collection.

1735 On behalf of Joseph Smith, Giambattista Pasquali publishes 14 engravings by Visentini of paintings by Canaletto in the "Prospectus Magni Canalis Venetiarum". Canaletto is refused membership of the Collegio dei Pittori as only one artist from any family may become a member.

1738 Bellotto's name appears in the list of the Venetian painters' guild.

1740 Accompanied by his nephew, Bellotto, Canaletto makes an excursion along the Brenta valley in search of new subjects.

Michele Marieschi publishes an album of 21 engravings. Francesco Algarotti tells his brother by letter that Canaletto has so many commissions he will need several years to complete all the pictures.

1740/41 For the first time Bellotto dates and signs a painting "detto [called] Canaletto".

1742 Canaletto signs and dates five large *vedute* of Rome. The "Prospectus" is reprinted with additional engravings.

1744 Death of Canaletto's father, Bernardo Canal. Smith becomes British Consul in Venice.

1746 George Vertue records Canaletto's arrival in England. In October, his first commissions include a painting of the festivities marking Lord Mayor's Day.

1747 Sir Hugh Smithson (later the Duke of Northumberland) commissions Canaletto to paint Windsor Castle.

1749 An arch of Westminster Bridge is hallowed out. Canaletto records the various stages of rebuilding and repair work in drawings and *vedute*.

1750/51 Canaletto briefly returns to Venice. He invests the money he has earned in England and buys a house on Zattere, in Venice.

1751 The artist returns to England for a further five years. The third edition of the "Prospectus" is published.

1755 Canaletto signs and dates *vedute* of the old Walton Bridge for Samuel Dicker.

1759 Algarotti refers to Canaletto's *capriccio* of the Rialto Bridge based on the model by Palladio that was never built.

1762 Joseph Smith sells the greater part of his collection to King George III of England.

1763 Canaletto is finally appointed Professor of Perspective at the Academy in Venice.

1765 The artist delivers his reception picture for the Academy, an architectural *capriccio*.

1768 19 April: Death of Canaletto.

1770 Death of Joseph Smith.

GLOSSARY

academy, an institution or society created to further artistic, literary, or scientific studies. The interest that the Renaissance inspired in science, literature and art led to the establishment of the earliest important Academies – in Milan (associated with Leonardo da Vinci) and in Florence (associated with Giorgio Vasari). These were modelled on schools of the ancient Greece. In the wake of political absolutism, the idea took root of an academy as a central institution with its own curriculum, an idea echoed throughout Europe. Prototype academies, both French, were the Académie Française (literature), founded in 1635, and the Académie Royale de Peinture et de Sculpture (art), founded in 1648 on the initiative of the artist Charles le Brun. In Venice, the Academy of Fine Arts was not established until 1750 (and officially recognized in 1754).

Bacino di San Marco, in Venice, the stretch of water into which the Grand Canal flows; it which adjoins the Piazzetta and the Doge's Palace.

bamboccianti, (It. "doll, child, dwarf"), group of 17th-century Dutch artists working in Italy who promoted a type of coarsely realistic genre painting. These works were known as *bambocciate* (sing. *bambocciata*).

Baroque (Port. *barocco*, "an irregular pearl or stone"), the period in art history from about 1600 to about 1750. In this sense the term covers a wide range of styles and artists. In painting and sculpture there were three main forms of Baroque: (1) sumptuous display, a style associated with the Catholic Counter Reformation and the absolutist courts of Europe (Bernini, Rubens); (2) dramatic realism (Caravaggio); and (3) everyday realism, a development seen in particular in Holland (Rembrandt, Vermeer). In architecture, there was an emphasis on expressiveness and grandeur, achieved through scale, the dramatic use of light and shadow, and increasingly elaborate decoration. In a more limited sense the term Baroque often refers to the first of these categories.

Bucintoro, the Doge's state galley, which was rowed by 200 oarsmen. The Doge would sail out to the open sea in it on Ascension Day in order to throw into the water a ring symbolizing Venice's union with the sea.

camera obscura (Lat."dark chamber"), a device once used by artists to help them depict views or interiors accurately and in detail. At its simplest, it consists of a box (originally sometimes a small room) that has a small hole in one wall. The lens in this hole focuses the light from the scene outside and projects a small, clear (and inverted) image of the scene on the opposite inner wall. They were used mainly in the 17th and 18th centuries, and artists known to have used them include Vermeer and Canaletto.

campanile, (It. "bell tower"), a church bell tower, often standing detached from the body of the church. Well-known examples include the Campanile of St. Mark's Cathedral in Venice, and the "Leaning Tower" of Pisa.

Campo (It. "field"), the name Venetians give their city squares, generally the forecourts of a church (the squares are usually named after the church), or the area between palaces that had not been built, usually with side access to a canal.

capriccio pl. *capricci* (It. "caprice"), another name for *vedutà ideata*. See: *vedutà*

castrati sing. **castrato** (It.), male singers who were castrated in childhood in order sing soprano.

chiaroscuro (It. "light dark"), in painting, the modelling of form (the creation of a sense of three-dimensionality in objects) through the use of light and shade. The introduction of oil paints in the 15th century, replacing tempera, encouraged the development of chiaroscuro, for oil paint allowed a far greater range and control of tone. The term chiaroscuro is used in particular for the dramatic contrasts of light and dark introduced by Caravaggio. When the contrast of light and dark is strong, chiaroscuro becomes an important element of composition.

Collegio dei Pittori, in Venice, the professional association of painters the Senate authorized (in 1682) instead of an academy. When the Academy was finally allowed (in the 1750s), the Collegio continued to exist alongside the Academy until Napoleon's troops invaded Venice and abolished it.

colonnade, a row of columns supporting a series of arches or an entablature.

commedia dell'arte (It. "professional comedy"), a form of improvised comedy emerging in Italy during the mid 16th century and flourishing until the 18th century.

copperplate engraving, a method of printing using a copper plate into which a design has been cut by a sharp instrument such as a burin; an engraving produced in this way. Invented in south west Germany about 1440, the process is the second oldest graphic art after woodcut. In German art it was developed in particular by Schongauer and Dürer, and in Italian art by Pollaiuolo and Mantegna.

Doge (Lat, *dux,* "leader"), the elected head of the Venetian state. The office was in existence from 697 to 1797.

Enlightenment, intellectual movement dominating Europe in the 18th century. It was broadly characterized by a new confidence in the power of human reason, and an optimism about human progress. In politics the Enlightenment saw the development of liberalism, and so prepared the way for the American and French Revolutions. Philosophy was strongly influenced by science, and the arts drew increasingly on classical Greek and Roman models.

fecit (Lat. "he/she made it"), word used with an artist's name or initials to indicate authorship.

flat, a two-dimensional piece of stage scenery on a movable wooden frame.

genre painting, the depiction of scenes from everyday life. Elements of everyday life had long had a role in religious works; pictures in which such elements were the subject of a painting developed in the 16th century with such artists as Pieter Bruegel. The Carracci and Caravaggio developed genre painting in Italy, but it was in Holland in the 17th century that it became an independent form with its own major achievements, Vermeer being one of its finest exponents.

Grand Tour, during the 18th century, an extended tour of the Continent undertaken by British aristocrats to broaden their education. The main destination was Italy, and Rome in particular, the attractions being the art and architecture of Ancient Rome and of the Renaissance. The Grand Tour played an important role in encouraging an interest in classical and Renaissance art to Britain, and also (because many visitors wanted works to remind them of their visits) in promoting a last flowering of Venetian art.

grisaille (Fr. *gris*, "gray"), a painting done entirely in one color, usually gray. Grisaille paintings were often intended to imitate sculptures.

hatching, in a drawing, print or painting, a series of close parallel lines that create the effect of shadow, and therefore contour and three-dimensionality. In **cross-hatching** the lines overlap.

history painting, painting concerned with the representation of scenes from the Bible, history (usually classical history), and classical literature. From the Renaissance to the 19th century it was considered the highest form of painting, its subjects considered morally elevating.

Impressionism, style of painting that developed in France at the end of the 19th century. Rejecting the contrived effects of Academic painting, the Impressionists usually painted out of doors and often with little preparatory drawing, their intention being to capture the fleeting impressions of light, atmosphere and weather. Their works are characterized by the use bright, clear colors, and spontaneous brushwork that conveys broad effects rather than details. Leading Impressionists included Claude Monet (1840–1926) and Pierre Renoir (1841–1910).

impasto (It.), the technique of applying paint very thickly; paint applied very thickly.

Inquisition, in the Roman Catholic Church, a tribunal whose function was to suppress heresy. It was formally established in 1232, and during its long history became notorious for its brutality.

Loggetta, the entrance to the Campanile of St. Mark's Cathedral in Venice. Designed by Sansovino (1486–1570), it is noted for its elegant architecture and statues.

Mannerism (It. *maniera*, "manner, style"), a movement in Italian art from about 1520 to 1600. Developing out of the Renaissance, Mannerism rejected Renaissance balance and harmony in favor of emotional intensity and ambiguity. In **Mannerist** painting, this was expressed mainly through severe distortions of perspective and scale; complex and crowded compositions; strong, sometimes harsh or discordant colors; and elongated figures in exaggerated poses. In architecture, there was a playful exaggeration of Renaissance forms (largely in scale and proportion) and the greater use of bizarre decoration. Mannerism gave way to the Baroque.

Molo, the promenade along the bank of the Grand Canal outside the Doge's Palace. On the opposite side of the canal the promenade is called the Riva degli Schiavoni.

palazzo, pl. **palazzi** (It. "palace") a richly decorated and generously built residential house, a mansion.

palette (Lat. *pala*, "spade"), the board on which an artist mixes colors; the range of colors an artist uses.

Palladian, in architecture, in the style of the Italian architect Andrea Palladio (1508–1580), who developed an austere form of classicism derived from ancient Roman architecture.

perspective (Lat. *perspicere*, "to see through, see clearly"), the method of representing three-dimensional objects on a flat surface. Perspective gives a picture a sense of depth. The most important form of perspective in the Renaissance was **linear perspective** (first formulated by the architect Brunelleschi in the early 15th century), in which the real or suggested lines of objects converge on a vanishing point on the horizon, often in the middle of the composition (**centralized perspective**). The first artist to make a systematic use of linear perspective was Masaccio, and its principles were set out by the architect Alberti in a book published in 1436. The use of linear perspective had a profound effect on the development of Western art and remained unchallenged until the 20th century. During the Baroque — especially in the area of set design – artists employed intersecting perspective, *scena dell'angolo*, which allowed for in-depth views and a greater sense of spatial depth in general.

Piazzetta, a small square close to St. Mark's Square (Piazza San Marco) in Venice. The Biblioteca Marciana (Libreria Sansoviniana), a famous library, is on the Piazzetta.

Procuratie, the palaces on the Piazza San Marco that Procurators used as living accommodation. The old Procuratie in the square's northern section were built from 1496–1520, the new Procuratie, in its southern section, in 1584. The Procurators were the nine highest ranking state officials, from whose midst the Doge was elected.

ritratto (It.), portrait

Rococo, a style of design, painting, and architecture dominating the 18th century, often considered the last stage of the Baroque. Developing in the Paris townhouses of the French aristocracy at the turn of the 18th century, Rococo was elegant and ornately decorative, its mood lighthearted and witty. Louis XV furniture, richly decorated with organic forms, is a typical product. Leading exponents of the Rococo style included the French painters Antoine Watteau (1684–1721) and Jean-Honoré Fragonard (1732–1806), and the German architect Johann Balthasar Neumann (1687–1753). Rococo gave way to Neo-classicism.

scena dell'angolo, see: perspective

scuole, sing. *scuola* (It. "school"), in Venice, the religious and social organizations attached to the guilds. They were often wealthy, and played a leading role as patrons of Venetian art.

segretaria (It.), in Venice, state administrators and officials.

signoria (It. "lordship"), from the 13th to the 16th century, the governing body of some of the Italian city states. They were usually small groups of influential men presided over by the head of the city's most important family.

sopra il loco (It.), of a painting, done on the spot, directly in front of the scene depicted.

sopraporta, (It."over the door"), painting or relief sculpture over a door. Accentuating the whole door area, they were particularly popular in Baroque and Rococo rooms. *Sopraporta* paintings were often *capricci*, and generally formed an integral part of the architectural ensemble.

staffage, in painting, the use of small figures (usually people, and sometimes animals) to enliven a view or landscape.

stucco (It.), a protective coat of coarse plaster applied to external walls; plaster decorations, usually interior. During the Renaissance stucco decorative work. often employing classical motifs, achieved a high degree of artistry.

Terraferma (Lat. *terra firma*, "solid ground"), the mainland possessions of the Venetian Republic.

thaler, silver coin used in several German states from the 16th to the 19th century.

topography (Gk. *topographein*, "to describe a place"), the accurate, and usually detailed, description of places.

triumphal arch, in the architecture of ancient Rome, a large and usually free-standing ceremonial archway built to celebrate a military victory. Often decorated with architectural features and relief sculptures, they usually consisted of a large archway flanked by two smaller ones. The triumphal archway was revived during the Renaissance, though usually as a feature of a building rather than as an independent structure.

trompe l'œil (Fr. "deceives the eye"), a painting which, through various naturalistic devices. creates the illusion that the objects depicted are actually there in front of us. Dating from classical times, trompe l'œil was revived in the 15th century and became a distinctive feature of 17th-century Dutch painting.

vedutà pl. *vedute* (It. "view."), a form of landscape, typically of a town or city, that is topographically accurate. The *vedutà ideata* (It. "ideal view"), on the other hand, is a painting or drawing of a city or landscape that combines real and imaginary elements, a fantasy landscape. The form was most fully developed by 18th-century Venetians such as Canaletto and Guardi. The *vedutà ideata* is also known as a *capriccio.*

vignette (Fr. *vigne*, "vine"), a decorative design at the beginning or end of a book; a design or image that fades off into its background at the edges

wash, a layer of thin watercolor or ink painted on a drawing.

zecchino (Arabic *sikkah*, "coin die"), a gold coin used in the Venetian Republic. It was also known as the sequin.

SELECTED BIBLIOGRAPHY

Baetjer, Katharine and J. G. Links, Canaletto, New York 1989

Constable, William George, Canaletto: Catalogue Raisonné, Oxford 1967

Constable, William George and J. G. Links, Canaletto, Oxford 1976/1988

Corboz, André, Canaletto: Una Venezia imaginaria, Milan 1985

Huguenin, D. and E. Lessing, Venedig. Glanz und Glorie. Zehn Jahrhunderte Traum und Erfindungsgeist, Paris 1993

Kozakiewicz, Stefan, Bernardo Bellotto, genannt Canaletto, Recklinghausen 1972

Levey, Michael, Paintings in the Collections of Her Majesty the Queen, London 1964

Levey, Michael, The Later Italian Pictures in the Collection of Her Majesty the Queen, Cambridge 1991

Links, J. G., Canaletto and his Patrons, New York 1977

Links, J. G., Canaletto, London 1994

Magnifico, M. and M. Utili, Vedute italiane del Settecento in collezioni private italiane, Venice, Milan 1987

Pallucchini, Rodolfo, La pittura veneziana del Settecento, Venice, Rome 1960

Parker, Karl T., The Drawings of Antonio Canaletto in the Collection of Her Majesty the Queen, Bologna 1990

Pauli, Gustav, Venice, Leipzig 1926

Pedrocco, Filippo, Canaletto und die venezianischen Vedutisten, Florence 1995

Pignati, Terisio, Das venezianische Skizzenbuch von Canaletto [Canaletto's Venetian Sketchbook], Munich 1958

Pignatti, Terisio, Canaletto, Milan 1979

Pignatti, Terisio, Venedig in Kupferstichen des 18. Jahrhunderts, Berlin 1994

Pilo, Giuseppe, Canaletto, Verviers 1961

Zampetti, Pietro, Vedutisti Veneziani del Settecento, Venice 1967

Zorzi, Alvise, Venedig: die Geschichte der Löwenrepublik, Düsseldorf 1985

Zorzi, Alvise, Emanuele Kanceff, Marilla Batilana, Francis Clandon, Piero Cuzzola and Gianni Carlo, Sciolla Venezia dei grandi viaggiatori, Rome 1989

PHOTOGRAPHIC CREDITS